Fundraising for
Small Museums

D1637431

Fundraising for Small Museums

In Good Times and Bad

Salvatore G. Cilella, Jr.

ALTAMIRA
P R E S S

A Division of Rowman & Littlefield Publishers, Inc.
Lanham • New York • Toronto • Plymouth, UK

Published by AltaMira Press
A division of Rowman & Littlefield Publishers, Inc.
A wholly owned subsidiary of The Rowman & Littlefield Publishing Group, Inc.
4501 Forbes Boulevard, Suite 200, Lanham, Maryland 20706
http://www.altamirapress.com

Estover Road, Plymouth PL6 7PY, United Kingdom

British Library Cataloguing in Publication Information Available

Library of Congress Cataloging-in-Publication Data
Cilella, Salvatore G.
 Fundraising for small museums : in good times and bad / Salvatore G. Cilella, Jr.
 p. cm. — (American Association of State and Local History book series)
 Includes bibliographical references and index.
 ISBN 978-0-7591-1968-0 (cloth : alk. paper) — ISBN 978-0-7591-1969-7 (pbk. :
alk. paper) — ISBN 978-0-7591-1970-3 (electronic)
 1. Museum finance—United States. 2. Fund raising—United States. I. Title. II. Title:
Fund raising for small museums.
 AM122.C55 2011
 069'.068—dc22

2010047458

∞™ The paper used in this publication meets the minimum requirements of American
National Standard for Information Sciences—Permanence of Paper for Printed Library
Materials, ANSI/NISO Z39.48-1992.

Printed in the United States of America

CONTENTS

PREFACE

A great museum relies on the age-old quintet of standards adopted by the museum field long ago: collection, interpretation, education, preservation, and exhibition. John Merryman, an Ivy League commentator and intellectual in cultural public policy, reduced the five to three: preservation, truth, and access. These three standards apply today but are being sorely tested by the change in the composition of audiences in the twenty-first century, the audience's changing tastes, and the exponential explosion of technology. The latter factor has changed the way we look at life, our view of the future, and how we receive and use information on a minute-by-minute basis—and how we fundraise.

In a recent article on the front page of the *New York Times* entitled "State Fairs, Sagging, Arrive at County Crossroads" (August 16, 2006), the story of a national pastime passing from the scene may be a cautionary tale for museums. The Illinois state fair was losing millions of dollars in revenue with the drop in attendance, and the state fair in South Dakota was in very real danger of being abolished. One state senator was quoted as saying, "We're trying to keep a dinosaur alive that's probably outlived its purpose." In Colorado, the state fair was being subsidized with a special appropriation of four million dollars, and the Nebraska fair is being subsidized by the state lottery after facing bankruptcy in 2004.

State fairs go back at least two hundred years in this country and were started in a rural economy for a rural audience. During the Civil War years, nearly 98 percent of the nation's population lived on farms. By 1900, that number had dropped to 90 percent. Today, the percentage of our

population residing on farms is between 1 and 2 percent. As a result, fairs have resorted to Disneyland-like attractions, including, in Texas, bungee jumping and a trained house-cat act. One fair manager was quoted: "It's a classic marketing and business problem, the product that you are selling was losing appeal." The article went on to say that "there are many signs of the urgent search for relevance. Not so far from the cows were animals not native to the rural fields of downstate Illinois: Bengal tigers, dancing black bears, sharks and alligators."

In this day of video games, live performances, DVDs, movies on the Internet fed directly to your computer, movies on demand, movies on your cell phone, pyrotechnics at concerts, music videos, three hundred-plus television channels, pay-per-view, and new museums opening every day, it does not take a vivid imagination to make the connection between museums and the sad tales coming out of the heartland relative to the institutions of the county and state fairs. As a marketing consultant once told me, "Your main competition is the couch, not the museum or cultural attraction down the road." In addition, the newest generation is completely wired. A sixty-plus-year-old who was raised on the old, static, look-into-the-old-case-at-the-cabinet-of-curiosities show and perfectly satisfied with the experience does not apply to the current, wired generation. And the concept of relevance has become a concern of paramount importance. Are we trying to sell a product that has lost its appeal?

In 1976, attendance peaked at the majority of American outdoor museums in celebration of the nation's bicentennial. Attendance declined until the 1990s, when the economic bubble fueled by the dot-com frenzy saw audiences returning to museums—although primarily to art museums. A mini–building boom produced new museums throughout every region of the country—again, mostly art museums were the beneficiary of this trend.

With the terrorist attacks of 9/11, the entire museum industry, particularly museums reliant on tourism dollars, fell on hard times. Old Sturbridge Village came near closing its doors for good during the 1990s. Colonial Williamsburg struggled through the same period with a $38 million deficit. Other museums, in an expansion frenzy, have discovered the sad truth that "if you build it, they will *not* come." The *Chronicle of Philanthropy*, writing immediately after 9/11, compared

different moments in American history and their impact on charitable giving correlated to times of stress. Ironically, major moments of turbulence, political strife, military confrontations, and economic troubles barely moved the charitable giving needle, although the only time since World War II that giving retreated was during the economic downturn and stock market collapse of 1987.[1]

Like state fairs, museums are in desperate need of reinventing themselves with newer and more creative ways of drawing audiences who find their offerings not only relevant but also entertaining. For our profession, the world changed profoundly when Walt Disney opened Disneyland in the 1950s. There the "imagineers" pioneered a whole new concept of interactive "edutainment." From that time forward, theme parks with "gee whiz" exhibits and interactive entertainment set the standard for all audience-driven venues. Science and children's museums embraced the new concepts immediately. Art museums and history museums have been slow to grasp the significance of interactive and technologically enhanced exhibitions. Large art museums in sophisticated and educated markets have delayed the impact of "gee whiz" exhibits by resorting to the audience-pandering blockbusters on Monet, Manet, King Tut, French Impressionism, and van Gogh. Art museums in small markets are struggling as much as history museums.

Technology is not the answer to energize diverse audiences to flock to attractions. Some museums have followed the path of rigid academia to the point of near extinction. The new Lincoln museum in Springfield, Illinois, has used the Disney techniques of animated figures and television/video technology that has alienated older museum professionals and at the same time caught the eye of the general public. New audience surveys indicate that museumgoers are now looking for the old-fashioned, unplugged model in museum experiences. They argue that with the advent of the iPhone and similar devices, they now want to be *disconnected* when they visit our museums.

Recent studies by David Thelen and others show that most Americans trust history museums more than any other institutions, including Grandmother, when it comes to presenting the truth. Americans have stated that they would rather receive their information on America's past from museums than any other sources. How, then, does one reconcile the phenomenon of declining attendance at many history museums with this

information? The answer may lie in some simple allusion as the "Statue of Liberty" syndrome. Many New Yorkers have never visited the statue but would probably abhor the idea of its removal. It is just "nice" to know it's there. This same phenomenon occurs in museum membership programs, where individuals will join an institution because it is the civic thing to do but never attend the museum's programs.[2]

What, then, can an institution do to get its audience "off the couch" to visit the new program or exhibit and eventually donate money to the cause? We should take our direction from the late Canadian museum professional Duncan Cameron, who in 1971 argued in his article "The Museum: A Temple or the Forum" that the museum had become a community gathering place where ideas, debate, and confrontation should take place. The concept, as with most very good ideas, was simple. The museum would become a forum for debate on current issues whether they were part of the institution's originally tightly constructed mission or not. On another level, museums ceded authority to the general populace and to diverse groups within the community. This was done in an attempt to include diverse minorities, which had traditionally been excluded from the predominantly Anglo-Saxon museums common in the United States since the nineteenth century.

Cameron wrote that museums could no longer afford to be temples but must become "forums": forums of conversation, forums of confrontation, forums dealing with current issues. Perhaps some museums, especially those in larger sophisticated urban areas, have passed beyond the "forum" stage of development and in order to survive have become centers of "edutainment." Is our choice in this postmodern world to be either video arcades or museums? Which would a member of today's fragmented society choose? Are those false choices? Is there a middle ground? Smaller museums away from large urban centers and lucrative fundraising prospects on all levels are definitely at a disadvantage. Certainly the devout who belong to the religion of technology would assert that more bells and whistles in an exhibit would draw the under-thirty crowd. The older generation decries the loss of mission-driven programming in museums while the shop managers and CEOs see income-driven blockbusters as the wave of the future. In Indianapolis, the Indiana State Museum had a very successful run of the exhibit "Star Wars"—a program that had absolutely nothing to do with the museum's

mission. But the gift shop made its entire year's budget during the show's four-month run. Traditionalists were aghast, but the bottom line turned from red to black for the year.[3]

The late Stephen Weil, a thoughtful and caring museum professional and author of several well-constructed articles concerning the museum world, wrote a book in 2002 entitled *Making Museums Matter*. He takes Cameron one step further in a continuum exploring museums and their relevance to modern society. His most compelling chapter was entitled "Museums: Can and Do They Make a Difference?" His provocative arguments ask the central questions: What is a bad museum, what is a good museum, and what distinguishes the two? He persuasively argues that museums are a place for entertainment, education, experience, and socialization. A good museum has a clear and worthwhile purpose, the necessary resources to achieve that purpose, a "fiercely determined" leadership committed to the museum's purpose, and finally, feedback. The word *entertainment* causes heartburn among older museum professionals who do not understand why the general public is not as serious about his/her profession as he/she is.

But, as Weil argues, entertainment can be found anywhere in our modern society. Education has been the staple of museums since the nineteenth century. Experience is a more complicated attribute debated fiercely by psychologists and sociologists, but Weil breaks through all that and argues that museums' capacity to provide an "experience-rich environment" sets us apart from all others and may be the only avenue of meaning and ultimately survival. Stressing the museum as a tourist destination will quickly be surpassed by the latest Disney-like attraction with a large checkbook. Educational programs abound in nearly all nonprofit institutions; museums have no monopoly on the education field. Socialization?—again the museum is not a unique place, particularly in a close-knit, smaller community. We are left with only the delivery of an experience. With our rich collection of genuine objects that have the power to communicate if presented in the proper way, we fill a unique space in the crowded marketplace of so-called leisure time. According to Weil: "What museums have that is distinctive are objects, and what gives most museums their unique advantage is the awesome power of those objects to trigger an almost infinite diversity of profound experiences among their visitors." The Smithsonian's 150th anniversary

exhibition asked people to "remember, to discover, and perhaps above all—to imagine."[4]

Small museums still have their collections, their objects, their missions to attract audiences and certainly donors. If they are clever and wisely use their resources, they can not only survive but also thrive. I state above that they are at a disadvantage. But is that completely true? Not really. The key to the future is the relevance of the museum's programs and the authenticity of genuine objects that tell a story. The future of the individual museum lies in its ability to tell its story effectively—"to tell compelling stories about enduring issues." A strong foundation for your institution will ensure successful fundraising in good times and bad.

In addition to a hard economic landscape, museums and nonprofits in general face what author Paulette Maehara calls six "megatrends" that are "dramatically changing the nature of fund raising and the philanthropic" world. She cites the "increasing competition for the charitable dollar, increasing demand for accountability and transparency, the public's push for greater technology capabilities, greater demand for non-philanthropic revenue, changing demographics of donors, and growing regulation of fund raising by government."[5]

Several years ago, I wrote an extended paper for the American Association of Museums. Most of the hard information in that piece is no longer valid in this Internet age. Yet the basic truths of fundraising it contains remain as valid today as when I first wrote them. That piece was addressed to the administrator of the small or medium museum with or without a fundraiser. As I wrote then, it was designed to reveal the hard-won lessons of fundraising by seasoned professionals. It pointed out what is still true. The age-old adage that people give to people remains as true today in the exponentially growing technological world we live in as ever before. Fundraising advice may appear at times counterintuitive and contradictory only because fundraising is an art and not a science. It is afflicted by clichés like "people giving to people," some of which are still valid. There is not a book or article written today that offers an absolute and uniform method to raise money successfully. You should not expect that from this book either. These thoughts and suggestions about development should stimulate additional ideas that you will apply in your individual situation. Sometimes they will work in a given environment, and sometimes they will not. After years of

teaching fundraising, I learned that the best answer to most questions is "It depends."

I would like to dedicate this exercise in writing and compilation to three fundraisers who influenced me greatly and who taught me how to ask for money successfully without fear of rejection. The first was Paul Franz, the vice president of development for Lehigh University in Bethlehem, Pennsylvania; John Taylor of the fundraising counsel Martz and Lundy, who taught me how to manage a capital campaign at Old Sturbridge Village; and Bob Wislinski, my director of development at the Columbia Museum of Art, Columbia, South Carolina, who, with me, wished and sweated a new art museum into existence in 1998.

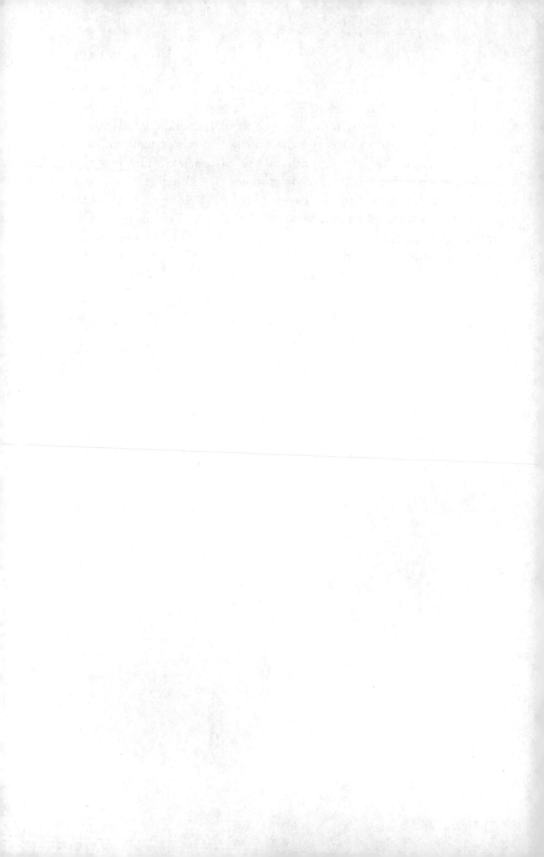

PHILANTHROPY AND THE NONPROFIT WORLD

No one has ever become poor by giving.

—Anne Frank

Supposedly, Ben Franklin started the first true American charity. He based his design on the corporate model with a corporate state charter, a board of directors, a mission, a series of products or programs, a staff, a physical plant, a plan, and, above all, funding. When the IRS came on the scene to monitor the business world and nonprofits, it was guided by the Internal Revenue code, which listed nonprofit organizations under section 501(c). That section of the code includes fraternal organizations and cemeteries—more than twenty different types of nonprofits. Museums are defined under the charities section—501(c)(3). That is unfortunate, for the term *charity* has come to more generally define social service agencies. Museums more and more are acting like for-profit corporations as the lines between the two become increasingly blurred. As Beverly R. Hoffman has pointed out, "In reality, 501c3 organizations are special *business* corporations that operate for the benefit of the general public; they have special tax dispensations under the assumption that their *work can not be accomplished at a profit by a commercial business corporation.*"[1]

As a result, nonprofits have resorted to a variety of ways to keep the mission on track and the doors open. Most are now in active fundraising mode. Some do a better job than others. Size remains relative. Good grassroots

fundraising by small organizations can be equally as effective as that of larger, more bureaucratic organizations. Just because you may be a small historical society doesn't mean that you will be less successful in your fundraising efforts. You may have to be more creative and nimble than the big guys.

The most important concept to remember about fundraising is that it is first and foremost a human endeavor. That is such an obvious statement that it appears ludicrous in print. My reason for making it is simple. Many people forget the human element and rely on modern technology, depersonalized mail solicitations, or an inordinate emphasis on the program or the project without the impact on the individual. One of the great clichés is that "people give to people." Basically, that is true. The most successful fundraising I have done or have witnessed has been accomplished after much hard research, good cultivation, and face-to-face solicitation. In the end, although I was there as a spokesperson for my cause, I had the distinct impression that the gift was made because of a mutual trust I had been able to build between myself and the prospect.

This should give heart to the small local organization that counts heavily on volunteer aid, has neither the budget nor the expertise to install a sophisticated computer system, and doesn't have the development staff employed by the larger institution down the street. There are a few simple fundraising truths which, if applied conscientiously, can work for the small organization as well as the large.

The three words *development*, *fundraising*, and *advancement* are often used interchangeably. Fundraising is the basis for all. Development is a word coined by then-president of the University of Chicago, Ernest D. Burton, in 1934. He defined it as "the planned promotion of understanding, participation and financial support." The term *advancement* has been adopted by large educational institutions to imply more than fundraising—such as "institutional advancement." For the small museum, the term *development* is most adequate, and it need not get caught up in "word inflation." Development can be defined as the well-organized, distinct management tool directly related to and integrated with the museum's goals and mission.[2]

It is not a once-and-done endeavor but an ongoing, structured management function designed to create understanding and to gather support for the institution. It is about honest personal relationships, organizational and personal quality, and transparency. The best fundraising is

done by professionals committed to the cause they represent, directing volunteers who wish to see the cause succeed in its mission. In all cases, the human element is primary. And when fundraising fails, it can usually be attributed to human omissions and commissions. Sometimes the "ask" is too early, too late, too much, too little. There may have been no follow-up. Fancy brochures and slick software packages will not camouflage poor preparation of volunteers, a poor institutional image, or the lack of imagination in presenting the cause. These truths hold for appeals made to foundations, corporations, individuals, and governments. In all these cases, an individual makes the request of another individual.

Unlike colleges and universities, museums do not have a loyal alumni group to fall back on for continual annual or special project support. This

The Giving Pyramid. Fundraisers have, for years, used the pyramid as a way of understanding that not all donors are equal and not all prospects will pan out. By its very nature, the pyramid narrows as larger and more transformative gifts are solicited and given.

means you must work hard at moving museumgoers and enthusiasts to members and eventually donors and then at moving them up the pyramid through carefully strategic moves that will ensure their loyalty and continued support.

But this is a two-sided coin. In the bargain, once you take the money, you must perform. Your performance around the circumstances of the gift, its intent, the donor's intent, and the ultimate disposition of the gift are laden with promise and peril. Increasingly, over the past thirty years, the exchange has shifted from the requester to the donor. Today the donor calls the shots as never before. Donors are demanding more accountability, which is a good thing, but in some cases they are trying to micromanage the use of their money, adding one more layer of diligence and concern over the entire process. The most important issues are, however: "What are the donor's needs?" "Do we have a way of meeting those needs in our museum?" "Is the donor interested in our museum?" and "If not, how can we interest him or her in our institution?"

Your first prospects are those who use your organization. You must move those visitors/users to become members if you have a membership program or annual fund donors and then to major supporters. Your goal is to eventually move these "users" to think about you as a legacy of their largesse in their will. The giving ladder up the pyramid necessarily narrows toward the top, indicating to you that only a small group of dedicated supporters will follow you to the top.

Fundraising Fundamentals

Where does fundraising start?

It starts with an assessment of your revenue mix. What are the sources of income for your museum? Do you have an endowment? How much money does it spin off for your operating needs? Do you count on earned income from rentals, gift shop sales, ticket sales, and/or service fees such as photocopying, research, and charges for special events? Do you have a membership that pays for itself, or is it a loss leader? Do you receive state, county, or local operating support or support from municipalities for special projects that are nonrecurring? Do you depend on grants to keep the doors open? Does fundraising play a large or small part in your operation? Those of us who have toiled in the field for many years have realized that

a diversified portfolio in a museum's budget is the best protection in any environment. When the economy is good, all cylinders are firing. When it goes badly, the diversity will theoretically protect the museum. In the recent "Great Recession," those museums with large endowments took a major hit. Universities such as Yale and Harvard lost 25 percent of their endowment values. Institutions that relied on other sources of revenue, with little endowment money at risk, lost very little. During the recent downturn, institutions that worked closely with their major donors just maintained their annual fund and major gifts levels—no increases, but the new "up" was the status quo.

Elizabeth Merritt, in a recent article in *Museum News*, says, "By cultivating all four streams, the museum attends to the needs and desires of a broad constituency: public officials, private donors, philanthropic foundations, and consumers."[3]

Strategic fundraising begins with six simple steps. First and foremost, develop your fundraising goals. If you are a five-person shop, who do you include in the planning process? Your education director, your finance person? Probably all of them. Be sure to include your board in your soul-searching. Develop a plan for each goal. For example, say you want to increase school programs by 5 percent in a certain section of your community. Do you need additional personnel, support staff, or volunteers to reach that particular goal? Another goal might be the purchase of a historical painting available only to you and your institution. Another, most important target is setting the annual fund goal. How much will you need this year; how often and at what level have your donors favored you over the years?

Second, write it down. A written plan is effective and efficient, and it clarifies your thinking. It also focuses the mind on the important over the trivial. Third, estimate your fundraising costs. Yes, fundraising costs money, but try to keep your dedicated fundraising costs to 25 percent or below of your entire project's costs. Fourth, develop a time line. Not doing so encourages the procrastinators and delays your success. The time line also helps focus the mind on the tasks at hand. Fifth, identify your sources. Who can you approach on your donor list that might be interested in this once-in-a-lifetime opportunity? Do your homework; there is more on that in the chapters on solicitation and grantsmanship. And last, evaluate and refine as you go along. Improve the plan, incorporate new

information, and adjust goals as they are achieved or delayed. As author Joanne Fritz advises, "Once your organization gets the hang of raising funds for a year's operation, you'll want to move on to multi-year plans, higher goals, more sophisticated strategies and newer techniques."[4]

Fundraising Is a Function of Board Service

News Item: The San Francisco Museum of Modern Art reported on February 5, 2010, in the midst of the worst recession since the Great Depression, that six months after announcing a $480 million fundraising target it had reached the halfway mark in its capital campaign with $250 million in hand—"largely through contributions from core board members."[5]

The nominating committee is the most important committee, just a step ahead of the development committee. Fundraising is a joint venture that is mutually shared by management and the governing board. And good board members are hard to find. Once you have them, they become invaluable community ambassadors for you.

Unfortunately, they do not think about you night and day—when they are not meeting with you. They are not like many management/staff people who live and breathe their museum responsibilities on a daily basis. Boards are like Congress or your city council—they can be terribly frustrating as a group. They can be disparaged by disaffected groups, the staff, or disgruntled members. But individually they are just as normal as the next person. It is easy to fall into the convenient complaint—"Oh, the board won't do this and the board won't do that"—or worse yet, the cowardly CEO complaint—"The board wouldn't let me do that." What you realize eventually is that individuals—like your councilperson or congressperson—are susceptible to the same influences and emotions that you are. Most trustees do not think about the museum until about a minute before they enter the board meeting. And, sad to say, they forget about you the minute they leave the board meeting. They are doctors, lawyers, and bank executives who grapple with their own issues and aggravations, and you can see their level of concern more readily today than just a few years ago. Today they are immediately on their cell phones, pagers, or iPhones—texting and taking care of their own businesses as they leave

the boardroom—and even more sadly, texting and e-mailing during the board meeting.

According to Elizabeth Schwinn in a recent article in the *Chronicle of Philanthropy*, boards are not "doing enough to raise money for their groups." She based her assertion on a new report that "surveyed chief executives and board members from more than 1,100 organizations." The BoardSource report showed that "only 40 percent of charity board members feel comfortable asking other people to donate to their organizations, and on average, only about three-quarters of board members donate money themselves." The president of BoardSource, Linda Crompton, emphasized that fundraising was the "No. 1 area of board performance that needs to be improved. The nonprofit sector needs more board members who understand their fund-raising role and are willing to take an active part in the sustainability of their organizations."

Crompton's advice to nonprofit organizations was to "set expectations for incoming board members about their role in raising money for the organization." Sadly, the study "found that about half (51 percent) of charity boards require their members to solicit donations for their organizations." A few more required "board members to attend fund-raising events (60 percent) and to identify prospective donors (61 percent). A little more than two-thirds (68 percent) of boards require members to make a personal contribution to the organization."[6]

However, according to the accounting firm Grant Thornton LLP, slightly more than half of charities require their board members to make financial contributions to their organizations. In the past, many charities have employed a "give or get" policy, where board members are required either to contribute to the organization or to solicit contributions from friends, colleagues, and other contacts. However, the survey, the fifth annual *National Board Governance Survey for Not-for-Profit Organizations*, shows that requiring board members to personally give is slowly becoming the norm. "Board members are increasingly expected by other constituencies and stakeholders to set the example by personally making significant contributions," said Frank Kurre, national managing partner of Grant Thornton LLP's nonprofit practice.

The *Nonprofit Board Report* suggests that branding is key to raising money with board members. Unfortunately, many trustees do not understand branding. To many, it is the corporate logo, its size and color, and

that's all. In reality, it is much more. Understanding branding involves the (1) "emotional affect of the organization's personality," (2) its "style or philosophy in delivering services," (3) its "tone of voice (courageous or authoritative)," and (4) its "tradition." Once these four factors are understood by the board and internalized into board members' thinking, the organization must learn to differentiate or distinguish itself from all others and then monitor the community's awareness of its image (more on image later). Once a board understands that branding goes far beyond the corporate logo and instead goes to differentiation from the competition and that perception is reality, it will be better equipped to raise significant money.[7]

Board Contribution Expectations

The survey also looked at how much board members are expected to give based on the budget size of the organization. Table 1.1 shows the range of gift expectations for board members, with the size of expected gifts increasing as the budget size of the organization increases.

On the contrary, the Association of Fundraising Professionals' 2006 survey on the state of fundraising also asked participants about board giving, specifically what percentage of their boards of directors financially support the organization. Respondents reported a significant amount of board giving. Nearly nine in ten respondents (87.4 percent) in AFP's survey reported that more than half of their board members made gifts to their organizations. In addition, more than seven in ten respondents (70.6 percent) said that at least 80 percent of their board members contributed to their fundraising efforts, and about 60 percent indicated that more than 90 percent supported the organization financially.

Table 1.1. If board members are expected to make a financial contribution to the organization, how much contribution is expected on an annual basis (by organization's budget size)?

	< $20M	$20M–$50M	$50M–$100M	$100M–$500M	> $500M
$1,000 or less	54%	39%	39%	24%	25%
$1,001–$2,500	20%	18%	15%	12%	12%
$2,501–$5,000	12%	7%	22%	4%	25%
$5,001 or more	14%	36%	24%	60%	38%

At the other end of the spectrum, 4.4 percent of respondents saw minimal participation (0 to 10 percent) from their board members. Another 8.3 percent of respondents experienced board participation in the 11–50 percent range. These numbers show an increase in board participation figures from the 2005 survey. In 2005, almost half of respondents (47.5 percent) reported that nearly all of their board members (90 percent or more) made gifts to their organization. About 10 percent of respondents reported that their board members barely participated at all (0 to 10 percent).[8]

Board involvement in fundraising, according to Robert L. Gale, former president of the Association of Governing Boards of Universities and Colleges, is an "indication of a successful organization. Financially sound nonprofit institutions generally are overseen by boards of directors who are committed philosophically and financially to their organizations." Gale goes on to say that organizations "that must struggle to stay fiscally afloat invariably have board members who are indifferent, are distracted by other commitments, or are unwilling to face up to their fiduciary responsibilities." Strong words indeed, but completely accurate. In the museum setting, trustees in large and small institutions need to be engaged. But how do you do that?[9]

For starters, establish a one-page list of expectations for new board members. Tell them in the most diplomatic way possible what is expected of them. Each new board member should receive a list of expectations that clearly delineates the role. Some organizations include a section rudely described as "give, get, or get off." I have too often seen new trustees come on board with little or no knowledge of what is expected of them by staff and current trustees. More often than not, they were recruited by current trustees with whom they are friends, and both sides "assumed" that the new members understood exactly what they were getting into and what was expected of them. Worse yet, they were told only after they joined the board that fundraising was a top organizational priority. How this aberration persists among some nonprofits remains a mystery. It probably stems from the fact that we are all on a mission that is good and proper and that can only mean progress, sweetness, and light. The reality is far from this point of view. Trustees have to make tough decisions in good times and bad.

Always ensure that you have corporate or businesspeople on your board. Lawyers, doctors, and consultants are fine—they are seldom major donors, but they can open doors.

The Indiana Historical Society uses the following one-page introduction to board service:

Responsibilities of the Board of Trustees

The Indiana Historical Society Board's governance responsibilities mirror those of for-profit entities, in that each member of the board is expected to comply with all legal and fiduciary duties, to participate in long range and strategic planning, to be good stewards of IHS resources, to assist in fashioning operational goals, to manage the hiring and supervision of the chief executive officer, to formulate wise policy, and to lend assistance to the overall functioning of the Board and the IHS in line with any special skills, experience or capacities each Board member may possess. To help ensure the faithful performance of these responsibilities and adherence to the above-outlined standards, the following additional, specific expectations are expressly delineated:

1. Regular attendance and constructive participation in board and committee meetings. According to the bylaws, trustees are obligated to attend at least three board meetings each year.
2. A willingness to serve as an ambassador from the IHS by regularly attending and/or supporting IHS programs and events. We ask that you attend, in particular, exhibit openings, evening lectures, special cultivation events, fundraising events, and meetings of your assigned committee(s).
3. Provide financial support to the IHS by giving generously according to your means, making the IHS a priority in your giving, and by obtaining access to other sources of funding. We ask that you make an annual gift of at least $1000 to become a member of the Council of 1816, participate in any special campaigns, and consider a bequest to IHS.
4. A willingness to work closely with management and staff in fulfilling the IHS mission. This is particularly important in the area of development and committee work.
5. Avoid all ethical conflicts of interest or personal gain from board membership.
6. Avoid ethical conflicts with other not-for-profit organizations with which you may be affiliated. Names or lists of donors, members, or benefactors are privileged information not to be shared with others.

Adopted by the Board of Trustees of the Indiana Historical Society on July 25, 2003. Revised and reaffirmed by the Board of Trustees on July 23, 2008.

A similar "Board Responsibilities" was adopted by the trustees of the Atlanta Historical Society recently. Other nonprofit organizations have developed similar statements of expectations with varying degrees of specificity. Very large art museums, for example, require large annual donations just for the privilege of sitting on the board. Small historical societies can rarely afford to impose large tariffs or fees in return for board service. Your current board, led either by your governance committee or nominating committee, should decide on what the traffic will bear in your community—a listing of minimal expectations for new board members.

The statement of responsibilities or expectations is so important for new trustees so that they can act responsibly with a crystal-clear idea of what is expected of them and exactly why they were recruited.

In sum, board members have *three principal duties*. They are:

- Duty of due care. The essence of due care is being able to make reasonable organizational decisions with sufficient and appropriate information. A lack of confidentiality will inhibit the flow of information to the trustees and reduce the frankness of their discussions.

- Duty of loyalty. Loyalty is the trustee's duty to act in the best interests of the organization. The failure to adhere to confidentiality can have numerous adverse effects on an organization, from fracturing the board to increasing the museum's potential third-party liability. If a trustee concludes that the best interest of the museum requires disclosure of confidential information, then such disclosure should be acknowledged and made to the chairman or vice chairman of the board or to the executive committee.

- Duty of good faith. Good faith requires each trustee to act honestly and fairly in his or her dealings with the museum. Unjustified breach of confidentiality violates good faith because it breaks the understanding that board communications will remain confidential.

Is it fair to ask the new board members to make an annual gift to your museum? Absolutely. It should be a requirement. At a minimum, your bylaws should call for all trustees to be members. Michael M. Kaiser, the president of the Kennedy Center for the Arts in Washington, D.C., was once the director of the Alvin Ailey dance group. He had a board of thirty-six members and an operating budget of six million dollars, yet half of the board was giving less than three hundred dollars per year. He "had to get the board to understand that was not an appropriate gift for an organization of that size." Eighteen board members resigned, and he recruited eighteen new ones to take their place.[10]

Helpful Hint: Do not go through life thinking that others can/will raise the money—determine whether your board members are "askers" or "door openers." If neither, replace them.

Jim Hackney of Atlanta's Alexander Haas fundraising counsel wrote recently on the topic of the simple board ask.

The Simple Board Ask

I recently asked a museum Board member if he had ever been solicited for a gift by the museum. He had been on the board over five years and he first exclaimed: "Sure!" Then when I asked him how it was done, he thought it through and said: "Well, I guess when I really think about it; I did get a letter once when we were conducting a drive."

Oh, my stomach turned. This museum was looking for ways to stabilize its annual operating budget and get beyond living month-to-month, wondering how to meet payroll. Their contributed income was not anywhere near 40% of the budget—the national norm according to an American Association of Museums recent financial survey. In fact, it was difficult to see the entire pie of their annual operating income because they were dealing with the critical needs in front of them instead of planning for the longer-term goals that would ensure the implementation of the mission. One way to get on track is to go to "family" first, and garner the full support of the Board by asking for their annual commitment.

The importance of an appropriate "ask" to each Board member, every year, for annual operating support is paramount to moving toward success for any museum. More than two-thirds of the museums for whom we conduct a development assessment will do the minimum—send a letter or pass out pledge cards at a board meeting—to determine what a board member will give each year. A Board member of another organization told me that the chair of the board sent out an email blast to the entire Board asking each person to email him back with the figure they would contribute for the current budget year. There was no suggestion to how much they should give or why. With this kind of woefully inadequate (misguided?) effort, is it any wonder that many institutions have low giving from the Board?

There are few things that any high-performing organization can take for granted. Having 100% participation and support from the Board is not one of them. To achieve this level of support the Board request must be done in the correct way. First, every year the Board chair and the development committee chair should make their own stretch commitment to the annual fund. Then, working together, they should personally visit each and every Board member to ask them, face-to-face, for a specific amount. Only by asking others to join together with them, and asking them personally to make a stretch gift, will you maximize giving from the board, generating larger annual gifts, and leading the way for other donors to join in.

It seems so simple, yet it is not done enough. When was the last time someone had a face-to-face with a member of your Board and asked them to make a gift to your museum—explaining the impact their gift will have and why annual dollars are needed? If you don't have this personal ask with your Board members each and every year, then you aren't doing it right! Time to get back to basics with what we know works.[11]

But what if people want desperately to serve on your board but do not have the same means to support you as other board members have?

There are three possible scenarios. (1) Do not offer them a board seat, but ask them to serve on a board committee as a community volunteer. (2) Place them on the board with the understanding that if they themselves cannot give, you expect them to open doors in the corporate, foundation, or individual community for you. (3) Ask them to suggest names of other individuals who can serve and also financially support the organization.

The *Nonprofit Board Report* says to think twice about (1) career builders—they usually want to build their résumé but really don't have the organization at heart; (2) authority figures who need to be in control at all times; (3) single-issue individuals who are really interested in only a small sector of the museum and do not think pan-institutionally; (4) grandstanders who love the sound of their own voice; (5) inflexible lone rangers who have ideas that will change the world, but they are the only ones who know it; and (6) wallflowers. In a perfect world, these traits would be banished from the boardroom. Reality, however, is quite dif-

ferent. In my experience, many board members exhibit some or all of these traits at different times. I think the most important first criterion one should seek in a potential board member is passion for the mission. Second, does the individual have the capacity to make a financial contribution, a contribution beyond wisdom? There is no such thing as a perfect board member. As some politicians say, don't make the perfect the enemy of the good.[12]

More helpful are authors Israel Unterman and Richard Hart Davis, who, writing in 1982 about the "strategy gap in not-for-profits," identify three types of policymakers who come into the nonprofit world from the profit world of directors (as opposed to trustees). The first type is the "professional" director whose mission it is to not only keep his job but also to promote the mission of the organization. The second type is the volunteer business leader who has been motivated by the mission and a strong social responsibility. The third type is the volunteer trustee who believes joining the board is the right thing to do and "because connections made on the board may be useful for professional advancement." What types of the latter two do you as the chief executive have on your board?[13]

The days of nonsupporting board members have long passed. At one time, the board of trustees of Monticello, the home of Thomas Jefferson, refused to accept donations because it was beneath the dignity of our third president's reputation. It reliably returned checks. The Monticello foundation now has a large membership and donor base, and its board is increasingly supportive of its mission. During much of the twentieth century, Eli Lilly generously supported the Indiana Historical Society as a board member. He left a sizable endowment that succeeding boards sat on and neglected to acknowledge that fundraising and financial support were their responsibility because the culture of the institution was not programmed to look beyond the growing endowment. That culture has also changed, and at this writing, the society is in the midst of a multimillion-dollar fund drive.

And today, more than ever, foundations and corporations are asking the question: "Do you have 100 percent participation from your board of trustees?" This is a critical issue that goes to the heart of the mission. If your own trustees won't support you, why should we?

The Unified Ask

Several years ago, the Atlanta Historical Society developed "the unified ask." This document, circulated among the board members at the beginning of each fiscal year, asks for a commitment to the annual fund; the support of the signature fundraiser of the year (the Swan House Ball); and support of the winter fundraiser. This allows each board member to make a commitment at year's inception and eliminates multiple asks throughout the year for each important fundraising initiative. It has both supporters and detractors. It is a convenience for the board members to make a year-long commitment, but it has proved difficult to "upgrade" donors in the annual fund. In addition, the winter fundraiser has proved less effective each year as it competes with the Swan House Ball. This is offered merely as a suggestion for those having difficulty engaging their board members in giving anything to the museum on any level. In the end, you want consistent support from your board for your annual fund.

There are other simple ways to keep your trustees involved and engaged. The next most important step after a new member joins your board is the orientation session. During that time, he or she should receive a pledge card, a mission statement, your strategic plan, a bulleted "History of the Historical Society" or fact sheet, the latest budget, and a financial briefing beyond the budget. In fact, the need to keep your board alive and active dictates an active nominating committee working year-round, not only when the time comes for the selection of new board members.

Professional Atlanta fundraiser, Aaron Berger, CFRE, writes on the website Turning Point that you need four different types of fundraisers on your board: Marketeers, Bridge-Builders, Cultivators, and Closers. He explains that this is an ideal board, but one that we should strive to achieve.

The Marketeer is someone who is willing and eager to sing the praises of your organization. They are those Board members who attend almost every function and actively participate in a variety of programs. Some marketeers write letters to the editor touting recent successes, while others may recruit friends to join them for your next opening

reception. Marketeers welcome potential supporters with open arms and provide an insightful, positive look into your organization.

The **Bridge-Builder** is a person who is capable of introducing the organization to a potential funder. They're connected in the community and well-liked. They may arrange a meeting between a local CEO and your development director, or have a connection to key member of the Board for an area Foundation. Bridge-Builders not only use their connections to expand your organization's sphere of influence, but also provide an endorsement of your good works.

Cultivators pick up where the Marketeers leave off. While a Marketeer invites someone to join in an activity that interests the Marketeer, the Cultivator wants to know more about the interests of the perspective donor. They are warm, hospitable people who might take someone to lunch or host a dinner in hopes of getting to know the potential donor, and their interests, better. Good Cultivators know that once they can uncover a supporter's interests, those interests can then be married to your organization's needs.

Up until now not one Board member has asked for a contribution, but the Marketeers, the Bridge-Builders and the Cultivators have each played important roles in preparing the organization for a solicitation.

It's now time to send in the **Closers.** These are the select few who are comfortable saying, "We would like to ask you to contribute $10,000 to this cause." Closers are direct, not aggressive, when asking. They are patient and consider the donor's feelings before their own. They are optimistic and positive as they answer questions and address any concerns. Above all else, Closers are appreciative and say thank you; whether the donor decides to give now or not.[14]

Understanding Governance and Management: The Difference

Your organization should understand the difference between governance and management and the board's role. According to BoardSource's website and Richard T. Ingram, *Ten Basic Responsibilities of Nonprofit Boards*, second edition (BoardSource 2009), organizations should expect trustees to do the following:

1. Determine mission and purpose. It is the board's responsibility to create and review a statement of mission and purpose that articulates the organization's goals, means, and primary constituents served.

2. Select the chief executive. Boards must reach consensus on the chief executive's responsibilities and undertake a careful search to find the most qualified individual for the position.

3. Support and evaluate the chief executive. The board should ensure that the chief executive has the moral and professional support he or she needs to further the goals of the organization.

4. Ensure effective planning. Boards must actively participate in an overall planning process and assist in implementing and monitoring the plan's goals.

5. Monitor and strengthen programs and services. The board's responsibility is to determine which programs are consistent with the organization's mission and monitor their effectiveness.

6. Ensure adequate financial resources. One of the board's foremost responsibilities is to secure adequate resources for the organization to fulfill its mission.

7. Protect assets and provide proper financial oversight. The board must assist in developing the annual budget and ensuring that proper financial controls are in place.

8. Build a competent board. All boards have a responsibility to articulate prerequisites for candidates, orient new members, and periodically and comprehensively evaluate their own performance.

9. Ensure legal and ethical integrity. The board is ultimately responsible for adherence to legal standards and ethical norms.

10. Enhance the organization's public standing. The board should clearly articulate the organization's mission, accomplishments, and goals to the public and garner support from the community.[15]

Invariably, in a small museum, the lines between governance and management are blurred. Many museums are started with a handful of passionate and dedicated individuals who not only make the policy decisions but also carry them out. One day a member of the board may make a financial decision as a board member and the next day serve cookies at the

Sunday afternoon lecture on Native American burial grounds in Franklin County. As museums gradually professionalize, board members need to let go of the procedural, management side of the operation and stick to governance and their roles as fundraisers. Unfortunately, there are no perfect trustees or staff members. Passion and emotion are powerful drivers when it comes to museums, history, and the presentation of cultural and traditional stories. They often interfere with the effective and efficient operation of all historical societies and museums regardless of size.

But you don't have to be a large organization to manage a fundraising program. As one fundraiser wrote, "You don't have to hire a consultant to develop your fund raising program. You don't have to test every mass-mailing piece. You don't have to have the biggest names and most powerful people in town on your board. You don't have to be on the cutting edge of technology to identify, cultivate and solicit new donors. You don't have to have a fifty member committee for your next special event. You don't have to have a planned giving program to solicit planned gifts." The director of a small museum should "develop fund-raising programs you can afford, coordinate, and execute." Don't get carried away with the big programs of large museums that—yes would be nice to emulate, but unrealistic. You need passion, determination and an enthusiastic board of trustees.[16]

In the small museum, the question always seems to be—"how can we be successful like the big boys?" From an article in *Board Café*, a monthly publication by CompassPoint Nonprofit Services, comes this list of five simple steps board members can take to begin the donor process. It is entitled "Five Things One Board Member Can Do to Raise $100 to $5,000"

> Most board members feel that they "ought" to be raising money, or more money. It's frustrating to be one board member who wants the board to do more to raise money, when others on the board are reluctant or even antagonistic about the idea. The board as a whole needs to ensure that there is an overall plan for raising or earning the money the organization needs to do its work. This "Main Course at the Board Café" looks NOT at what the board should or can do (that's for another issue), but suggests what each of us, as just ONE board member, can do as an individual.
>
> 1. Make a personal contribution. Hand write a short note to the board president explaining why you are making the contribution,

and give the check and note to him or her as you leave the board meeting.

2. Host a dessert party in your home or business and invite twenty friends and relatives. On the invitation say that they will learn about the organization, be asked but not pressured to make a contribution, and enjoy a great dessert. Hold the party on a weeknight around 7 pm. The day before the party, call *everyone* again and urge them to attend. Invite three or four other board members so they can learn how to do this themselves. Make or buy finger desserts, such as cookies or éclairs (cakes don't lend themselves to parties). Bake some cupcakes but do not serve them. At the party, have one client speak for three minutes about what the organization has meant to him or her. Next, have one staff person speak for another two minutes. Then YOU explain to the group why you serve on the board and think the organization is important. Ask the group if there are any questions, and encourage your guests to make a contribution, if they feel the cause is worthwhile, before leaving the party. As a bonus, offer them two cupcakes to take home if they make a contribution before leaving: this gives them a "reason" to write the check tonight.

3. Write a letter and send it to ten friends and relatives. In the letter, explain why you volunteer your time at the agency. Ask them to consider making a contribution to the organization, and let them know they can send the check to you or directly to the organization. (If you send out a holiday letter, you can include this in your letter.) Give your list of names to the staff and ask them to notify you immediately if they receive any contributions.

4. Volunteer to match the contributions from other board members. Tell the board that you will match, dollar-for-dollar, every contribution from a board member before December 31, up to a specified total. The catch: You will only do it if each and every board member makes a contribution. Alternatively, have a staff member tell the board that an anonymous board member has made this offer.

5. Together with two or three other board members, pledge significant gifts. Then write a letter to the rest of the board showing your collective commitment: "We—Felicia, Pat, Laura, and Edgar—have pledged to give a combined total of $4,200 to our organization this year. We're doing this because we believe in the work we're doing and we want to make sure we can do as much as

we can. Won't you join us in building the important work of our organization?"[17]

Fundraisers love lists. Today they are most likely to call lists of donors their "database." Yet there abound several lists that contain no names but that are culminations of years of experience in the development field. At the end of each one of the eight chapters of this book are lists of wisdom from known fundraisers and anonymous gurus. Some of the advice in these lists is timeless, some mundane, some commonsensical, and some just plain interesting. The first list comes from the grand dame of fundraising in the Atlanta area, Be (Mrs. Leonard) Haas, founding principal of the firm Alexander Haas. Her "Ten Basic Commandments of Successful Fundraising," originally published in 1954, was recently republished by that firm in its newsletter.

1. Join the "Willie Sutton Club"
 Willie Sutton was a famous bank robber of the 1920s. When he was finally caught, somebody asked, "Willie, why do you always rob banks?" And his answer was, "Because that's where the money is." The greatest, most eloquent and elaborate fundraising appeal will fall flat on an empty pocketbook. It is amazing to us how blithely some leaders in organizations talk in millions as proposed campaign goals without having given any real consideration to whether Willie Sutton would give their potential prospect list a second glance. So . . . to put it simply, DEVELOP THE RIGHT PROSPECT LIST before you embark on any fundraising venture.

2. "Consider Not the Homeless Cats"
 Now if you happen to be a great cat fancier, this commandment may flop like a lead balloon. But, I don't think there are too many people who can get stirred up over the housing needs of homeless cats. So . . . be sure you have a worthy cause—one that a majority of your prospects will agree is vital and important, once they know the facts of the case.

3. QED—Which Was to Be Demonstrated
 You must not only have a worthy cause, but you must have a real need that can be proved. When Georgia Tech and the University of Georgia Alumni first decided they should step up alumni giving and create the Joint Teach-Georgia Development Fund to solicit corporations, they might have blundered forth, armed only with the statement

that more money was needed to supplement faculty salaries. But they knew such a generalization would not hold water without proof. So . . . exhaustive studies were made including comparative salary scales with other colleges, faculty turnover, and tangible needs of every department in each school. From this intensive research startling statistics and data emerged . . . indisputable facts which served as silent salesmen that produced results. In fundraising, you'll find the woods are full of doubting Thomases—so prove it you must. Thus, QED.

4. Take Me to Your Leader!

Before you dive into any fundraising campaign, take me to your leader or leaders! There lies the success or failure of any campaign. You must ask three basic questions about the potential leader of a campaign.

1. Does he/she have the time to do the job and is he/she willing to devote it to insuring successful campaigns?
2. Does he/she have access to and influence with the people who have money? The test of this is often whether he/she is in a position to make a major donation him/herself?
3. Can he/she enlist the required manpower—both in quality and in quantity? Remember that top level leadership can rush in where angels fear to tread. The wisest investment in any campaign is the time spent in getting the best leadership. Without it most campaigns are lost. With it, success is almost automatic.

5. Consider the Iceberg

The actual mechanics of a fundraising campaign all reduce themselves to very simple terms. The job is to get the right man to make the right appeal to the right prospect for the right amount at the right time. Guess you could call this our exclusive "Bill of Rights." This objective may sound simple . . . but it requires as much behind the scenes planning and hard work as the part of the iceberg below the sea relates to what you see above the surface. Getting the right people committed to work . . . compiling a list and evaluating the prospects so that you have the right prospects . . . putting those two together so that you have the right man making every important solicitation—armed with a pre-evaluated request for a specific amount . . . this vital planning and preparation takes a lot of time, hard work and know-how. John D. Rockefeller, Jr., once said, "When you have gone to all the trouble to sell a prospect on the worthiness of your project, he also has the right to expect you to answer his next question—how much should I give?" Organizing the soliciting

teams, scheduling the campaign, pre-selling the prospects, backing up the solicitor with a competent office staff . . . these are all part of the iceberg beneath the surface of fundraising. This thorough approach spells the difference between success and failure.

6. Avoid the Tender Trap

Needless to say, we are law-abiding citizens. However, we strongly caution you to beware the law of averages. This can be the downfall of unsuspecting and inexperienced fundraisers.

A southern college was faced with an emergency that called for the immediate raising of $250,000 for a critical need. The trustees of the foundation got together and decided they would get 150 prominent alumni and businesses to contribute $1,000 or more each, and raise the balance from a general campaign to alumni. But after getting seventeen $1,000 gifts—none higher—they got bogged down. Why? Because fundraising by averages just doesn't work. Some prospects can give $1,000 and some can give $50,000, as finally happened in that campaign. Less than 10% of the givers will contribute from 60% to 90% of the total in capital funds campaigns. The percentages are almost as high in substantial annual giving efforts.

The professional fundraiser performs one of the most valuable services in determining the size of gifts and how many of each is required to meet the goal.

In addition, the professional fundraiser works closely with the campaign committee to help them figure where the substantial flooring gifts are coming from. These gifts are the best guarantee of success of any campaign. So . . . avoid the tender trap of averages. It can hopelessly snarl your campaign.

7. Recruit Both Chiefs and Indians

I have already discussed the importance of the right chiefs—capable leadership. But you must have Indians, too. Many campaigns have fallen short of their goal simply because a shortage of manpower left many calls unmade. And let me add here that by calls I mean personal calls—not telephone calls or letters. Most substantial amounts of money are raised by the right man asking a prospect for a contribution in a face-to-face interview.

Manpower for campaigning is in far shorter supply than money for contributions. At the very beginning of campaign planning, manpower should be the subject of the most earnest and honest discussion. Check your manpower—figure the number of calls—not gifts, but calls—it is going to take to get the necessary gifts to reach the goal. Then divide

these calls by five. That's how much manpower you need as a minimum. The maximum number of calls which should be given to the average solicitor is five. Three or four calls are better.

So, when I say "Indians" I mean workers. I am not talking about headhunters. I am not talking about recruiting boys to do men's work. I am talking about an adequate number of people capable of making the kind of calls required for their prospects. But be sure and count the Indians before you start. With the multitude of campaigns in every community and the number of times capable men are called on to participate in fundraising campaigns, "Indians" are a scarce commodity. Check your manpower realistically.

8. Tell 'em and Sell 'em in Advance

Since solicitors are at a premium and their time limited, it is folly to expect them to make the kind of "pitch" for a contribution which could be made by one of your campaign leaders who knows the story from A to Z. A training session for solicitors is important, but you rarely are able to get all of them to attend. Workers' information sheets and printed selling tips are good, too, but few solicitors absorb it all or use what they absorb. Too often solicitors walk in and say, "I've got your card in such and such campaign," without making a real presentation of the need. This calls for pre-selling through campaign meetings, publicity, etc. The type of publicity used, whether it covers the broad spectrum of the media, depends of course on the nature and breadth of appeal. In some cases where the prospects are limited, direct mail is your only medium.

The foundation stone of campaign selling is the campaign brochure. We have never been advocates of unnecessarily elaborate costly brochures. I am reminded of the question that was asked, "How long should a letter be?" And the answer, "Like a lady's gown—long enough to cover the subject, but short enough to be interesting." Your brochure must cover the subject and be interesting. I cannot overemphasize—successful campaigns require face-to-face, personal contacts . . . which bring action. It brings far more successful action when you have pre-sold the prospect on the worthiness of your cause and the size of the contribution you are asking of him. Tell 'em and sell 'em in advance by whatever means your particular campaign requires for success.

9. Shun the Triangles . . .

They lead to divorce. Two is lovely company, but three is a crowd. If you want the most successful fundraising campaign, watch your timing so that you are not competing for the same dollars from the same people at the same time—that's a triangle that can kill your campaign.

Of course, I know it isn't always possible to get all your prospects off into a cozy nook all by yourself with no other worthy cause asking them for money at the same time. But try. At least steer clear of the Community Fund Campaign or an appeal that has the community's whole power structure behind it. Study your timing in advance to avoid competition. Remember—you are not only competing for the donation dollar, but for available manpower as well.

10. Remember—Things Don't Just Happen

Unless you have a trained staff whose sole job is to follow through on the details of a campaign and see that every man does his job, all of the pre-planning, all of the preparation of prospect lists, the evaluations, and the organization can go by the board. This is not a job for volunteers, well meaning though they be. Here you stand or you fall. The best plan in the world is no good unless it is followed out. This follow-through takes trained people who are making it their prime responsibility, not a side line.

Moses and Joshua led the children of Israel out of the wilderness and into the Promised Land . . . based on laws laid down in the Ten Commandments. While I do not presume to compare these thoughts with the Divinely given laws of old, still I am sure that these ten basic commandments can lead you and worthy organization into the promised land of successful fundraising campaigns.[17]

In Summary

Although her words are fifty years old and some are no longer politically correct, Be Haas captured the essence of fundraising that is still valid today. In a long tradition dating all the way back to Benjamin Franklin, the nonprofit world has depended on the kindness of others. The job of the fundraiser has not changed in all that time. We must still understand the world in which we exist and know ourselves inside and out before we venture into the marketplace. We still must make and keep friends for our institutions in good times and bad. We must still care and nurture those who care and nurture our institutions. Fundraising is still "friend raising." It requires intellectual and emotional quotients on the part of the fundraiser and the institution.

In the end, you must build trust. You do that by staying true to your mission. There no longer exists the notion of "brand loyalty." Consumers

today are more fickle than ever. With the advent of the Internet and social media, distractions abound, and the pressure on every nonprofit to stand out from the rest is enormous. What you have to offer is authenticity—the objects in your care are authentic, and the stories behind them are real and, more than often, compelling. But to get someone to visit you and make a commitment to join you through your membership program, and then to enlist that person as a bona fide donor, is a monumental task today.

THE UNIVERSE OF FUNDRAISING

The highest use of capital is not to make more money but to make money do more for the betterment of life.

—Henry Ford

The Institution

Before you can begin any serious fundraising, you must test your understanding of your museum by answering the following four questions:

1. Why do you exist?

2. Where are you going?

3. How will you get there?

4. How are you perceived?

Purpose/Mission

This question tests your understanding of the institution's mission or purpose. Do you know why you exist? I am not asking what your goals are, or what your strategic plan is—but why do you exist? Some museums have been in existence so long that they have forgotten why they are in business. The original founders are long gone, and new leaders and members

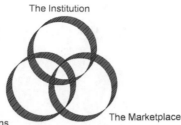

The Institution

Donor Relations The Marketplace

The key to building community support is an understanding of these three contexts in which the museum operates: the internal culture of the institution; the marketplace in which fundraising occurs, and the continuity of approach, or donor relations. These three elements and your understanding of them are critical to successful fundraising. And understanding these requires asking important questions about each.

have no idea what they had in mind. Are you now a full-fledged museum that may have started out as a local archive for family papers? In good times and bad, maintaining large artifact collections, seen by many as an asset, is also very much a liability that requires large sums of money to preserve. Fundraising for this legacy is burdensome and essential.

So as the major fundraiser or the only fundraiser in your museum, do you know what your mission is? Is it current? Do you have a mission statement?

The purpose or mission of your institution is the starting point for all fundraising—in large and small museums, in all nonprofits. Your mission statement should be concise and understandable to all—members, donors, board members, staff, and political and policy-making groups.

Do all of these constituent groups understand why you exist? In this increasingly hostile environment—in any environment—it is imperative to show that you are relevant to today's rapidly changing landscape. If you cannot do that, you have serious fundraising problems.

There is some controversy in the field over whether a mission statement should be a call to action or a statement of what you are and do. I support the last. In my opinion, a vision statement coupled with a well-thought-out strategic plan is sufficient. Thanks to our facilitator, at the Indiana Historical Society we kept it really simple: "Indiana's storyteller." That is what and who we are—nothing more, nothing less. When it

was first suggested to us it was not widely or readily accepted. But as we worked through the strategic planning process, we became used to it. It became so "user friendly" that we eventually copyrighted it.

How do you promulgate your mission? The best mission statements are meaningless if no one knows they exist. If you have one, how do you promulgate it?

I certainly hope it is on your website—and on the first page. I have used it in all staff and new trustee orientation sessions. When a new trustee comes on board, he or she receives a board notebook that has the mission statement on the front page. You should have your mission statement framed at the front door for all visitors to see when they enter. If it is short enough, print it on your letterhead and put it on the masthead of publications, including your website. Above all, it should be on the front page and in the introduction to the strategic plan where the potential donor cannot miss it as he or she peruses your grant application. It should definitely be the very first page in the staff handbook, in the personnel manual, and in the emergency manual. Again, if it is short enough, put it on your business cards.

All fundraising must be mission driven. You are wasting your two most precious resources—time and money—if you do not tie your fundraising to your mission. Allow no fundraising in your museum if it is not mission driven. But wait, you say, what about breaking even? Nonprofit counsel John Durel has written of the "tyranny of OR." Some folks complain that your museum is not doing programming that is mission driven, and board members love to rail against money-losing programs that are mission driven. Durel writes that the most successful companies "embrace the genius of 'AND.' That is, instead of choosing activities that are either mission-driven or profit-driven, they develop programs that are both."[1]

Priorities/Goals/Objectives/Needs

Planning gurus use the words *goals*, *objectives*, *strategies*, and *needs* interchangeably. The exact meaning of each word can be debated interminably, but the result remains that you must understand your goals. This is not brain surgery or rocket science. Let's keep it simple. For the purpose of this argument we are going to limit ourselves to two basic words—goals and strategies.

Whatever you call them and although it may appear obvious, you must set institutional goals before developing development goals. Organizational goals should drive development goals. What does this mean? The institution, not its fundraising advocates, must determine its needs, not the other way around. This comment is aimed at the well-intentioned but misguided volunteer, board member, or occasional staff member who wishes to raise money for a project that bears no relationship to the organization's direction or its mission. Let's say, for example, that you, as leader of the small band of volunteers for a small museum, have five pressing priorities that you all have agreed upon as worthy of pursuing support. The board of trustees and your three staff members have all bought into these priorities. But along comes Mr. "Thinking Outside the Box," who thinks that he has a better notion, that his idea for a new addition to the original museum will solve all the problems, and that he has a donor to help pay for it. This may be all well and good, but as a leader, you must ask yourself what the implications of this "new idea" are. What will the operating costs of this new wing be? Will it come with an endowment? Are you prepared to launch a capital campaign when you have these five other agreed-upon priorities?

This example clearly demonstrates why you must set institutional goals before development goals and before you begin any fundraising. It means that no one can or should go off and begin raising money for non-essentials, for projects not in the "plan."

There are always exceptions to the rule. In fact, this one begs to be broken when a golden opportunity presents itself for funding that is remotely connected to your strategic plan. Entrepreneurial directors who recognize these opportunities can exploit them effectively for the good of the organization.

Sticking to the plan requires enlightened and courageous leadership. If you are not successful in fundraising, it may be your fault as the director because you have not sold the "vision thing" to your staff and your board. Setting goals is where fundraising and CEO leadership intersect. Leadership/management must be willing to make tough choices and decide where the priorities are. In addition, the question that invariably arises is: Who is responsible for fundraising, the director, or the board, or both? In a small-museum situation, it is usually the professional director who must bear the burden of fundraising—particularly for the annual fund cam-

paign. The small-museum director will not usually have a membership or annual fund director and must manage the annual fund campaign alone with the help of volunteers. This was the cold reality I faced as a brand-new museum director of a small Midwestern historical society at age twenty-eight. The well-meaning board had no clue how to raise money, and I didn't either, but I learned all too soon. The answer to the eternal question is that the work should be shared, but the initiative must come from the director.

All goals must be:

Practical: Overarching vision is one thing; setting day-to-day priorities that are practical and can be achieved with limited funds is quite another. An impractical goal might be to accomplish a task that is totally beyond your traditional resources. I recently visited the Mythical Historical Society as a consultant. The society had two sites, ten miles apart with ten buildings to maintain. It had a staff of only four full-time personnel and a yearly operating budget of four hundred thousand dollars. It wanted to expand its programming with a board of trustees who either refused to raise money or were incapable of raising money. It wanted to reach a larger audience. Such a goal was completely impractical.

Realistic: An attribute similar to *practical*. A goal stating that you wish to be the premier historical society in your region when you have a two-person staff, a limited budget, and a board of trustees who won't or can't raise money is an unrealistic goal.

Salable: Akin to *realistic*, every goal has to be salable to a potential buyer. A savvy donor knows when a plan will not work: when it is not being sold. If, in the age of technology, you plan to refresh your major permanent exhibit *without* touch screens, interactives, or some "gee whiz" aspect but instead intend to use outmoded technology, you will probably not appeal to anyone.

Current: Raising money for outmoded technologies or improvements that do not add value for your organization is not a good use of your time and resources. Raising money for the purchase of a collection or the completion of a building that have both been secured with borrowed funds (loans or a bond) is nearly impossible. An old-time comedian once defined alimony as "buying oats for a dead horse." Outdated goals should be stricken from the strategic plan and replaced with current needs.

Articulated: Every successful salesperson is articulate and can give the organization's elevator speech in no more than four or five points. You must be able to relate your goals to the potential audience whether it is a member, a donor, or an elected official. This means clear language, a clear message, and, most important, a thorough understanding of your project in order to articulate it.

Quantifiable: A goal is really not a goal if it can't be quantified. Otherwise, how would you know if you achieved it? Too often, museums set vague, unquantifiable goals that prove meaningless. Examples of quantifiable goals might be: We wish to increase our audience in certain neighborhoods by 10 percent; or we wish to increase museum attendance by 20 percent from the local community and 10 percent from tourism. An admirable goal is to increase school attendance by 10 percent this fiscal year.[2]

In a recent article for *Museum News*, authors Elizabeth Merritt and Erik Ledbetter use the acronym "SMART" in relation to goal setting. It stands for "Specific," "Measurable," "Attainable," "Relevant," and "Time-Bound." Whether you use one or the other is of no consequence as long as you keep in mind that all goals must eventually be measurable. If not, they are meaningless.[3]

Examples of nongoals abound. The "increase and diffusion of knowledge among man" is the mission of the Smithsonian Institution, not a goal. In many grant applications I have read over the years, I have seen such nongoals as "We wish to provide better educational programs for our community," or we wish to "broaden our base," or "to enhance our image," or even more vaguely, "to build capacity." The latter has become a catchphrase in the new century, and while an admirable intent, it cries out for numbers to back it up.

Numbers play a key role in establishing goals not only because they quantify the end result but also because they focus the minds of those responsible for achieving those goals.

Most important, all development goals must be based on three immutable factors:

1. The level of past support

2. The frequency of past support

3. The need

Relying on only one or two of these criteria will lead to failure: all three must be present to set realistic goals for the year. Why are these important? Because you cannot set an institutional fundraising goal merely on need. The most common mistake made by inexperienced fundraisers is to appeal for funds solely on the basis of need. For example, our museum "needs" twenty-five thousand dollars this year to close its deficit. First, it is suicidal to raise funds for a deficit, and second, most people outside the organization really don't care if you can't manage your budget and remain largely unsympathetic if you have run a deficit. Besides, if donors gave you money earlier and you ran a deficit with their money, will the same thing happen if I give a gift?

On the subject of need—savvy donors respond much better to your appeal if you are trying to solve a wider need, to respond to a community issue rather than one of your own needs. Assume that your organization has no needs—rather, they belong to the community. The chances of success for any appeal rely heavily on all three of these factors.

The frequency of past support means just that: are your donors habitual supporters or only occasional supporters? Did they give to you sporadically or frequently over the past few years? The level of past support is equally important to your goal setting. Donors who habitually give at low levels are not prime candidates for large increases in their giving. I realize that those "once in a lifetime" occurrences—such as an elderly lady who had supported her favorite charity with fifty-dollar annual gifts but who then left the charity a million dollars on her death—make the local papers, but they are rare.

What this means for the museum is that it must ask often. It must be intelligent and strategic about its goal setting. More important, it must get its donors in a regular cycle of increased giving, and that means managing donor relations.

Strategic Planning

Now that you know who you are (the mission) and you know what you want to achieve (establishment of your goals), you must move the organization through a series of steps to achieve those goals (a plan). Once you have institutional concurrence on which goals your museum will pursue, those goals must inform the strategic plan. The plan should be a road map toward your goals.

Raising money without a strategic plan is wasteful, useless, and irresponsible. Keep your plan simple, articulate it to all who will listen, and then act on it to make it a living document. A plan on the shelf will gather dust, not support.

From the small museum director's point of view, strategic planning is a consensus-negotiated process whereby management and the governing board agree on a series of precise steps, large and small, to reach the institution's goals. The plan should have a series of goals—and each goal should be supported by a series of strategies. The entire strategic plan—goals and strategies—must be approved by the board because the board sets the direction of the museum and has ultimate fiduciary responsibility for the museum, large or small. Every aspect of the plan should have a price tag.

Once the plan is approved, the staff and board should be in complete agreement that although the board has responsibility for the entire plan, the execution of the strategies is the purview of the staff. The goals of the plan are the purview of the board. Goals should not be dropped or altered unless the board agrees to do so. The board should not meddle with the staff's strategies put in place to achieve the goals. That is why it is so critical that both board and management agree on both aspects of the plan. Once the plan is adopted, the staff or management is responsible for the execution of its strategies; the board is responsible for monitoring the success or lack of success of the plan. A strategic plan developed in a vacuum or only by the

board and imposed from the top down, or by the staff without board input, is a waste of time, will fail miserably, and should never happen. The development of the goals should be shared by staff, the board, and a solid group of constituents—donors, members, former trustees, interested community leaders, and if your institution receives municipal funding, councilpersons or representatives. Once the plan is agreed upon, the board of trustees alone has the power to change, modify, drop, or add goals.

I am often asked, "How do you get others—trustees and staff—to accept a new idea or fundraising initiative?" or "How do you get others (specifically trustees) to do their job as fundraisers?" The simple answer is the strategic plan. If it's in the plan, it is viable. If it is in the plan, the board has bought into it and has approved it as an official policy of the museum. If it is in the plan, it is not a surprise to the board when the "ask" comes around. If it is not in the plan, it should be discussed at the committee level (preferably the development committee) initially and then, if it has merit, brought to the attention of the full board.

The strategies should be reviewed periodically by the board with suggestions for modification. The director should report to the board on the progress of the strategies on a timely basis. If a strategy is not working, it will become obvious to all because the result will fall short of its target. For example, let's say that the board of a small museum has approved an annual appeal goal of fifty thousand dollars (the goal) and the director and staff decide to hold a large party (the strategy) to raise the money. They could choose a snail-mail appeal, a telethon, a cookie bake, or a combination of all. The board needs to understand the details of the plan to ensure that it will work, but in the end, it is the director and her staff who are responsible for implementing the strategy to meet the board-established goal. If the planning for the party is faulty (the tactics), the strategy will fail, and the goal will not be reached. The board has to realize that micromanagement is not an option here. The board members have done their part in adopting the goal with staff input. Now is the time for the staff to ensure that the strategy will work.

As stated earlier, every aspect of the plan should have a price tag. If the party is to clear or net fifty thousand dollars, then much more must be raised or a sponsor found to underwrite most of the costs.

Also, a good strategic plan must be well integrated. Too often in museums, large and small, the strategic plan is constructed as a series of silos.

Museums that I have consulted with have shown me strategic plans with five or more sections. One section is devoted to education, one to curatorial, one to marketing, one to development, one to administration, and so on. The key word in writing any plan that will make your fundraising easier is "integration, integration, integration." The only way to do that is to ensure that all of the goals are pan-institutional.

The broad overarching strategic plan will inform all constituents that you are an integrated institution as they look in from the outside. Your education and curatorial program people will understand that their audience is also your membership. Your membership and development people (volunteer board or paid staff) must understand that they are working to support the programmatic aspects of the organization. They are not operating in a fundraising vacuum. Fundraisers must understand that all that energy going into a special event or annual appeal drive is for education or curatorial programs, their salaries, and their well-being. Education, curatorial, and other programmatic areas must understand that the fundraising going on is for their benefit in the end. Their salaries and operating funds come from the efforts of well-intentioned development staff. The strategic plan is no different from the score of a symphony. Everyone knows where they should be in the piece and their role in it.

Some foundations today will not entertain a proposal from you unless you have a strategic plan in place that has withstood the rigors of board approval. The American Association of Museums (AAM) requires a strategic plan for accreditation. The additional burden on any nonprofit in bad economic times is that you must not only plan to "survive the current economic downturn; you need to think about how to position your museum for long-term success when the economy rebounds."[4]

Image

Within the institutional context, the last museum-specific criterion that you must understand is your image. How is the museum perceived by the market that will make a leisure-time decision to visit you, spend money with you, perhaps join you as a member, and if all goes well, make a conscious decision to invest in your program? You must know what the community's temperature is before you venture forth asking for money. A working knowledge of the organization's image is essential not only to institutional and fun-

draising goal setting but also to the successful selling of your museum. How are you perceived in the community? Do you have a good reputation among all the major stakeholders? Do members of the outside community—beyond the stakeholders—understand your good standing in their community? Do you tell them of your relevance to their everyday lives, or are you perceived as fluff that they can take one way or another? Worse yet, do you have a terrible reputation in the community for being a poor steward of your largesse?

As hard as it might be, take the community's temperature. Do focus groups, front-door questionnaires, evaluations of your educational programs by the participants. Are you providing the lectures, classes, seminars, and programs they are consuming? Or are you just spinning your wheels for a few?

Do you have a weak board? Is it common knowledge in the community that your board is fairly powerless when it comes to making critical decisions? Or that it is an old boys' network that refuses to recognize the new realities of shifting demographics, changing technologies, and the responsibility to raise money for the institution?

When checking your image in the mirror, items to look for are: Do you have a weak board? Have you had any scandals, recent or historical? Have you been involved in any public disputes over deaccessioning? Have you received negative press for a particularly controversial exhibit? Has a disgruntled employee gone to the press? Has a board member leaked unapproved raw minutes to the press on a particularly hot topic? Has an angry donor gone away or, worse yet, to the press?

As a recent article (January 4, 2010) in the *Philanthropic Journal* reported: "Feed the Children, one of the nation's biggest antipoverty charities, alleges in court documents that its fired president, Larry Jones, took bribes, misspent charity funds, pocketed travel money, misused a charity employee as a nanny, and hid pornography at the organization, *The Oklahoman* reports. Mr. Jones, who founded Feed the Children 30 years ago, denied all wrongdoing. He was fired in November and that month filed a wrongful-termination lawsuit against the organization and its board of directors. 'What they're trying to do is build a case up against me,' Mr. Jones said. 'It won't hold up. . . . I didn't do anything.'" How do you suppose you would deal with something like this if you were Feed the Children's development officer? Your institutional image has been damaged, and you will probably not recover in three years, setting back your planning and fundraising for that planning.

On the positive side, because of the *diversity of funding sources*, it is imperative to know and understand your subject—that is, your museum—inside and out. It is important to understand your standing in the community in order to be creative about fundraising. Are you perceived as a community asset, or are you perceived as a pariah by the community? Worse yet, are you completely unknown and ignored by most of your community?

Once again, it is much less complicated raising funds for a small operation where less can go wrong and where the bureaucracy does not stand in the way of communication and information flow. Weekly meetings with key individuals, which consist not just of reports by those around the table but are substantive meetings that deal with substantive issues that revolve at nearly all times around the strategic plan are critical.

In fundraising, a poor or poorly focused image or misunderstood image will be far more damaging than inarticulate goals, poor strategic planning, and ignorance of the mission.

Helpful Hint: You will not be successful and win support of your community just because you run a good cause. You must continue to provide evidence that you are relevant and therefore worthy of continued community support.

Quite the opposite, you must work to communicate the good news. You cannot sit back and expect the money to roll in the front door.

Peter Drucker, the nonprofit management guru, entitled one of his books *The Five Most Important Questions You Will Ever Ask About Your Organization.* In it he answers these five basic questions.

1. What is our mission?

2. Who is our customer?

3. What does the customer value?

4. What are our results?

5. What is our plan?

Drucker's categories are slightly different, but they all go to the heart of the matter—the need to understand the institution's mission, goals, strategic plan, and image.

The Marketplace

Once you understand your own institution through its plan, goals, and image, you must understand the marketplace in which the museum operates. You must answer the following questions: Who gives what to whom? Who gives how much? Why do they give? There are only two large sources of money for charitable support: governmental and private giving. The latter can be divided into foundations, corporations, and individuals. A fourth category discussed below is social clubs such as Rotary International. Governmental agencies are at all levels: municipal, county, state, and federal.

The good news: Americans are generous!

Americans Are Generous: Governmental and Private Giving

In 1966, donations from the private sector reached $100 billion. In 1989, just twenty-three years later, the number reached $150 billion. In 2009, the last year numbers were available for this purpose, Americans through corporations, foundations (excluding state, federal, and municipal governments), and as individuals gave $303.75 billion—down from approximately $307 billion in 2008—a 3.2 percent drop and the second year in a row of decline. In 2009, $12.88 billion came to the arts from the private sector—down from $13.1 billion the year before. Americans have increased their giving every year except 1974, when contributions dropped a total of 5.4 percent and decreased from all donor types, according to *Giving USA*. That study, done in 2008, called the drop "unusually severe . . . compared with the other years with 8 months or more of recession." And foundations and corporations, because they make up a much smaller part of the pie, are unable to pick up the slack in a recession. 2009's drop was due to an 8.6 percent decline in foundation giving, but individuals kept up their 2008 pace with $227 billion, or 75 percent of all private giving. That statistic is remarkable and suspect given the severity of the recent recession and the overwhelming anecdotal information and news stories from nonprofits throughout the country.

Until this recent harsh downturn, on average and before adjusting for inflation, giving in the United States grew annually at 8.4 percent. In recessions it still grew—but at a slower rate, 6.2 percent. Giving still grows in a slowdown an average of 0.8 percent. The very bad news is that giving to arts, culture, and humanities sectors will always show the largest decline during economic downturns, and the "Great Recession" of 2008–2010 is no exception. In 2002, immediately after 9/11, those sectors experienced a 7 percent decline, and in 1983, a 12 percent decline.[5]

At the federal level the total giving to museums amounted to less than $500 million. NEH doled out $116 million; NEA, $115 million; and IMLS, $25.8 million. The percentage of federal grants to private giving to the arts is a mere 4 percent. This disparity in the numbers provides constant fodder for contention on both sides of the argument. On one hand, the difference is a strong argument for those who demand more government involvement and more government money for the arts. On the other hand, it is hard to miss the fact that the "target rich" environment is in the private sector. This is not to say that government grants from the three museum granting agencies should be ignored. It means that your two

most precious resources—time and money—are better spent in cultivating and raising gifts in the private sector. Above all, don't forget that federal and state governments still allow donors to take a standard deduction or itemize their charitable contributions. In most years that amounts to a federal subsidy to all nonprofits of about fifty billion dollars. As with most things in life, the federal tax deduction has its trade-offs. As it encourages philanthropic giving and growth, it also deprives the federal government of revenue, which in these perilous times adds to the deficit.

Types of Foundations

There are more than 72,000 grant-making private and community foundations in the United States today, and the number grows daily. It has tripled since 1980, when there were only 26,000. All foundations were established with the same common goal—to maintain or aid social, cultural, educational, charitable, and religious or other activities to serve the common good. They all began from single or multiple sources—a single individual or a family.

They are nongovernmental, nonprofit organizations managed by their own trustees or directors. Most foundations are small, are locally oriented, and give large numbers of small grants. Foundations in low-asset categories often have little or no full-time staff, and although most respond quickly and effectively, many do not.

Fewer are larger and generally more responsive to your calls. They publish large annual reports that are a gold mine of information for the curious fundraiser. The larger foundations are also more regional in nature and have a staff, program officers, and a schedule, such as for quarterly submissions. They evaluate proposals systematically and give larger grants. However, the foundation world is so diverse that generalizations do not always pertain.

Foundations deal with every imaginable issue. The larger ones such as Ford and Rockefeller are constantly changing focus and responding to areas of global concern, such as the abolition of nuclear weapons, national and international security, AIDS in developing countries, population issues, food issues, clean water . . . the list goes on and on. Under the provisions of the Tax Reform Acts of 1969 and 1976, foundations must now expend a percentage of their "minimum investment return" or their

"adjusted net income," whichever is greater. Those two reforms called for greater accountability by the Internal Revenue Service and state and local governments. As a result, many foundations have become more professional in their management and governance.

Many new foundations have been started in the past ten years with the growth of the economy in the late 1990s and the early 2000s and tend to be personal and family foundations. A new trend indicates that some family foundations are being abandoned in favor of donor-advised funds. The tightening regulations have driven many wealthy donors who established foundations to close them in favor of "donor directed funds" with large nonbank financial institutions such as Schwab and Fidelity Investments. These firms take all the paperwork, hassle, and legal traps out of the equation. The funds are not subject to the 5 percent rule of distribution that foundations must observe. They are also private, which means they do not stand the same scrutiny of foundations and they allow the donor a larger tax deduction than foundations do.[6]

With the economic storm of 2008–2010, the nation's foundations lost "nearly $150 billion in assets" in 2008, an amount equal to what they had given over the past four years combined. Giving remained level, falling a mere 1 percent at $46 billion. Inherent in this story is the destruction of assets—some as high as 30 percent.[7]

In the following year, 2009, more than 40 percent of foundations expected to give much less money than previously. The *Chronicle of Philanthropy* surveyed the top 104 grant makers in America that lost more than fifty billion dollars in assets the previous year. The recession was definitely to blame for 38 percent who said they cut staff and other expenses; 21 percent who cancelled, stalled, or spread out payments to grantees; 22 percent who offered nongrant assistance; and 21 percent who increased the net percentage of net assets it will distribute. Many of these foundations will probably recover as the economy does. Others may merely go out of business.[8] In fact, reality met the dire projections of 2009. According to the Foundation Center, overall foundation giving dropped 8.2 percent, from $46.8 billion to $42.9 billion. The largest category of foundations—independent and family foundations—cut their support 8.9 percent to $30.8 billion, corporate foundations decreased donations 3.3 percent to $4.4 billion, and community foundation giving declined 9.6 percent to $4.1 billion. The latter drop-off exceeded decreases by corporate and independent foundations.[9]

Helpful Hint: Many local and family foundations remain an area of lucrative fundraising for local and small museums. Add a foundation person or two to your board. You will be glad you did.

There are four basic types of foundations, and it behooves the grant/money seeker to know the difference between them. In no particular order they are corporate, community, operating, and private.

Corporate Foundations

Corporate foundations are begun with company funds; they are constituted independently. Corporate giving officers will try to convince you otherwise, but corporate foundations make grants with high regard for the corporation's visibility and business interests. The governing boards usually consist of company directors and officers. Many have a large corpus or endowment that comes from the company; others serve only as a conduit for current company funds. They will control the foundation's corpus to ensure payoffs in down business years. Decisions are made by the board, which usually consists of all insiders. On rare occasions outsiders will sit on the foundation board. Some decisions may be made by local company officers. This is good news for the small museum in a community with ties to a major corporation. The local plant should be your ally if you are approaching the global giant in your backyard. In the past few years, company foundations have become very sophisticated with highly regimented procedures.

The Nissan Foundation, for example, focuses only on very specific areas such as Southern California, middle Tennessee, Atlanta metro, and south-central Mississippi—regions where the company has plant or administrative operations. They are most interested in diversity—their mission reads as follows: "The Nissan Foundation supports educational programs that celebrate and foster an appreciation and understanding of our diverse cultural heritage." The foundation lists its requirements on its website. It enumerates its core values, funding initiatives, grant awards ($10,000 to $50,000) for each calendar year, eligibility requirements, what it does not fund (capital campaigns), and a step-by-step process for applying for funding.[10]

Do not confuse corporate foundations with direct giving programs administered within a corporation. Direct giving programs usually accept applications separately and independently from the foundation. They operate in close concert with the corporation's interests and marketing strategies at the time and will change as the corporation's strategies change. Your knowledge that a pharmaceutical company is attempting to attract a certain market may help you in determining whether your historical society is a good vehicle for their message.

In 2007, 2,600 corporate foundations gave $4.4 billion, up 7 percent from 2006. Adjusted for inflation, corporate foundation giving increased 3.7 percent in 2007. The increase was due to corporations pouring more money into their foundations. The year before, gifts into corporate foundations rose over 9 percent to $4.4 billion.

Before the economy soured in 2007–2008, 54 percent of corporations expected to increase their giving in 2008. Forty-four percent anticipated giving increases above 10 percent. However, 29 percent expected to reduce their giving in 2008, up from 26 percent in 2007. Overall, corporate foundation giving represented over one-tenth of total foundation giving in 2006.

Community Foundations

Community foundations are classified by the IRS as public charities that receive tax-deductible contributions in addition to making contributions back to the community. Their grant making is restricted to specific local areas, with decisions made by committees representing the local community. The funds managed by the community foundation consist of a pool of money from individuals and other nonprofits in the community. Some of the funds are donor directed; others are applied for with their own guidelines, deadlines, and procedural requirements imposed either by the donor or by the foundation. They are restricted and unrestricted. All funds are pooled together, much like a mutual fund. Decisions on grants are made by a board of directors representing the diversity of the community.

Community foundations operate with one central administration, which is efficient and economical. The concept appeals to large donors who wish to avoid the administrative overhead costs of setting up and maintaining their own foundations or donor-directed funds. In fact, it

remains in competition with the newer concept of donor-directed funds offered by investment houses as alternatives to private foundations.

Operating Foundations

Operating foundations operate their own programs determined by their charter or board. They do not exist to give money away, although they occasionally give small grants externally. The concept of an operating foundation is grounded in scientific research done by independent testing laboratories, which would fund individual research activities. Today, large public museums such as the Indiana State Museum and the Louisiana State Museum have their own operating foundations as their private centers of fundraising.

Independent Foundations

Independent foundations are usually established by initial contributions from a single source: family, individual, bequest, or group of individuals. They are administered by a board of trustees or members of the family and are usually oriented geographically and toward family interests.

They usually have paid staffs that come in all sizes. The smaller ones may be managed out of a desk in the estate section of your local bank. The larger ones, such as Rockefeller, Ford, and Carnegie, have large staffs, offices in major cities, and a global perspective. They can change their focus and often do every three to five years. They tend to publish a glossy annual report that can be a gold mine of information for the grant seeker. They tend to be very formal, with formal submission procedures, formal interviews, and formal reviews of applications they accept to review.

Not all independent foundations are as approachable as the Dobbs Foundation in Atlanta. Its mission is to memorialize Atlanta insurance leader R. Howard Dobbs, who died in 2003 at age ninety-seven. The foundation now carries on his quiet philanthropy "to improve the quality of life for individuals, families and communities by supporting educational opportunities, improve access to health services," foster environmental stewardship, and last, improve the arts/community. The foundation provides prospective grant applicants with a simple four-page document outlining its procedures and timetable.[11]

Smaller foundations tend to make larger numbers of smaller grants, but they more often tend to be local and therefore well known in a smaller community, where the smaller historical society may operate. They tend to be operated by known local bankers or investment brokers who, because of the foundation's size and the community's size, know the local issues that the small museum might face and therefore be more sympathetic to a proposal.

But do not overlook major, large independent foundations just because you are a small museum. When I was the director of the Columbia Museum of Art in Columbia, South Carolina, we applied to the Rockefeller Foundation for a grant and got it. At the time, our budget was a most modest eight hundred thousand dollars with an endowment of the same stature. We wanted to do an exhibit of Guatemalan textiles, owned by a local collector. The Rockefeller Foundation at the time was anxious to further its South American initiatives, particularly in Guatemala. The resultant grant of ten thousand dollars produced the show and published the catalog, and we hosted a modest reception to open the exhibit. It would not have happened if not for a very alert development director whose research turned up this gem of a source for funding a rather obscure exhibit and topic.

Helpful Hint: The tsunami in losses in foundation assets will hit in 2010 and beyond. Look for fewer dollars from foundations in the future.

The 20 Biggest Fundraising Mistakes

Call them what you will—gaffes, blunders, oversights, or errors—mistakes creep into everyone's professional life. But in fundraising—unlike other fields—where thousands if not millions of dollars are often at stake, mistakes can be especially hazardous.

Who hasn't forfeited a significant gift, or received but a token one, due to some serious miscalculation?

While there may be hundreds of them, 20 potentially costly fundraising mistakes stand out. They can't really be ranked, since circumstances alter their impact. But here they are in an effort to ward you away from them.

1. Thinking Your Organization Will Attract Support Simply Because It's a Good Cause

Just because you have a good cause—one of thousands, really—doesn't mean money will wend its way to you.

Organizations must attract support the old-fashioned way—earn it. Giving away money is something we all do reluctantly, and it's hardly an instinctive act. Nonetheless, people will support you if you present them with a challenging project that is consistent with their interests.

To succeed, you must explain exactly why you seek the funding, why your project is compelling, who will benefit, and why the money is needed now.

In other words, your needs—presented as opportunities—must be specific, people-oriented, and have a sense of urgency.

Keep in mind, always, that people give in order to get. They don't simply want to give away their money; they want to feel they're investing it and getting something in return.

2. Thinking That Others Can Raise the Money

Successful fundraising abides by the "rock in the pond" principle. That is, you can't expect others to contribute until those closest to the center of your organization do so. The farther from the center, the weaker the interest.

In short, solicitation starts with your inner "family"—most notably the board. Only when these individuals have made proportionately generous contributions do you reach out to your external constituency.

Why this principle? Because it only makes sense that if a board approves a program involving significant outlays, with the understanding that money has to be raised, then these same trustees must commit themselves to giving and getting.

If your governing body won't do so, who will?

3. Believing That Because People Are Wealthy They Will Contribute to You

Simply because someone is wealthy, or thought to be wealthy, is no reason to assume that he or she will want to give to your project. This is the thinking of neophytes.

People make gifts, substantial gifts, that is, only after you've reached out, informed them of your work, and meaningfully involved them in your organization.

It is then that the prospective donor understands your goals, recognizes their importance, and welcomes the opportunity to have an impact.

Solicitation rightfully becomes the final step in the fundraising process, not the first one.

4. Thinking You Can Whisk Wealthy Prospects In at the Last Minute

Individuals, if they are to be committed to your organization, must have the opportunity to be involved in your work—and not at the 11th hour.

Intensively courting prospects just prior to your fundraising drive is an insulting ploy, and most are smart enough to know what you're up to.

Much more advisable is to continuously involve prospects, for just as the best trustees are those who are meaningfully involved, the best contributors—and best solicitors, too—are involved in your drive from conception to victory.

Dollars, as Jerold Panas notes, follow commitment. And commitment follows involvement.

5. Failing to Research and Evaluate Prospects

Rarely do meaningful gifts come from strangers. Most major donors are either associated with an organization or have logical reasons to give.

It is the role of prospect research to reveal these logical reasons by focusing on three elements, namely, linkage, ability, and interest.

Is there any link between the prospective donor and your organization? If so, then this link—and it must be legitimate—makes an appointment with the prospect possible.

Next is the person's ability to give. Does the prospect have enough discretionary income to justify your soliciting him or her for a major gift? Research will tell you the answer.

Finally, what is the prospect's interest in your organization? If he or she has little interest or limited knowledge about you, then you will likely receive a small gift if any at all.

6. Failing to Ask

Very often, when campaigns fail, it's not because people didn't give, it's because they weren't asked. In fundraising, asking is the name of the game.

The problem is, only for the rarest person is asking for a gift easy. For most of us, the discomfort is so strong we'll invent 100 excuses to procrastinate.

Despite any training, despite any inspirational send-off, asking will always be the biggest challenge.

What can temper the fear to some degree is keeping in mind that prospects, who are usually more sensitive than we expect, respond favorably to solicitors who are dedicated and genuinely enthusiastic about the causes they represent.

7. Thinking That Publicity Will Raise Money

Publicity, despite our best wishes, doesn't raise money.

If you have solicitors and prospects, a strong case, and a campaign plan, you won't need any publicity.

Those who do insist on a big splash are, more often than not, people who don't want to face the rigors of a campaign. When the publicity push fails to create a stir, they use it as an excuse for not working.

As for campaign materials, most serious donors see them as nonessential. They much prefer a persuasive verbal presentation, underscored by simple documentation.

So long as you treat your press releases, brochures, drawings, or photographs as aids and not as solicitation devices, they will be useful, but they will never take the place of direct asking.

8. Failing to Recruit the Right Trustees

Of all the groups important to an organization, none is more vital than the board of directors.

There are exceptions, to be sure, but in 99 out of 100 cases, an organization that consistently attracts the funding it needs has a board that accepts fundraising as a major responsibility, despite any other governing duties.

Put another way, an organization's ability to raise money is almost always in direct proportion to the quality and dedication of its leadership.

As Hank Rosso, founder of the Fund Raising School puts it, "People who have the fire of leadership burning within their souls, and who have that deep commitment to the organization's mission, will drive any program through to success."

9. Believing You Can Raise Money by the Multiplication Table

People new to fundraising often get it in their heads that all you have to do is divide your goal by the number of likely donors, then ask everyone to give an equal amount.

But you can't raise money adequately by the multiplication table—trying, for instance, to get 1,000 persons to give $1,000.

There are several inherent problems here. First, not everyone will give (which throws a wrench into the whole approach). Second, we all tend to give in relation to others. If someone, five times wealthier than you, pledges $1,000, are you likely to feel a $1,000 pledge from you is fair? Third, seeking $1,000 from each donor in effect sets a ceiling on what an unusually generous person might wish to pledge.

10. Failing to Have Deadlines

By nature most of us are procrastinators, and whatever we have plenty of time to do, well, we seldom get it done.

For many if not most volunteers, the thought of asking someone for a contribution leads to procrastination.

To counter this, you must press for specific accomplishments within prescribed deadlines. In other words, to force action you need a campaign schedule with target dates understood by all.

Everyone will then know the rules of the game and, despite the pressure, will be grateful for the deadline.

11. Failing to Have a Strong Rationale

Before setting out to raise money, each organization must think through the rationale for its appeal: why do the funds need to be raised, what will they achieve, and who will benefit?

The mere fact that you and your board need money won't stir people, no matter how well organized your effort.

Rather, with your case for support you must move your prospects emotionally and intellectually. They need to feel that, by contributing to your organization, life will in some way be better for them, for their children and grandchildren. They need to sense that their community— or even the nation—will be advanced as a result.

12. Failing to Cultivate Donors

Cultivation, a sustained effort to inform and involve your prospects, is needed for practically every gift—the bigger the gift, usually the more preparatory steps needed.

The best cultivation, which uses a mixture of printed matter, special events, and personal attention, takes place slowly over a period of time, sometimes years.

If there's any secret to it, it is being yourself and cultivating people the way you would want to be cultivated. That is, with simple sincerity, not glitzy programs.

Donors give more when they can visualize an organization not as an organization but as people. Achieving that end is, in essence, the goal of all successful cultivation programs.

13. Failing to Set a Realistic Goal

In all but the newborn nonprofit, it's a mistake at the outset of a campaign to say, "We'll raise as much as we can."

This often reveals to prospective donors that your board or staff hasn't analyzed the organization's needs.

Rather, a tenable dollar goal should emanate out of your organization's growth pattern and the (evaluated) financial ability of your prospect list. It is not, as some assume, simply a percentage increase over last year's gross, nor is it necessarily the difference between the total dollars you need, less expected income.

While some argue for a high goal and others insist on a low, achievable one, what really is desired is that magic number that inspires your volunteers, makes them work harder than they expected, and gives them the unmatched thrill of victory.

14. Failing to Train Solicitors Adequately

No matter how virtuous your project or organization, most prospects need to be sold on contributing. You must, therefore, have a team of highly trained solicitors—a "sales force," if you will.

Generally, you'll be dealing with three types of volunteers, each requiring slightly different treatment. First is the rookie who wants to help but needs detailed instructions. Second is the veteran of many campaigns who needs special prodding to attend trainings. And third is every volunteer who's being introduced to new procedures.

No matter how bright or experienced your volunteers, nor how busy they are, too many drives degenerate due to mediocre solicitor training.

15. Failing to Thank Your Donors

Thanking donors, besides being polite, is an act of cultivation—and a smart one.

People appreciate when their generosity is recognized. They not only feel closer to your organization, they're inclined to continue giving.

Most importantly you should make saying thank you an ingrained work habit and acknowledge all gifts positively and quickly. You want the donor to know that your trustees are aware of the gift, that his or her generosity will stir others to give, and that your organization will put the money to good use.

Board members can be especially effective in expressing appreciation, either by sending notes or by making telephone calls to selected donors.

16. Failing to Focus on Your Top Prospects First

It is foolish to squander your efforts on small donors until you've approached all of your best prospects.

This is, of course, known as sequential solicitation.

You begin by seeking the largest gift first—the one (at the top of your gift table) that is needed to make your campaign a success.

If this top gift comes in at the level you require, then it will set the standard and all other gifts will relate to it.

If it's too low, other gifts will drop accordingly and possibly imperil your whole campaign.

Sequential solicitation forces you to focus on your most promising prospects. While small donors are graciously treated, they do not receive disproportionate attention.

17. Failing to Ask for a Specific Gift

The need to ask for a specific gift is one of the most misunderstood— or is it feared?—principles in raising money. "Will you join me in giving $500 to the Wakefield Symphony?" leaves no doubt as to the size of gift the solicitor is requesting.

Most prospective donors need and want guidance. By requesting a specific amount, you show that you've given thought to your drive and you put the prospect in a position of having to respond.

The suggested amount becomes a frame of reference, one that will get serious consideration if the solicitor is a friend, peer, or respected community figure.

18. Failing to Focus on the Best Sources and Methods

Nearly every board hopes it can raise the money it needs from foundations and businesses. These sources, perhaps because they're more impersonal, are seen as less scary than people.

And while, certainly, you want diversity in your funding, it's imperative that you and your board understand that most contributions—fully 90 percent—come from individuals. Here is where you'll invest your time and effort if you're serious.

As for methods, the most effective way of raising money—and most productive in terms of the size of gifts—is the face-to-face approach. The second most productive—again in terms of the size of gifts—is the appeal made to a small group of persons. The third most effective is the telephone call. And the least effective solicitation, in terms of gift size, is direct mail.

19. Failing to Find the Right Person to Ask

Find the right person to ask the right person is an old but enduring maxim in fundraising.

There will of course be exceptions, but a solicitor who makes a $100 commitment to your cause should call upon prospects that are capable of giving a similar amount. Likewise, a $500 prospect is best approached by a solicitor who himself has contributed a similar sum.

As important as matching like amounts, is choosing just the right solicitor. Some prospects expect to be asked by the president or the chairperson of the board. Others are less formal and would welcome the person they know best from the organization to ask for the gift. Still others may need the ego stroking of a team of solicitors. Reading this dynamic correctly is the key to success.

In a large campaign, solicitor/prospect matching can consume hours. But it is one of the very best uses of time.

20. Failing to See Your Top Prospects in Person

While there are dozens of ways to solicit prospects, nothing beats the personal request. The adage "people give to people not to organizations" is another way of phrasing this principle.

Certainly if your organization has a favorable image it helps. But the personal request of a friend or peer for support has a far greater impact than any knowledge your prospect may have about you.

Harold Seymour, legendary fundraiser, puts it best: "For clinking money, you can shake the can. For folding money, you should go ask for it. For checks and securities and gifts in pledges, you have to take some pains—make the appointment, perhaps take someone along, count on making two or more calls, and in general give the process enough time and loving care to let it grow and prosper."[12]

In Summary

The universe of fundraising is vast and complicated. Your understanding of the three contexts of your museum, the marketplace, and the complex matrix of donor relations is invaluable to successful fundraising. Understanding the multifaceted aspects of your institution should allow you to be as creative as possible when you are looking for potential donor-partners. Knowledge of the marketplace will keep you from embarrassing and time-consuming missteps. And familiarity with your donors goes without saying. There are fundraising posers in this world who do not believe in planning or any sort of internal assessment of needs or institutional priorities. These people "operate in a vacuum," "shoot from the hip," are "cowboys," "lone rangers," and any other cliché you can imagine. They have never met a plan they liked. They believe that no understanding of your organization, the marketplace, or the stewardship of donors is necessary. If you are a small museum, knowing these factors before engaging in fundraising is more critical for you than in a large museum. Why? Because your size will expose your faults more quickly, and they will be obvious to the savvy donor. The leader of a large institution can sail along for months, even years, without a clear strategic map of where s/he will take the organization.

STEWARDSHIP
Managing the Donor
Relationship or the Continuity of Approach

I have found that among its other benefits, giving liberates the soul of the giver.

—Maya Angelou

Donor Motivation: Why Do People Give?

What possesses people to give away a portion of their hard-earned cash? Most of us are hardwired to work diligently to provide income for ourselves and our family. But give it away? That is another matter. Since childhood, we are told to save, not to waste our money on frivolous expenditures, and, well, "A penny saved, a penny earned." But we are also told to share the wealth and to help others less fortunate. In many churches we are told to "tithe" or give away a tenth of our income. As we grow older and more sophisticated about the ways of the world, we discover that there are benefits in giving away a portion of our wealth. The federal government and the IRS in this country have placed incentives at our disposal that encourage us to give money away. In fact, besides the ability to deduct our state income taxes and the interest on our home mortgages, the only other deduction remaining on our federal income taxes is a charitable contribution. But there are also myriad other reasons an individual donates money to a nonprofit. In no particular order are several that I have seen in four decades of fundraising. These motives apply to all levels of fundraising and are true for large and small museums of all disciplines.

Ego/Immortality—I want my name on the building, the gallery, the garden, or whatever will outlive me with my name on it. It implies buying eternity with a major gift.

Sincerity/Altruism—Sincerity is rare in this age of cynicism. Happily, there are still some people in the world who sincerely believe that they can make a difference and will give their money in that dearly held belief. They believe that you are a force for good in the community and you need to be supported.

Tranquility—This motivation implies that if I give you this money, I expect you to go away. This syndrome afflicts small donors who respond to a cold-call membership or annual appeal drive. They usually donate ten dollars or twenty-five dollars with the hope that you will not bother them again for at least a year, and if they are lucky, never again.

Peer pressure—"All my friends" are part of the campaign. This is in line with "keeping up with the Joneses." These donors do not want to be outdone or shown up by their peers or neighbors and respond to flattery more easily than logic or emotion.

Guilt—This is a difficult emotion to pin down but is more closely related to social issues—green issues—the environment, climate change. A corporation that has been cited as doing business in a less-than-ethical way may wish to pay for its transgressions with a gift showing remorse.

Fear—This motive is related to immortality and can be seen in gifts to social service and health agencies. For example, a gift to the American Cancer Society might be motivated by hope that a cure will be found before the donor contracts the deadly disease. Fear never motivates museum supporters.

Matching Gift as Motivation

How effective are challenge grants, matching gifts toward increasing giving? It depends, according to author David Leonhardt. Two economists, John List and Dean Karlan, posited that most fundraisers are fueled by intuition. They (fundraisers) "think" that matches and challenges work.

So List and Karlan set out to determine the accuracy of that insight with empirical data. Early economic data indicated that matches made a huge difference. From a purely economic view, a straight-up gift to a charity of one hundred dollars is one hundred dollars for that charity; but a three-to-one match means three hundred dollars for that charity from the same single request. List and Karlan determined that matches do matter, and conversely, the size of the match does not. "Donors who received the offer of a one-to-one match gave just as often, and just as much, as those responding to the three-to-one match."[1]

In a half-serious, half-chiding way, Eric Gibson wrote in the *Wall Street Journal* that we should not be motivated so much by recognition. He remembered St. Paul's letter to the Corinthians, where he distinguished the act of giving from the attitude of charity with his famous quote, "And though I bestow all my goods to feed the poor, and though I give my body to be burned, and have not charity, it profits me nothing." He also reminds us that true charity does not "behave unseemly." Gibson also quotes the medieval Jewish philosopher Maimonides, who wrote of the "Eight Levels of Charity." His second level is reserved for the anonymous donor who gives to the poor "but does not know to whom he gives, nor does the recipient know his benefactor." Gibson's point is that giving, in the purest sense, does not involve recognition. He also cites Andrew Mellon's magnanimous gift to the nation in the National Gallery of Art, where Mellon specifically forbade his name to be used in the event others would be put off and not donate to it as well. "So much for leveraging," writes Gibson. Today's donors are more interested in credit than anonymity.[2]

Three Broad Motivators

Direct experience—People who are directly involved in some way are donors (volunteers).

Affinity—They are an integral part of the team, more intimately involved than those with direct experience (board members).

Excellence—Donors give to winners, not losers, and to organizations that have proved they can be the best of their kind.

—Goettler Associates[3]

Donors are also impressed by an urgent need to further a *cause*, not to satisfy your budget. Donors want to see a vision, a notion of what lies beyond tomorrow. But they also want to respond to valid needs that have not been artificially concocted to raise dollars. This is especially true in hard times, when you are competing with social agencies' needs.

Donors respond to the value of *well-defined priorities*. This is where a well-conceived and well-executed strategic plan is critical. If you are raising money to refurbish the permanent collection gallery that houses the story of your community, ensure that you have a plan before you go out asking for support of the idea. If you have well-defined priorities, it follows that you will have *tangible projects with measurable results*—another trait to which savvy donors respond.

One of the most difficult results many well-intentioned donors want to see is *honest change* as a product of their gift. In some circles, this is known as transformational giving. Not all gifts can be transformational. Some gifts are needed just to keep the lights and heat on.

Donors always respond to a prestigious, enthusiastic, and supportive *board of trustees*. They know that the board will steward their gift wisely and prudently. A board of trustees with a bad image or bad reputation will repel donors. Raising money is extremely difficult, and donors can find an infinite number of reasons not to give. Don't give them a "softball" reason to turn you down, such as an incompetent board of trustees.

In the end, the sincerest way to a donor's heart is simple and genuine *gratitude*. Saying thank you with no strings attached, no additional asks or invitations—just a pure thank-you—will ensure that a donor will know that the philanthropic gesture he or she has made has received due gratitude.

On the other end of the spectrum, donors are put off by myriad large and small pet annoyances that can cost you dearly. The most common is junk mail. It would behoove every organization, no matter how small or large, to avoid the appearance of junk mail. Personalizing letters and other communications will take your promotional materials out of the odious category.

One of the more common practices in the museum field is to exchange mailing lists. The donor community has weighed in heavily against trading its information to other organizations. In this age of increasing intrusions on privacy, members and donors are decreasingly tolerant of this practice. There are two immediate ways to deal with it. The first is to stop it; the second is to inform new donors and members

that your organization practices such policies but with only other local museums and libraries (if that is the case).

Members and donors really dislike being overwhelmed with telemarketing calls and direct-mail appeals. Telemarketers will insist that the dinnertime phone call is effective, yet most anecdotal information indicates that most people detest such calls as much as they do a root canal.

One of the most egregious errors in fundraising is not asking for the order. As far as the donor is concerned, the most outrageous omission you can be accused of is not thanking the donor. Overwhelmingly, donors are put off by not being thanked. They are also offended by not being heard. Fundraiser after fundraiser will tell you how important saying thank you is, yet some organizations are so ungrateful and rude that they cannot be grateful and express their gratitude. There is much more on this in succeeding chapters.

Finally, donors are most disturbed if you are not using their money as agreed. Much more on this later also.

> *Helpful Hint:* Please note that tax deductions are not mentioned as motivation for donations. Various studies have shown that tax deductibility can be an incentive to high-end donors to increase the size of their gift, but not as a motivator to the average donor.

So how do you get community support for your programs? And how do you get support from all sources on a continual basis? Who do you approach? More important—how do you approach them?

Once you understand your institution—its mission, goals, plans, and image—and the marketplace or the donor universe, you must also understand the concept of donor relations.

Above all, this process goes to the heart of management and is much more than the popular notion that fundraising is asking for the money and nothing else. In other words, solicitation must always be preceded by a healthy dose of cultivation and followed by an equally robust serving of recognition. This model is further proof that development/fundraising/advancement is a management process and not once and done, as already noted.

The practice of good donor relations is more than superficial marketing or "just being nice" to those who support you. Paraphrasing Blanche

DuBois in *A Streetcar Named Desire*: "We depend on the kindness of strangers." Our goal is to win over those strangers to be friends of the museum. But it is not a once-and-done exercise. It means keeping those donors close to the family as long as possible. It requires vigilance, patience, people skills, and an ability to deal with ambiguity. It all starts with cultivation.

Cultivation

Cultivation consists of two components: identification and education.

Identification

The process of identification means that you must identify suspects from a large pool of individuals who are suspected of having the financial means and inclination to make a major gift to your organization. It means that you must look to past donors, people who use the museum's services, advisory boards, volunteer groups, and all auxiliary and affinity groups. It means research, research, and more research: look to suspects who have demonstrated their philanthropic interest in kin groups—such as the symphony, the opera, the zoo, and the botanical garden.

These leads are not foolproof—old directories, the Internet, the foundation center, and so on. Read annual reports, newsletters, program guides, and plaques on other cultural buildings' walls. National, regional, and local news outlets occasionally publish lists of top-paid executives and families in your community.

Turn Suspects into Prospects

Wealth screening, offered by consultants, can provide names of large donors in your neck of the woods. Don't waste time on some millionaire two counties over. If you know about him/her, you can be sure you are not the first. Use your board members—your success here depends on the knowledge of your board.

And Who Do You Ask for Money?

Best prospects are already part of your constituency—past contributors, people who use the museum's services, advisory boards, volunteer groups, and others.

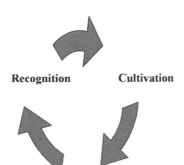

Recognition **Cultivation**

Solicitation

Donor relations, the circle of fundraising, and the stewardship of donors are synonymous with good management and good fundraising. Breaking the circle is unforgivable and will lead to more work to catch up. Each segment of the circle depends on the other and is so closely related that it is hard to imagine only one as a stand-alone.

Volunteers are your most important source of viable prospects. For several years the Independent Sector, a coalition of more than eight hundred nonprofits in the United States, has done a biennial survey of the nexus of volunteerism and giving. It last updated its survey in 2001. The coalition continued to find a close correlation between volunteerism and charitable giving. In that year, 46 percent of the adult population were donors, and 42 percent were donors and volunteers. The volunteerism was quantified to a regular schedule of monthly or more often, averaging more than twenty-four hours per month.

At the beginning of the decade, 89 percent of households gave money to a charitable cause, averaging $1,620 or 3.1 percent of household income. The average contribution among volunteering households, however, was $2,295, compared with $1,009 from nonvolunteers. Much of this money has gone to religious organizations, but the most important finding year after year for the Independent Sector is that of those households that were asked to donate money, 61 percent did, compared with 39 percent that were not asked.[4]

The two important lessons to take away from this information are that (1) volunteers are an excellent pool of prospects, and that (2) you

must ask for the order. It doesn't matter whether you are a large, five-million-dollar organization or a small museum with three staff members.

Helpful Hint: People will not contribute to you just because they are wealthy. They must have the capacity and the interest. Both must be present. If they possess just one of these traits, you will not get a gift.

Education

In the world of fundraising, education means alerting and indoctrinating prospective donors about your mission, your relevance, and your goals. It can take the forms that many of us already employ—parties, receptions, openings, educational programs, lectures, all are excellent venues to show off your wares. Above all, use your board members to convey your enthusiasm and energy. But beware of major pitfalls.

A common failure of many historical societies/museums is the rush to establish auxiliary groups. Some have lost their origins in the mists of time. They are often called, in older organizations, "The Women's Guild," "The Founders," "Pioneers," "Current Historians," or "The Young Contemporaries." They should not be confused with donor clubs such as "The Federalist Society" used at Old Sturbridge Village, "The Raleigh Tavern Society" at Williamsburg, or "The Chairman's Council" at the New-York Historical Society. These clubs are excellent examples of the intersection of cultivation and recognition. They are established to express gratitude for annual gifts for unrestricted purposes supporting the general operating fund. They usually begin at the $2,500 or $5,000 level on up to $50,000 for large historical museums. They are more fully discussed in chapter 5, "Membership, Annual Appeal, and Special Events."

Each group I am referring to was either initially or later established as a "club" of hobbyists who shared a common interest. Over the years, such clubs provide very little support for the institution while creating a drain on the institution's resources of time and money. They are vestigial remnants of an old paradigm in museums when times were good. Everyone was welcome. At one time, the Indiana Historical Society had several special-interest groups called "sections." These included military groups, friends of the library, and early settlers of the region. Over time, these groups in all

museums contribute less to the institution than they bring. In a recent purge of such groups, it was determined that the annual membership provided by each member of a "friends group" of twenty-five dollars per year cost the institution to provide services and programs equal to around $115 per member, per year. This upside-down number included all direct costs such as bimonthly food and drink for 25 to 30 members of the 120-member group. After years of benign neglect, the group was disbanded by management, relieving the budget of an unsustainable burden.

Cultivation is a genuine, sincere desire and effort on your part to make your organization a part of the immediate community by involving members of that community in your mission and goals. I replaced a CEO in one of my many incarnations who believed that spending money on cultivation—dinners, lunches, breakfasts, cocktail parties—was a sinful waste of money. He steadfastly refused to wine and dine potential donors to his institution, to the museum's detriment. The result was little income from any sort of gifts and, more distressingly, a corporate culture that accepted the notion that the museum was not using its money wisely. Another cliché in fundraising is "you must spend money to make money." Cultivation is not pandering. If you somehow find it offensive, then you are forgetting the long-term goals of the institution you are trying to help.

In essence, cultivation, according to two experienced fundraisers, "makes solicitation possible." Kay Sprinkel Grace points out ten truisms about cultivation that could apply to any large or small organization and all those in between.

1. Cultivation involves board members, volunteers, donors, and staff.

Staff sets up and participates in opportunities for board members and other volunteers to meet and talk with prospective donors. It is a cooperative project but is dependent on your volunteers making themselves available for cultivation events. Be sure to include current donors as well. They are excellent advocates for your cause.

2. Cultivation is strategic.

Parties and events mean nothing if there is not good follow-up based on a good cultivation plan. Cultivation planning has two parts: general and specific. General cultivation is all about regularly scheduled events (think tours, coffees, and presentations). Specific cultivation activities are those meant for special prospects, those who may or may not also attend regularly scheduled activities and events.

3. Cultivation is systematic.

Every event or activity should have a follow-up plan. Good ways to follow up are adding prospect names to your mailing list and sending thank-you letters. Follow-up can be an e-mail or personal phone call from a board member or event committee member to patrons of the event. At an event, do assign a board member to each table and provide him or her with confidential lists and short bios of those at the table. If large donors or prospects attend, be sure a board member looks after them.

4. Cultivation should be coordinated.

All interaction with prospective or current donors should be reported to a central person (development director, executive director, or board chair). Set up forms that staff or volunteers can fill out and fax to the coordinator. If you have a donor database, enter this information. Such "intel" can be crucial to good follow-up and future cultivation.

5. Cultivation should not be limited to large gift prospects.

Be sure that everyone who attends an event leaves it with increased knowledge about your organization. This can be a brief presentation, materials at each table, or a packet given out as attendees leave.

6. Not all cultivation involves personal interaction.

Cultivation occurs any time you communicate with prospects. Your regular newsletter can be very effective as a cultivation tool, but be sure it is communicating the message you most want your readers to receive:

- Does it communicate the impact and results of your programs, or does it focus on your needs?
- Does it portray—in words and photos—the kinds of people you serve in your programs?
- Does it balance volunteer information, donor recognition, and program impact? Or does it overemphasize your special events?

7. Don't forget that cultivation can be unexpected.

For instance, you might receive favorable press coverage that brings prospective donors to you. Board members and other volunteers, who are enthusiastic about your cause, might arouse interest through their own social gatherings or professional contacts.

8. While it is important to cultivate, know when to ask.

The purpose of cultivation is to ease and ensure the success of your eventual solicitation. Learn the signs that a prospect is open to being asked for a gift. Because cultivation is pleasant and painless, it can easily become all consuming and stave off the inevitable: asking for a gift.

9. Cultivation of corporations and foundations is different.

With these entities you usually know what the deadline is for a funding request and what the process is for closing the gift. It is easier to sequence your activities. With individuals, there isn't such a calendar. But the same rules apply: cultivation must be systematic, coordinated, and strategic.

10. Be sure there is a budget for cultivation.

Cultivation does not have a predictable or immediate return. Consequently, it may be hard to make the case that these activities are necessary for eventual gifts. Have at hand a few anecdotes about prospects who became donors as a result of good cultivation.

As Kay Sprinkel Grace points out in her book, *Over Goal!* cultivation is a process and a tool. It provides opportunities for the donor to learn about your organization and requires coordination, strategic thinking, and great follow-up.[5]

Solicitation

The essence of strategic fund-raising involves the right volunteer asking the right prospect for the right amount at the right time.

—Goettler Associates

The simplest yet most difficult effort for most people is to ask others for money. We shy away from it because we hate asking people for money, not only because it seems unseemly (begging?), but also because more directly we fear rejection. A story circulating around the Smithsonian development office in the 1980s was that Secretary of the Smithsonian Dillon Ripley was sent to ask John Paul Getty for a large gift. As he waited in the reception room just outside Getty's office, Ripley could hear Getty's rising voice on the phone. As the argument on the phone intensified, Ripley became wary of asking for money at such a time. When the conversation was over, he was asked to come into Getty's office. Before he did, he left the proposal behind on the couch and then engaged in a long conversation about birds—both were ornithologists. Whether that story is true or not is immaterial; the point is that he never asked for the order.

To overcome the fear of rejection, you must position your case as "well" or "superior," not as a beggar or supplicant, and not as a charity.

Never begin your fundraising as a "beggar" or "supplicant." Just because the IRS and the law consider your nonprofit as a "charity" does not put you in the role of a panhandler with a tin cup on the corner. Deal from strength.

Not haughty, but good. You must deal from quality and in terms of investments and the returns on those investments. You must feel secure in your mission, your institution, your cause. Rejection is not personal and shouldn't be taken as such.

Author Kim Klein, in an article entitled *Getting over the Fear of Asking*, prescribed solutions for your volunteers designed to overcome asking "for the order." Her advice is as applicable to the small museum as it is to the large institution. It applies to membership requests as well as annual appeal and capital campaigns. Her two group exercises are detailed below:

Asking people for money is both the most difficult and the most important part of fundraising. Every community-sponsored organization uses a variety of methods to ask for money, such as direct mail appeals, special events, pledge programs, products for sale, and so on. But the hardest way for an organization to raise money is for board, staff, and volunteers to ask people directly for donations. Experience has shown, however, that it is almost impossible to have a major gifts program without face-to-face solicitation of the prospective donors.

Sources of Our Fears

Asking a person for money face-to-face is an acquired taste. Few people love to do it initially. In fact, most people are afraid to do it. If you are afraid to ask for money, that's normal. If you are not afraid, that's great. Stop reading this article and go ask somebody for a donation!

People are afraid to ask for money for a wide variety of reasons and we can't hope to explore them all here. However, it is important to look at the role money plays in our American society to understand the sources of our fears.

Most of us are taught that four topics are taboo in polite conversation: politics, money, religion, and sex. Many of us were also raised to believe that asking people what their salary is, or how much they paid for their house or their car is rude. In many families, the man takes care of all financial decisions. It is not unusual, even today, for wives not to know how much their husbands earn, for children not to know how much their parents earn, and for close friends not to know one another's income. Many people don't know anything about the stock market, what the difference is between a "bear" and "bull" market, or what the rising or falling of the Dow Jones means for the economy.

Many small organizations have discovered that if they seek a paid staff person to be a program or volunteer coordinator; they will be flooded with applications, but if they seek a fundraising coordinator, they will have almost no skilled applicants.

The net effect of these taboos about discussing money is that money takes on the air of being both mysterious and bad. The hidden message is that good people don't deal with money except insofar as they must in order to live. Many people, misquoting the Bible, say, "Money is the root of all evil." In fact, Paul's statement to the Philippians in the New Testament is, "Love of money is the root of all evil." Money, in

itself, has no good or evil qualities. It is not a moral substance. Money facilitates people getting what they want or need. As such, how money is used, where it is obtained and inequities of who has it and who does not, have moral implications. This is very different from money itself being evil.

When money is mysterious and taboo, only those persons willing to learn about it can really control it. In America, an elite upper class controls most of the nation's wealth, whether by earning it or inheriting it, or both. It serves the interest of this ruling class for the mass of people to continue not to know about money. As political activists and participants in social change, it is not only important for fundraising, but for all organizing purposes, that we learn about money—how to raise it effectively and ethically, how to manage it, and how to spend it wisely.

Klein describes two easy exercises your group can do that will help dispel fears about asking for money. A member of the group can act as facilitator or you can ask someone outside the group to facilitate. These exercises can be done individually, but they are more effective when group members share with each other in recognizing and letting go of fears about money. To do the exercises, you will need a black board or sheet of butcher paper.

In the first exercise, the group looks objectively at its collective fears about asking for money. Fear of asking for money is similar to what you feel when you hear a noise in your house at night when you are alone. Your immediate, normal reaction is to fear. You have two choices about how to respond to this fear: 1) you can give in to it, huddling under the covers, and imagining all the worst things the noise could mean, or 2) you can take the more sensible, but much more difficult action of getting up and turning on all the lights until you probably discover that the noise was something as simple as the cat, a leaky faucet, the wind, or nothing at all.

In the same way, looking at all your fears about asking for money in the light of discussion with others will show that many of them are irrational, and that for most, the feared outcome is far less likely to happen than you think.

To begin the exercise, each person imagines asking someone for a large amount of money (anything over $50). Going around the room each person says out loud what they think will happen to them. What will the person they are asking think of them? What will they think of themselves? The facilitator writes down all the feared outcomes.

Responses might include the following:

- The person will yell at me (or hit me)
- The person will give me the money; but won't really want to, and will resent me
- I know the person doesn't have the money
- It is imposing on our friendship for me to ask, and we won't be friends anymore
- The person will think that the only reason I was nice to them was to get money
- The person will say "yes" and then ask me for money for his or her cause
- I don't know if my group really deserves the money as much as some other groups might
- The person will ask me questions about the organization that I can't answer

The fears listed will fall into three categories:

- Fears of responses that are extremely unlikely to happen (I'll be punched, I'll be sued, I'll have a heart attack)
- Fears of things that might happen but could be dealt with if they do (the person will ask me for money, the person will ask questions I can't answer)
- Fears of things which will definitely happen occasionally (the person will say no).

Looking at the third type of fear first we realize that the worst thing that can happen when you ask for money is that the person will say no. Everyone who does fundraising will experience this kind of rejection. Remember, just as it is your privilege to ask for money, it is the other person's privilege to turn you down. The person being asked may have just spent $400 on his or her car, or been asked to give to five other organizations, or have other current priorities. While no one likes to be turned down, it is important not to take being turned down as a rejection of you personally.

In the second category of fears—that someone will give to your organization, and then ask you for money for his or her special cause—you can make your own decision. You don't owe the person a favor. To be supportive of him or her and the cause, you may want to say yes, but you are not obligated to do so.

Questions you can't answer can be responded to with "I don't know" or "I'll find out and let you know."

Fears such as, "I know the person doesn't have the money" are very common. However, unless you have a financial statement from the person you are asking, or unless you know her or she is on welfare, or has recently experienced a devastating tragedy, you don't know that the person doesn't have the money.

Other fears can be dealt with the same way. The group should look at each fear and see which category it fits into.

Sometimes it is not appropriate to ask someone else for money, but this is true far less often than we think. When you consider asking someone for money, and decide not to, ask yourself, "Do I have a reason not to ask, or just an excuse based on assumptions I am making about the other person?"

When thinking about why a person would give money to an organization, think about why you give money to any organization. Your reasons for giving or not giving will be much the same as everyone else's and will help you understand what motivates people to give.

In a second exercise, participants imagine that an acquaintance has come to them, explained a cause he or she is involved in, and asked for a gift. Imagine that the gift is an affordable amount, but not an amount one could give to everybody who asked. For most people, this amount is somewhere between $25 and $50.

For thirty seconds participants write down on their own sheet of paper all the reasons they would say yes to this request. Then for the next thirty seconds, they list all the reason they would say no. Asking participants to share their results, the facilitator then writes the "yes" and "no" reasons on two separate sheets of butcher paper, or two sides of the blackboard. Generally, there are more yes reasons than no reasons. The following are the most common reasons:

YES: In the yes group, these comments were given: I like the person asking; I believe in the cause; I get something for my money; I can take a tax deduction; I feel generous; I know my money will be well used; I just got paid; I want to support my friend; I feel guilty saying no; I know other people in the group; and I liked the approach.

NO: No reasons were: I don't like the person asking; I don't believe in the cause; I don't have the money; I was in a bad mood that day; The organization has a bad reputation; I give to other things; I had already been asked several times that week; I don't know what my money will be used for and I think that the person asking is naïve.

Looking at the no list, we discover that the answers fall into two categories:

A. Reasons which are not the asker's fault, and which could not be known ahead of time

B. Reasons which appear to be "no" but are really "maybe."

In the first case, the asker usually cannot know that the prospect does not have the money right now, or that he or she is in a bad mood, or has been asked several times that week. When this is the reason for the rejection, the asker can only thank the prospect for his or her time, and go on the next prospect.

In the second case, if the prospect knew more about the organization, knew how the money was used, knew that the reasons for the bad reputation have been cleared up, he or she might give. The "no" answers are really "maybe." "Maybe I would give if I thought the organization did good work." The person asking for the money must be prepared to discuss the prospect's reasons with him or her and hope to persuade the prospect to change to an affirmative answer.

A few of the "no" reasons reflect badly on the asker. For example, if the prospect thinks the asker is naïve or pushy or dislikes the asker altogether, then this was an unfortunate choice of a person to solicit the gift.

The point of this exercise is twofold—to illustrate why people give and don't give and to illustrate that people have more reason to say yes than to say no to a request for a contribution.

These exercises and the subsequent discussion they involve will help people in your group understand that asking for money is not as frightening as they may have thought. The worst thing that can happen is that the person asked will say no and usually they say no for reasons outside your control or knowledge.[6]

Helpful Hint: "Never . . . apologize for asking someone to give to a worthy cause any more than as though you were giving him the opportunity to participate in a high-grade investment. The duty of giving is as much his as the duty of asking is yours. Whether or not he should give to that particular enterprise, and if so, how much, is for him alone to decide."[7]

Consider this paragraph from a real solicitation letter written by the real director of a real museum in the winter of 1982. The date may seem unremarkable, but the country and the fundraising community were fac-

ing the same strong economic headwinds as the recent "Great Recession" of 2008–2009. Unemployment hovered around 10 percent, and mortgage interest rates were an ungodly 16 to 18 percent. The Dow Jones languished at around 800. This one-page, five-paragraph letter told of all the great things the museum was doing and what it planned to do. Paragraph four closed in on "the ask"—and completely misfired:

> Sustaining the highest levels of preservation and scholarship presents a serious challenge for the . . . museum in this current economic climate. Federal support programs have been cut back and corporations, caught by tight economic conditions, are restricting their contributions to the arts. We have been fortunate in attracting support for our activities from a wide variety of sources, both public and private, local and national, but we must look as well to our loyal members and friends to help us maintain the level of performance you have come to expect. Our goal for the 1982 Annual Giving Appeal is $50,000, an amount we know we shall require to meet our obligations.

Sadly, this letter makes no call to action. As the recipient, what am I being asked to do? How much am I asked to donate? Will one hundred dollars be enough to meet your "obligations?" Or would twenty-five dollars do as well? Why should I care about your "obligations?" The letter should have been more specific in asking: "Therefore today I am asking if you would consider a gift of $500 to underwrite the visits of two hundred Title I schoolchildren during this next school year." Think about the message of this paragraph as you read three common asks that absolutely drive me crazy.

Solicitations That Drive Me Nuts!

- "Give what you can." Can you imagine asking a millionaire that question? He will either dismiss you (throw you out) or, more politely, laugh in your face.

- "Give what you are comfortable with." So, okay, I am comfortable with giving you ten dollars or one dollar. How comfortable are you as a solicitor with that? Not very comfortable, I'll bet.

- "We would appreciate a gift in the range of $— to $—." This indicates to the prospective donor that you really have no clue

what they are capable of giving or what you need to meet your intended goals.

These are all ways of asking that have persisted over the years because they are used and uttered by those afraid of rejection. They occur in all sizes of institutions and disciplines. They are our human way of avoiding the pain of refusal. They are particularly common in small museum situations in which the museum is within a smaller town or community that is well connected and where everyone knows everyone else. With these phrases, a solicitor can always say, "Well, s/he didn't reject me; I got something out of him/her."[8]

Helpful Hint (nay—admonition):

- *Always ask for the order!*
- *Always ask for a specific amount!*
- *Avoid the preemptive gift!*

The greatest sin in all of fundraising is not asking for the order. Recently a young museum professional asked me what that meant. I thought it was obvious, but she was serious, and I realized that it was unclear. It means to ask for the gift and for a specific amount regardless of how painful you might find it. A preemptive gift is one where the prospect offers a gift before you are able to ask for the order. For example, you are scheduled to talk with Joe Smith to ask for a one-thousand-dollar gift for your annual fund. He knows that you are coming to visit him and why. He has been involved in campaigns before and suspects he will be asked for a four-figure gift. When you visit him, before you can begin your presentation he gives you a check for five hundred dollars as his contribution. What do you do to avoid the preemptive gift? You thank him profusely; tell him that you had hoped that as a leader in your community, he would provide a leadership gift of a thousand dollars. The total campaign is fifty thousand dollars, and you and your campaign team are canvassing the leaders for gifts of a thousand dollars. If you have already received many gifts or a few gifts in that range and your donors have allowed their names to be mentioned, you should inform him of that fact and ask him to join his peers at their level of giving. You should also mention that you are

taking three-year pledges, ask whether you can consider this gift a first payment in the campaign, and ask to visit with him again next year or in a few months to talk about an additional gift.

Don't expect the prospect to respond to you if you do not have a specific dollar figure in mind. Prospects will be embarrassed if they do not understand the length and breadth of your need. Have you articulated the need in both broad and fine brushstrokes? Your goal on the "call" is to set the prospective donor at ease and explain in a calm and coherent voice the institution's needs. Then you must explain in very clear terms how much of that particular need they are being asked to bear. If, for example, you are conducting a fifty-thousand-dollar campaign and you have rated this particular prospect for one thousand dollars, he or she should know what is expected. In addition, and by inference, you should let a prospect know that others are being asked for similar amounts according to their ability to give. This particular bit of information is important to the prospective donor because it gives him or her perspective on where his or her gift lies on the spectrum of the campaign.

You must give a solid business case for the dollar amount you are asking from the prospect so that the prospect understands the numbers. For example, some solicitors will mention what other donors are doing—without giving names—or say something like, "We are approaching twenty members of the immediate 'family' for gifts of five thousand dollars."

Ask the prospect to "consider" a dollar amount and, if needed, assure the donor in a major campaign that the gift can usually be paid out over a period of time—normally three years.

Don't wait for a response a week later or by a put-off remark such as "I will get back to you next week" (next month, never). Instead, you might launch into your recognition program, the number of students the prospect's gift will touch, or the enduring benefits that will come from his or her participation.

Remember That This Is a Negotiation

In 2000, the *New York Times* ran a long article on a star fundraiser in New York City, John Rosenwald. Within that article were Rosenwald's ten rules for asking for money. They summarize and expand at the same time the information given above on solicitation. They are excellent words of wisdom that make sense in all fundraising circumstances.

John Rosenwald's Ten Rules for Asking

1. Don't ask anyone to do anything if you haven't done it yourself.
2. Never send a $1000 giver to make a million dollar ask.
3. Don't give until it hurts; give till it feels good.
4. Think twice about naming a trustee who can't make a substantial contribution.
5. Never set a capital campaign goal you can't reach.
6. Never announce a campaign with less than one third of the total already raised.
7. Nobody is insulted by being asked for too much.
8. Sell the excellence of the institution. People want to be associated with winners.
9. Be patient. Courting major donors is like catching big fish on light tackle: pull too hard and the line breaks.
10. The sale begins when the customer says no.[9]

What do you do when the donor objects to one of your initiatives and begins to push his or her weight around with you? During my tenure as president and CEO of the Indiana Historical Society, I was fortunate to work with two very gifted individuals who were longtime professionals in the fields of marketing and fundraising. The first, Bruce Hedrick, has his own firm, Hedrick Communications, and was our marketing adviser. Brian Payne was president of the Central Indiana Community Foundation. Bruce would issue a communiqué to his clients called "Weekly Wisdom." I quote below an excellent case study dated April 29, 2005, and entitled "Donation Dilemma," relating the story of a group of donors who were not pleased with a nonprofit's decision to change its marketing strategies.

Donation Dilemma

After years of running a sizable weekly newspaper advertisement, a nonprofit organization recently decided to go with something smaller. Although the decision came in the course of budget discussions, there were two key reasons for the reduction: the ads weren't cost effective and didn't fit the organization's strategy.

But a small group of longtime donors got upset. They felt that the smaller ads hurt the organization's image, especially since a key "competitor" runs larger ones. After discussion, the donors suggested that they might want to underwrite the cost of returning ads to their original size.

When the organization's board learned of the donor's offer, members debated whether they should accept the money. Some argued that accepting the contribution would mean that donors were being allowed to reverse a strategic decision by waving their checkbooks. Others suggested that it would be poor stewardship to accept money for an ad that they all know is ineffective. Still others, however, made the point that taking the money and honoring the request would not be a hardship, and would allow them to maintain good relations with friends of the organization.

What to do? We asked Brian Payne, president of the Central Indiana Community Foundation—which works with donors and philanthropic organizations to increase the effectiveness of donated funds—how a nonprofit should address a situation in which donors offer money for something the organization hadn't planned to do. The answer is never cut-and-dried, he said, but an organization would do well to consider the following factors when making the decision.

How big a deal is it, really?

What are the donors requesting? For the organization to make a major strategic change or adopt something that would oppose its mission? For it to hire a particular person? For it to undertake an expensive, distracting and unnecessary project? Or for it to do something relatively inconsequential? In this case, is the ad size really a big deal? Would accepting the money truly represent a surrender of control?

Are the donors open to a discussion about the gift?

Would the donors be willing to hear an explanation about why the board was hesitant to accept the gift, and to consider suggestions about other ways their funds could be used to achieve the same objectives?

Is it new money?

Is the money the donors want to offer for the project in addition to their usual contributions? Or do they want to redirect current donations? If it's a redirection of pledged or donated fund, the nonprofit should resist, Payne says, explaining to the donors, "We need your usual funds to keep the doors open, pay the bills, and conduct our usual campaigns." Do not give in on that issue, he adds.

Will it affect other resources?

Would accepting the money and the project the donors suggest require the redirection of other resources, such as staff time, money or materials? In this case, for example, would a staffer need to spend time putting together an ad, or hire an agency to create one? If so the gift should be declined.

Is there a win-win in this?

Could there be a compromise that would allow the donors to feel good about the outcome without overturning the organization's decision? In this case, would a slightly larger ad be acceptable, with the understanding that the rest of the donation would be used to pursue a different method for achieving the ad's objectives?

The bottom line, Payne notes, is that the organization needs to decide whether the disagreement over the use of the funds is worth the risk of alienating the donors. If there is no real harm done—it's new money, it doesn't require the redirection of funds or changes in the organization, the donors welcomed discussion but remained dedicated to their cause—then accept the money and do what the donors want.

However, if it is a big deal, the donor's request is unreasonable and no compromise can be reached, then, certainly, decline the money—and be prepared for the fallout that will follow.[10]

Recognition

But well before you solicit the first gift, you must think strategically and carefully how you intend to recognize all of your donors. Like cultivation, recognition must be genuine and sincere. It should be thoughtful with the realization on the part of both parties that the museum is extremely grateful for the support of its donors. According to the Seventh-day Adventist World Headquarters in a piece called "Accent on Recognition: Saying Thank You to Donors and Volunteers," once the gift is in hand, your responsibilities are not complete. It talks of your duty to continue to encourage donors to invest in your organization. The path to keeping donors close to your organization is to provide a positive and lasting relationship.

The first step is to decide the level of recognition for different levels of support. A one-hundred-dollar donor should not be acknowledged

in the same way a one-thousand-dollar donor is. According to the authors, "These levels should be determined by the size of your institution, the public it serves, the estimated wealth of that community, its fund raising history and the length of time the institution has been in operation."[11]

At a minimum, the authors suggest the following seven principles:

1. All donors must receive a receipt for their contribution and a printed statement of thanks.
2. Donors should be sent cultivation materials to keep them informed of your organization's accomplishments and needs. Make your past donors your best prospects—keep in touch.
3. Value the donors for more than their money. Donors can help you in ways that don't include their checkbooks. Use a donor's talents to enrich your organization through activities such as guest lecturing, serving on committees, and recruiting other donors.
4. Notify the donor of any publicity surrounding his gift. If you feel that the gift warrants local media attention, be sure you have the donor's permission to use the media before engaging in any publicity activities. Also provide donors with the opportunity to proofread any news releases.
5. Avoid awarding plaques, desk sets, paperweights, and similar off-the-shelf items to donors at the upper levels. Try instead to select unique gifts tailored to each donor's background and interests. For example, if the donor has had a lifelong concern for the physically impaired, a painting done by a quadriplegic artist with a small engraved plaque attached might be a more meaningful gift. (For the donor who has given money for a capital project, place a plaque on the project, but also provide a copy of the plaque that they can take with them and display in their office or home.)
6. National practice suggests, as a general rule, a 1.5 to 3 percent ceiling on spending for thank-you gifts and activities. There are times you have to vary a few percentage points for very special occasions or gift club operations. But many donors are justifiably put off when institutions spend lavishly on frills. Don't mark your institution as being financially irresponsible! That's the one message you don't want to send.
7. Don't overlook on-site opportunities to better inform donors about your work and to entertain and involve them. The Adventist article

points out that good donor relations will pay dividends, and donors will spread the good news story by word of mouth.

"In expressing appreciation you can never do enough. In giving recognition, do everything and anything within proper taste and appropriate to the donor." Jerold Panas provides this summary of advice on recognizing donors in his book *Mega Gifts* (Pluribus Press, 1984).[12]

An increasingly contentious area of fundraising is "naming opportunities" for donors of large gifts. This is an area fraught not only with human relations implications but also with strong ethical considerations. Well into the twentieth century, eleemosynary institutions invariably named monuments, museums, and public works after deceased individuals to memorialize them. Today we have adopted the practice of naming everything in a new museum after the donors—a practice that has backfired in a most public way and at the most inopportune times. Horror stories abound concerning people who had given large amounts of money to universities and institutions that have honored them with their names on the building only to have the donor fall into disgrace and the institution have to rename the facility or remove the name completely. "At the University of Missouri at Columbia, the Kenneth L. Lay Chair in Economics, named after the Enron executive, is still open (2007)."[13]

University presidents and museum directors have struggled with this issue and will continue to do so as long as the donor-donee relationship exists. In a long rumination in the Harvard University *Gazette*, May 4, 1979, then university president Derek Bok wrote on this very issue. Entitled "Reflections on the Ethical Problems of Accepting Gifts: An Open Letter to the Harvard Community," he waded into the ethical morass of problem gifts, their donors, and the donee's responsibilities. He spoke of gifts improperly restricted, controversial donors, and gifts with ulterior purposes.

In the first instance, in the case of a museum, the donor might wish to endow the director's chair and then insist on choosing the new director. In the second instance, controversial donors, such as a Kenneth Lay, are not unusual—sadly enough. Bok cites a predecessor at Harvard who "refused to rebuff a benefactor who had repeatedly violated the law, arguing that Harvard had never assumed that its decision to accept a gift

represented an affirmation of the donor's good character." He concedes that "reasonable people may argue that even if the naming of a building is not a certificate of good character, it does invest the donor with a certain respectability and carries at least a faint connotation that his life and works are not demonstrably at war with the values of the institution." He concludes with an obvious observation that an institution should never "agree to use the names of donors when it knows in advance that their lives and conduct are in plain conflict with the values and ideals of the institution."

In the last case, gifts with ulterior motives, Bok speaks to motivation of the donor and the admonition to accepting institutions that they must discern before accepting a gift if the donor has an ulterior motive. This is not always possible. The best advice to the small museum and indeed any museum is to follow the lead of the American Association of Museums and adopt policies that will govern acceptance of corporate sponsorships and individual gifts in all situations.[14]

Perhaps the most important aspect of recognition is your need to determine whether the donor really wants to be publicly recognized. Some donors are either naturally shy or, for privacy reasons, refuse to have their names attached to a particular cause. Before you splatter their names all over your newsletter, annual report, website, or Facebook page, be sure that they are comfortable with your intentions.

And how about this for a radical idea? Suppose that recipients and donors of large naming gifts decide to limit the time of the naming opportunity? That is an idea floated by philanthropist David Koch, who suggested it should be discussed by boards and donors across the country. Koch, among the world's wealthiest men and a major benefactor of such museums as the American Museum of National History, the Smithsonian's National Museum of Natural History, has suggested a legally binding expiration date of fifty years on one of his largest gifts—his 2008 gift to the theater at Lincoln Center. The rationale behind this unorthodox idea is that if the named-gift opportunity has an end date, then the opportunity can go to another donor and secure another leadership gift for the institution. When asked about this concept, Koch responded: "I've strongly requested in my remarks on a couple of occasions to the audience . . . that they, too, should consider letting their name expire in fifty years

on whatever they choose to give to, so that the trustees can then use that aspect to raise money." He went on to say that he feels "a moral obligation" toward philanthropic giving.[15]

Small museums are in the unique position to offer less, ironically, that may, in the end, be more meaningful. As one author pointed out recently, "Unwanted recognition can quell the giving spirit." That author, Kimberlee Roth, quoted a study done at the Gunderson Lutheran Medical Foundation, La Crosse, Wisconsin, that found what donors wanted most is a "personalized message from someone of consequence in the organization"—a simple gesture such as a phone call to the donor, saying something like: "I just came out of a meeting on the XYZ project that you funded and I wanted to let you know that everything that we wanted to accomplish so far on the project is moving along swimmingly." Donors today are more interested in and sensitive about how their money is being spent than at any time in recorded history. They are sensitive to extravagant thank-you gifts and the expenditures that they imply.[16]

Most important, donors want prompt and sincere thank-you letters and receipts for their gifts. Any official acknowledgment over two weeks old is unacceptable. This means that you must keep pristine gift records. This is an activity museums and nonprofits sometimes overlook. It is done in the back office, by accountants, and is never glamorous. But it is essential in the recognition process. Do you have the correct address? The correct salutation? The correct spelling of the individual's name? Is your acknowledgment timely? Donor Susie Buffet, speaking to a group of nonprofit management students, said, "Sometimes, when people ask you for $50,000 and you give $35,000, it's amazing how people react. A simple thank you would be nice. You would be amazed at how many charities simply forget to say thank you. David Rockefeller, Jr. . . . says 'many charities just don't keep donors informed enough of how they're having an impact.'" Aside from the emotional importance of saying "thank you," the practical side is that donors will walk today faster than at any time in the past. They will stop their giving if they are ignored, and the institution will spend more money either trying to get them back or trying to get new donors.[17]

As a CEO and also a development director in several museums, large and small, I have been on the other end of the telephone with an irate

donor who either had received the wrong thank-you letter, had received a late thank you and receipt, or was wondering when we were going to send one out. With today's technology, a thank-you letter or acknowledgment should never be delayed more than two weeks. In the old days of fundraising when thank-you letters were typed on typewriters, subject to correction fluid, with multiple copies, and that had to be revised when the CEO or the "thanking" individual was not satisfied with the language, a thank-you letter may have taken a month during heavy donor months such as December and January.

Thank-you lunches, receptions, dinners, parties, and openings are all forms of saying thank you, and they are increasingly expensive. Yet some donors do appreciate them, and you can do them if you think strategically. Piggybacking a thank-you opening of an exhibition on a corporate-sponsored evening with the concurrence of the sponsoring corporation is an inexpensive way of saying thank you. Be sure to invite them to all of your openings, whether it is a grand banquet or not.

You should say thank you as often as possible. It doesn't hurt to have the chair of the board or the chair of the development committee send a handwritten note to the donor. When gratitude is lacking, it reflects on the whole organization. Say thank you using different people in your organization—including the children served by the donor's contribution. At the Atlanta Historical Society, we initiated "thank you" phone calls. It works, it's inexpensive, it's personal, and our donors absolutely love it. Several board members divide up the names after gifts are received and make quick, sincere calls to donors from fifty dollars to large dollar figures. Above all, keep it sincere.

After a major campaign, have a donor wall prominently displayed in your lobby, but ensure that everyone wants his or her name listed. It is not unusual to see donor walls where the listing of names begins with "Anonymous." Above all, donors want proof that their gift was meaningful. Perhaps most significantly, sincere and measured recognition will build a stronger relationship with an individual, a couple, a foundation, and even a corporation and will be a means of cultivation for the next gift.

Several years ago, various philanthropies gathered together to write up a donor bill of rights. The full text below speaks to transparency and honest negotiations between the donor and the nonprofit. The Donor

Bill of Rights was created by the Association of Fundraising Professionals (AFP), the Association for Healthcare Philanthropy (AHP), the Council for Advancement and Support of Education (CASE), and the Giving Institute: Leading Consultants to Non-Profits. It has been endorsed by numerous organizations.

The Donor Bill of Rights

Philanthropy is based on voluntary action for the common good. It is a tradition of giving and sharing that is primary to the quality of life. To ensure that philanthropy merits the respect and trust of the general public, and that donors and prospective donors can have full confidence in the nonprofit organizations and causes they are asked to support, we declare that all donors have these rights:

I. To be informed of the organization's mission, of the way the organization intends to use donated resources, and of its capacity to use donations effectively for their intended purposes.

II. To be informed of the identity of those serving on the organization's governing board, and to expect the board to exercise prudent judgment in its stewardship responsibilities.

III. To have access to the organization's most recent financial statements.

IV. To be assured their gifts will be used for the purposes for which they were given.

V. To receive appropriate acknowledgment and recognition.

VI. To be assured that information about their donation is handled with respect and with confidentiality to the extent provided by law.

VII. To expect that all relationships with individuals representing organizations of interest to the donor will be professional in nature.

VIII. To be informed whether those seeking donations are volunteers, employees of the organization or hired solicitors.

IX. To have the opportunity for their names to be deleted from mailing lists that an organization may intend to share.

X. To feel free to ask questions when making a donation and to receive prompt, truthful and forthright answers.

In Summary

The "care and feeding of donors" is another cliché used in fundraising. In some respects it is demeaning in that it reduces the relationship of the donor and donee to the level of animal and trainer. Nothing could be further from the truth. The relationship, the stewardship of your donors will determine your future. If you treat them poorly, they will walk, if not run, away. There are far too many places where they and their generosity will be welcomed and nurtured. Understanding human nature is probably the most important trait you can have as a successful fundraiser. Empathy and emotion are powerful engines of charitable giving that are understood by the successful fundraisers and ignored by the "posers." The latter also have little capacity to listen to the donor. Some have the audacity to thank the donor only when they are pursuing another gift. Remember to treat donors with respect, say thank you often and early, and always use their money as they have requested.

METHODS OF SOLICITATION
Asking for the Order

To give away money is an easy matter and in any man's power. But to decide to whom to give it and how large and when, and for what purpose and how, is neither in every man's power nor an easy matter.

—Aristotle

It's not too difficult to disabuse a person's apprehensions about fund raising. Education comes first. No one gives money unless they want to; it is not an imposition to ask a person to help support a cause that you believe in. And people seldom give large donations unless they are asked for large donations.[1]

There are several ways to approach a prospect to ask for an investment in your museum. Some are more effective than other ways. Some just do not work. Once again, these modes are applicable to all museums, large and small, no matter what their discipline.

Face-to-Face

The best method of asking for money is face-to-face. This is the one most people hate, but it is the most effective. We avoid it because we are afraid of rejection. Instead we call, we write, we e-mail, we leave voice mail—all in order to avoid the face-to-face request for a gift. This fear is being enabled by the revolution of the "social media," which further distances people from one another.

The old-fashioned visit with a prospect remains the ideal.

Face-to-face solicitation is imperative in the pursuit of large gifts. In addition, such a call demands this personal visit with a peer of the prospect. Time-honored results invariably demonstrate that large prospects will usually respond favorably to donors who have already made a substantial commitment. In other words, never send a thousand-dollar donor to ask for a gift from a million-dollar prospect. In the small museum environment, which does not have the means for the latest technological advances, this may be a blessing. It will force fundraising to be done the old-fashioned way—face-to-face.

The Case Statement

In any campaign, the case statement is essential and should be carried by the solicitor as he or she visits with the prospect. There will be more on the case statement in a following chapter as we discuss the various steps necessary to manage a successful capital campaign.

Direct Mail

Direct mail is still being used by fundraisers, particularly to solicit memberships and the annual appeal. Direct mail still works but is waning with the advent of the Internet, social media, and electronic communications. Direct mail's major failing is that it usually cannot be personalized. By its nature, it is a generic and general appeal that lacks the warmth of a personal appeal. It has both positive and negative ramifications for the small museum. A personal handwritten note from the director, while wildly uneconomical for the big museum director, is an easier proposition for the small museum director, who can more easily reach out and touch his constituents in a more traditional way.

Telephone Solicitation

Telephone solicitation is still practiced by some colleges and universities using students to contact alumni across the country. For the small museum it can still be effective in raising money for memberships and for the annual appeal. In smaller communities where people still tend to know one another and their families, this intimate connection is essential and often most effective. If you can get an "angel" to pay for the telephone setup in a boiler room situation, you can feed hungry volunteers with pizza and soft drinks and then ask them to spend a few hours calling friends and neighbors to support your museum. Telephone solicitations by selected volunteers who have already contributed are also excellent tactics for wrapping up your annual fund campaign in order to win over those last-minute stragglers who have not yet sent in their checks. For those large donors still outstanding, ask the chairman to make that call. The director should also be involved in the end-of-the-year mop-up of membership or annual appeal stragglers.

The Brochure

When seeking bequests, deferred gifts, or funds for a memorial program, a handsome, tasteful brochure is definitely in order. The printed piece should be dignified and exude gravitas. These types of asks are not to be taken lightly: they should be seriously addressed and, in the case of deferred giving, suggestions should be clearly spelled out that the family lawyer or financial adviser be involved. Brochures are still used in membership and annual appeal campaigns but are truly a costly endeavor for the smaller institution.

The Internet

The Internet is proving to be both a source of information and a means of giving. According to one fundraising firm, "Recent evidence indicates that combining the time tested methods of effective fund raising with advancing technology will allow more organizations to raise more money, more effectively. Today, the use of email and internet sites has evolved to actually become an intimate form of communication and appeal for funds."[2] Within twenty-four hours, the new social networking sites—Facebook, MySpace, and Twitter—were able to raise millions of dollars in relief of the 2010 earthquake in Haiti. Increasingly, prospects are turning to the Internet for information on the potential recipient of their largesse. Having your own website to encourage donations online and to enhance your marketing efforts is becoming essential. The IRS form 990 is now online, and it has become increasingly detailed, offering prospective donors a more intimate, behind-the-scenes picture of most nonprofit agencies. Above all, never use e-mail to solicit a major donor.

Helpful Hint: When seeking corporate, foundation, or major donor support, use reason and logic in your appeals. When cold prospecting for memberships or small annual fund gifts, use emotion!

Know Your Terms

The following are standard accounting terms established by the Financial and Accounting Board, or FASB. They were established by FASB in the

mid 1990s when it consolidated a jumble of terms into the three listed below. FASB's reasoning was that since businesspeople sat on nonprofit boards, these new rules would allow them to better understand the non-profit balance sheets and financials. Quite the opposite happened. Almost immediately, neither board nor management could understand the new rules. Together, they are officially known as "FASB Pronouncement 116." Auditors and accountants refer "fondly" to them as "FASB116." I never refer to them fondly. They are represented here because it is critically important that museums of all stripes understand them and what they represent.

I remember being interviewed for the top development position at a large international nonprofit by the chief executive officer. I was keenly aware of all the different types of funds that could be raised as well as their priorities within any organization. I asked the CEO which funds he needed the most. Was it unrestricted for immediate general operating support, or was it longer range for endowment funded by bequests and de-ferred giving? His answer to me was that he needed money and he didn't care what it was as long as I was bringing in cash. I did not get the job, and I was grateful, because whoever did get the position would have a big job on his or her hands simply educating the CEO on the different strategies and priorities for different types of gifts and funds. And that was years ago. Today, generally accepted accounting practices are more precise.

Museum directors and those fortunate enough to have a development person should familiarize themselves with these terms to understand not only their meanings but also their ramifications for fundraising. Keep in mind that these definitions were established to differentiate between a pledge that could be officially "booked" by the nonprofit and a mere thoughtful intention on the donor's part. Cash contributions with strings are also subject to scrutiny by your auditors and must meet Generally Ac-cepted Accounting Practices (GAAP) standards.

Unrestricted

This usually refers to gifts to general operating support—salaries, heat, light, air-conditioning, and so on. It is not project support, and it is usually a recurring expenditure. An unrestricted gift may be so desig-nated by the donor, by the board of trustees, or by virtue of its type. It is

generally accepted in the fundraising environment that annual fund gifts and memberships (large numbers of small gifts) are always designated as unrestricted.

Temporarily Restricted

Temporary restriction refers to a project with a limited time frame or a once-and-done expenditure. It is a nonrecurring expenditure. It is temporarily restricted until all conditions of use and time have been complied with. For example, a donor gives you $10,000 to purchase an object for your Civil War collection. Once you purchase the object, the funds and their expenditure are transferred to the balance sheet as unrestricted income. According to the most current accounting rules, once the object has entered your collection, it is no longer temporarily restricted. The same rules apply to a three-year grant you received from XYZ Foundation. Once the three-year project is completed, the money restricted for that use is reclassified as unrestricted. This means that you must use the money for the purposes that you and the donor agreed upon originally.

Permanently Restricted

Permanent restriction refers almost always to endowment, where the principal is used to generate interest, dividends, and growth. The interest, dividends, and growth are used for either unrestricted or temporarily restricted purposes. An example might involve a donor who wishes to give you one hundred thousand dollars for your endowment and they want any type of income—interest, dividends, growth—to be used for painting conservation. Here, both principal (the corpus) and any money it generates are restricted. The corpus cannot be used for operating expenses, and its yield can be used only in painting conservation. Another donor might make an unrestricted endowment gift, which on the surface sounds contradictory. The corpus is restricted to the endowment, but its yield can be used for anything. The board or the management may decide how it is to be used. If the management decides, then the use of the yield could change year to year without board approval. Of course, if the board designates the use of the yield, it must be used for that purpose until and unless they change it.

The Financial Accounting Standard Board Pronouncement No. 116, "Accounting for Contributions Received and Contributions Made," covers all entities that receive or make contributions. Some key definitions included in the FASB116 statement are:

- Contributions—An unconditional transfer of cash or other assets to a not-for-profit entity or the settlement or cancellation of its liabilities in a voluntary nonreciprocal transfer by another entity acting other than as an owner.

- Promise to Give ("pledge")—A written or oral agreement to contribute cash or other assets.

- Donor-Imposed Condition—A future or uncertain event whose occurrence or failure to occur can result in the return of the assets transferred to the promisor or the release of the promisor from an obligation to transfer assets.

- Donor-Imposed Restriction—A stipulation and limitation in the use of contributed assets. These restrictions can be limited as to purpose, time, or both.

- Contributions received, including unconditional promises, should be recognized as revenues in the period received. For purposes of the Statement of Financial Position, they should be recorded as increases in assets or decreases in liabilities and as either restricted support or unrestricted revenue:

 - Contributions without donor-imposed restrictions are reported as unrestricted support and increases in unrestricted net assets.

 - Contributions with donor-imposed restrictions are reported as restricted support unless these restrictions are met in the same reporting period.

- Receipts of unconditional promises to give in which the payments are due in future periods generally are reported as restricted support. Generally, receipts of unconditional promises to give cash in the future would be presented as

an increase in temporarily restricted net assets and would be present valued.

- Restricted support should be reported as permanently restricted net assets or temporarily restricted net assets, as appropriate.

- Gifts of long-lived assets received, without stipulations about how long the donated asset must be used, are reported as restricted support if it is an organization's accounting policy to imply a time restriction that expires over the useful life of the donated assets.

- Contributions with donor-imposed conditions are recognized as assets and accounted for as refundable advances until the conditions are met at which time revenue is recognized.

- Contributed services are recognized only if the services received create or enhance nonfinancial assets or require specialized skills, are provided by those individuals possessing those skills, and would have to be purchased if they were not provided by donation.

- Contributions, as a general rule, are measured at the fair value on the date received. For contributed services, the fair value may be determined based upon the fair value of services received or fair value of asset or asset enhancement resulting from the service.

- Unconditional promises to give cash should be measured at the present value of the estimated future cash flows, with subsequent interest accruals recognized as contribution income.

- The expiration for donor-imposed restrictions should be reflected when the stipulated time has elapsed or stipulated purpose has been fulfilled. Such expirations of donor-imposed restrictions are reported as reclassification (between temporally restricted and unrestricted) and are reported separately from other operating transactions.

- Contributions of works or art or collection items may be recognized and capitalized if certain conditions are met.[3]

Additional Terms

These additional terms[4] repeat those listed above and expand further on them. They were intended for the accounting profession to understand FASB116, but they are equally important to directors and fundraisers in order to understand the new environment of the "contract of gift giving." In effect, they go beyond FASB and deal with the theoretical, which often confronts the fundraiser when dealing with a prospect.

Conditional Promise to Give

The conditional promise to give is not recorded or closed as income or asset until a predetermined event comes to pass. The predetermined event may be a "match." The donor is saying, "I will give you $50,000 if you raise an additional $100,000 in the private sector." He or she is not bound to give until a future uncertain event takes place.

Time and Purpose Restrictions (Temporarily Restricted Gifts)

This is a temporarily restricted gift that binds you to spend the money as the donor directs. The donor has said that he will give you one thousand dollars if you begin an educational program that has historical American music as its main component. The donor may or may not place a time restraint on you, such as you must implement the program within two years. This temporarily restricted gift has noncompliance ramifications. It is considered a pledge that may be booked by your accounting office as a gift immediately, but then you must perform or return the money once it is paid.

Income Restrictions (Temporarily or Permanently Restricted Gifts)

Income restrictions on permanently restricted gifts must be clearly spelled out so that both sides clearly understand how the restrictions apply. For example, the donor may restrict the use of the principal, or the income on the principal, or both! Restrictions can be specific, such as you may use the money for any expenditure that is not unrestricted. Or you may use the money only for education programs for fifth graders from district 121, and only on-site—not for outreach. Alternatively, a donor could require you to retain earnings until the fund reaches a certain level,

at which point the income may be used for specific or general organizational purposes.

Contribution Requirements

This category is less binding than income restrictions. Here the donor may require a report from you on how his or her gift was used. The report might recommend future actions, or it might not make any recommendations, merely providing a narrative on how the money was utilized. The failure to follow up with specific outcomes may impair donor relations but probably won't require you to repay the gift. Contribution requirements may come with the contribution without causing a condition or restriction.

Donor Suggestions

Donor suggestions are merely that—"suggestions." These are implicitly optional and do not carry the force of conditions, restrictions, or requirements. For example, a donor may suggest that donated funds be used for conservation work or "another appropriate purpose" as determined by the board. If so, no restriction exists. Here, the final decision is left to the board, and the donation becomes a "board-designated" gift. In other words, the donor has given over the use of the money to the judgment of the board of trustees.

Reliance

If you have ever built a building, you know how important reliance can be. You are counting or "relying" on the gift to finish the building. When a donor makes a pledge, that donor acknowledges and confirms that the nonprofit is relying on and taking action on this commitment. You have the right to sue the donor if he or she does not pay. As a practical matter, that course is not recommended, although some large universities have done so over large gifts. Once a donor makes a payment that isn't subject to conditions or restrictions, the donor has virtually no control over how or when the nonprofit uses the gift.

Intentions to Give

Our mothers used to say that "the road to hell is paved with good intentions." A donor may tell you she is making you a beneficiary of her

will. This is a unilateral statement. Your business office does not record intentions, they are not pledges, and they do not count in your development goals for the year.

Board-Imposed Designations

The difference between this and donor-imposed restrictions is that the board and succeeding boards may change the designations of the original gift. For example, the board may direct management to accumulate unrestricted gifts that it does not need for general operating expenses and direct that the accumulation be used for conservation or exhibitions. Both parties should understand the level of commitment involved in a donation and the nature of restrictions on gifts and on the income that they generate.

The moral of the story is that today the donor calls the shots. The old days of a generous board member covering the museum's year-end deficit are long gone. Today donors are demanding a stricter and complete accounting of their gifts, sometimes with outcomes and an expectation of transforming the institution to which they have just given a portion of their hard-earned wealth. With the increasing donor oversight of their gifts and the growing complexity of the tax laws and audit requirements, fundraising needs—never always of one type—now vary more greatly in difficulty than ever before. As a result, not only does the savvy fundraiser need to know his terms as above, he has to completely understand the needs as well. He must avoid the pitfalls each type of funding presents. One of the most commonly misunderstood types of funds is endowment. Many supposedly well-informed board members I have known over the years believed that raising money for buildings is as easy as or similar to raising money for projects, as it is for endowment. Each has its own peculiarities and characteristics. And the good fundraiser knows the differences; when you don't, turn to legal and accounting professionals who do know.

What happens if you violate or change the use of the funds received with restrictions? Can the donor sue you if he/she is unsatisfied? According to John H. Wade, writing in CASE's *Currents*—not really. You could use the funds in other areas and not be subject to legal action. But ethical considerations should outweigh all issues in this case. In dealing with this issue, courts have fallen back on the doctrine of *cy pres*, which is French for "as close as possible." As long as you use the gift within your mission and you are true to your mission, you will probably be within the letter if not

the spirit of the law. Under this doctrine, "a court can validate an alternate use for a contribution if its original intended use no longer exists or the alternate use complements the donor's intensions." As one development officer remarked, donors cannot be allowed to "dictate our mission, but we must always be sensitive to their wishes. When the institution accommodates a donor's intent, everyone benefits. It's a matter of building trust."[5]

If you don't believe the donor really calls the shots these days and you are on the line to defend the museum's mission and vision, you must read these two case studies from author Harvey McKinnon's book entitled *The 11 Questions Every Donor Asks and the Answers All Donors Crave*. He writes about two classic cases of donor desires and the need to control the use of their gifts. His quotation on donors is reprinted below as a preface to the two tales of donor relations.

> Parents know they don't have a lot of control. . . . When your infant demands a feeding at two in the morning. When your teen listens to gangster rap despite your distaste. When your cum laude angel gets engaged to a ne'er-do-well. You can quickly start to feel powerless. But you can still hope to have "influence." And that's what many donors want and deserve . . . as long as it stops there.

A fundraiser in the West was delighted when a young rich Silicon Valley entrepreneur wanted to give a substantial gift to the organization where the fundraiser worked. Unfortunately, the gift came with strings. Not unheard of, the man wanted a seat on the board for his gift. He also wanted to change the institution's mission. By calling himself a "venture philanthropist," he could rewrite the rules. This was no different from any other venture capital deal where the investor was able to call the shots. If it worked in the world of Wall Street, why not on Main Street with a nonprofit organization? In this case, the would-be donor wanted more than control over his gift. He wanted control of the organization. The fundraiser politely refused.

In a second case, another fundraiser was confronted by a donor who wanted to give money for something that wasn't needed. McKinnon's friend "Daryl" was presented with the following dilemma.

> Freddie Mercury, the lead singer of Queen, died in 1991 from AIDS. At the time, Daryl was head of fundraising for the Terrence Higgins

Trust, one of the largest HIV/AIDS charities in the world. The manager of Queen called and asked Daryl for a meeting. The band wanted to release "Bohemian Rhapsody" and direct all royalties and profits to the Terrance Higgins Trust, so long as the money would build the "Freddie Mercury HIV/AIDS Ward" in a hospital. Daryl's dilemma was that the UK didn't need such a ward. By then, anti-retroviral drugs had been introduced, improving the health and life expectancy of those with HIV and leading to an oversupply of beds. Plus, the medical profession was no longer isolating HIV/AIDS patients in hospitals. What were Daryl's choices? He could take the money, with the perk of singing backup at the tribute concert. Or he could use his skills to negotiate a different arrangement (a better choice, since he can't carry a tune). After two meetings, and long hours of negotiation, Daryl finally persuaded Queen, its management team, and their record company to accept his view—they should use the money to advocate for those with HIV/AIDS and to launch a campaign to prevent its transmission. The parties ceded control because Daryl listened to them, understood their viewpoint, and showed them how the funds could have greater impact. "Bohemian Rhapsody" went straight to number one in the UK and many places worldwide. The record raised a total of $10 million.

And so McKinnon asks, "What has changed? Why is it that donors want more control these days?" He concludes that donors are fearful today that you will not spend their money wisely. The author cites the decline of trust in our society, in our institutions and authorities. He includes nonprofits. But he also blames the media. He surmises that we probably have fewer cases of outright fraud and misconduct today than we did a hundred years ago, but "the occasional scandal, given great airplay (a good thing, actually), does periodically undermine trust in the charitable sector," he writes.

The second reason donors want to be more involved is nothing more than a yearning for human contact, he writes. "Think of the ways we increasingly isolate ourselves," McKinnon says. "For instance, why meet with someone or call a friend when you can catch up by email? A donor saying, 'I want to see how you put my gift to work' may not be interested in heavy-handed control at all. Rather, he may simply want to see the child who will get a new wheelchair. Or he may want to meet the refugees learning English in a class he helped to make possible. That strengthens the emotional link, and the feeling that he's helped change lives."

According to McKinnon, this is a fundraising opportunity. "What answer can you give when a major donor asks: what influence will I have over my gift?" he asks. "You may have one answer. Your boss or board may have another, or even offer a variety of conflicting answers. That won't inspire confidence. Clarifying in advance, and in writing, what 'control' you're willing to give donors will mean that when a wealthy young entrepreneur, a world-famous rock band, or any other donor offers you a gift with strings, you'll be able to take advantage of the opportunity without trading away your organization's soul. Or your own."[6]

Now consider this story from Los Angeles of a very strong and demanding donor and the museum in which he has invested his time and treasure. It is the story of Eli Broad, a self-made entrepreneur from Detroit who has made millions that have provided him the means to collect art and become a cultural and philanthropic force in Los Angeles.

Every American city has its power brokers, but only Los Angeles has an Eli Broad. "Mr. Broad dominates the arts there with a force that has no parallel in any major city," the *New York Times'* Jennifer Steinhauer writes. She insists that "Los Angeles would literally not look the same had Mr. Broad not chosen it as his home 40 years ago." He applied his business-focused method of managing his giving, which earned him a reputation as both a "genius and a despot."

In a move not unheard of in the art world, Mr. Broad dictated his choice for a museum director for the Museum of Contemporary Art, which he recently favored with a "bailout" gift of thirty million dollars, increasing "his grip on the city and its arts" as never before.

Broad, a billionaire philanthropist whose beneficence comes not just with "strings but with ropes that could moor an ocean liner, is known to pull his support, resign from a board or, in some cases, decline to fulfill his financial promises when a project comes together in a way he does not like." "For me there has been no downside," said Roland G. Fryer, Jr., an economics professor at Harvard who has collaborated with Mr. Broad on education projects and who Mr. Broad, in typical fashion, hunted down one Christmas Eve in Austria, where he was on vacation, to discuss their work. "But I think if you're not on your game, Eli will crush you."

Broad is a founder of two Fortune 500 companies. He has reached into all aspects of life in Los Angeles—the arts, the sciences, and the civic

areas. With his $2.5 billion foundation he has supported the University of Southern California and UCLA. He chaired fundraising for the Walt Disney Concert Hall. His vast personal art collection is available for loan and another nucleus of a new museum. He was the founding chairman of the Museum of Contemporary Art in 1979. He is demanding. "If we start with a game plan, I want to make sure it happens," he said. "At age 76 I don't want to feel frustrated."

"Eli is not the problem," said Ann Philbin, the director of the Hammer Museum, who sparred with Mr. Broad when he sat on and eventually resigned from that museum's board. "The problem is that we don't have enough Elis in Los Angeles to balance out his generosity and the power of his influence." His impact, however, can be stormy, as with his recent showdown with the Los Angeles County Museum of Art.

Author Steinhauer continues the Broad saga:

> In 2003 Mr. Broad pledged $50 million for a much-needed new building to hold contemporary art. He personally lobbied the Italian architect Renzo Piano to design it, and it was universally inferred that Mr. Broad and his wife, Edythe, would donate much of their extensive personal collection for the walls of the new building. But just before the new wing opened in 2008, Mr. Broad said he would keep the 2,000-plus works in his collection and instead loan hundreds of them to the museum. Soon the new wing became home to various shows and other works of art, in addition to the Broad pieces, enraging Mr. Broad. As a result, several board members said, he did not pay the balance of his pledged gift of roughly $6 million. "He owes us a fortune," said Lynda Resnick, a board member. "There was a period he wouldn't speak to me for a year and a half" over the dispute.
>
> The ensuing debate centered on whether the museum or Mr. Broad had honored their commitments. Mediation and arbitration were suggested to no avail. As Ms. Resnick said: "When Eli gives, it is like negotiating a business deal. It is not altruistic. It is not blind charity. And there is a difference between being generous and being charitable. But it doesn't matter in the end because the good was still done."

Broad's measurement of success means that "museums should see attendance rise and giving increase by board members. Schools should see test scores go up. In his estimation, 'if we're not getting results why should we spend all that money?'"

His focus on minute details also makes museum leaders and others chafe; it is much like taking money from your rich parents who then tell you what car to buy and where your kids ought to go to school. As the new building that would bear his name at the Los Angeles County Museum of Art was under construction, dust flying, paintings carefully readied, staff put into place, Mr. Broad was deeply concerned about what would be done about the weather stripping. "He also wondered where the temperature readings would be on the wall,' said Michael Govan, the museum's director."

Author Steinhauer concludes with a quote from Jane Nathanson, a longtime trustee of the Museum of Contemporary Art, "'Eli does nothing without strings, but I happen to think you need strings. I think there is a new type of philanthropist now. With old-family wealth, people gave money because it was the chic thing to do. New wealth is earned, and if you can get it, there is going to be a great deal of control.'"[7]

The above could happen to any organization, large or small. I have firsthand knowledge of a small museum that was controlled by three or four interlocking families. They sat on the board perpetually, they instituted lifetime memberships at one hundred dollars, others gave when the families gave, and didn't give when the family didn't. The first professional director lasted two years, the second one twenty-seven months. Only in the past ten years has the museum found its place in the wider community. Unfortunately for our profession, this is not an isolated case but a fairly common occurrence, particularly among smaller institutions. But as the Los Angeles example shows, no organization is immune from the outsized influence of the few. Fundraising consultants are always calling for organizations to "broaden their base." This is one overriding reason to do so.

And if you don't think that you need to understand the differences in all these types of funds and terms, consider this news item from Los Angeles as a follow-up to the Eli Broad story. The headline in the *New York Times* Arts Beat blared: "Los Angeles Museum Board Members Ordered to Undergo Financial Training." It seems that when the Museum of Contemporary Art lost thirty million dollars in its endowment over several years and ended up with only five million dollars on hand, it began using what was left in the endowment to pay general operating expenses and, in doing so, broke California state law. The state's attorney general

ordered the museum's trustees to "undergo special fiduciary training" to remedy the situation.[8]

General Operating Support

Right behind endowment, raising money for general operating support is the most difficult, but it is the lifeline of every nonprofit operating today. It must be addressed every year, every month, every day. General operating support is best raised with an annual fund, membership, and special events. All three will be discussed below. Suffice it to say that each of these has its own special characteristics and must be mastered with different skills and techniques. Special events can bring in much-needed operating cash if they are run efficiently. At the Atlanta History Center, the annual Swan Ball has been around for twenty-five years and has taken that long to build into a signature event that raises a half-million dollars net each year.

Sociologist Peter Frumkin, author of *Strategic Giving*, says that people operate under two "master theories of giving." The first theory is "direct service to individuals and the other is change through advocacy and public education." The difficult times we are experiencing in the beginning of the second decade of this century prompt donors to "gravitate toward direct service because they want something concrete from their giving." From his description he would probably place museums in the second category—public education and advocacy. Direct service is "like buying bonds, and advocacy like growth stocks, and so in tough times donors rebalance their giving portfolios into safer investments."[9]

Project Support

Money raised from corporations, foundations, and occasionally individuals will almost always fund specific projects. Corporations tend to fund exhibitions that promote them and their products. Foundations lean more heavily toward education programs, research, and more scholarly endeavors. Occasionally, individuals with a large capital base will fund a pet project. This route is acceptable if it does not violate your mission. The Atlanta Historical Society noticed that although our loyal donors stood with us when the economy soured, most of the large corporations and foundations turned away from us and toward the

social services agencies where the pain was the greatest—"direct service to individuals."

Capital Campaigns

Most companies, foundations, and individuals respond well to capital campaigns in good times. There is an old saying in the field that there is no good time or no bad time to raise money. During the "Great Recession" of 2008–2010, many nonprofits closed down or temporarily suspended their capital campaigns in recognition of the extreme nature of the downturn and its effect on the wealthy. In a more "normal" time, major foundations, corporations, and individuals expect the nonprofits in their community to mount campaigns for capital needs. As a result of the economic downturn, a pent-up demand for capital improvements, once the economy improved, caused a rush on foundations and other donors at once.

One major company in Atlanta has generously supported the cultural community almost since its inception. They do not give to capital campaigns but prefer to support one of an institution's signature programs during its capital campaign. In effect, they want to be part of a capital campaign but not give to it directly. This works for the nonprofit because then they can return in a year for more support for another project, whereas a foundation making a three-year commitment will not entertain another round of requests until the current commitment is satisfied. The moral of this story is elaborated elsewhere—and that is talk to the potential donor but also listen, listen, listen![10]

Fundraising in bad times is a lot easier when you have the proper tools in place, the right volunteers, the correct message, and a solid history of good relations with your donors. At the Atlanta History Center, we concentrated on our top donors as the economy began to slide. We wrote to all of our donors to tell them the steps we were taking to ensure sustainability during the dark times and viability in the good times when they returned. Our purpose was to tell them that we understood the issues and we were being active, not passive, in dealing with them. What follows is a copy of that letter, for which, anecdotally, we received high marks from our major donors and supporters.

January 7, 2009

Dear Member of the Atlanta History Center:

We begin 2009 at the Atlanta History Center buoyed by an array of achievements and the promise of very strong programs in the years ahead. But at the same time we are facing the same financial challenges that virtually every business, institution and individual is experiencing today.

We are very grateful for your generous support as a donor/member at History Center campus or Buckhead campus and regard you as an important investor in this institution. For that reason, I want to share with you our plans for navigating through these times and our commitment to remaining Atlanta's premier resource for local and national history.

The past three years at the History Center have been notable for a series of winning exhibitions, popular and diverse public programming, and a dramatic increase in attendance. In just two years, our visitation has expanded to almost a quarter of a million people at our campuses in Buckhead and at the Margaret Mitchell House in Midtown. Sixty thousand school children throughout the metropolitan area now participate each year in museum tours or outreach programs in their schools. Thousands of families enjoy our festivals and home school days. Countless more people, including teachers across the state, use our online curriculum and research resources.

Even with all this success, the economic downturn has resulted in a 30% decrease in the History Center's endowment, with a significant negative impact on our annual operating budget. In addition, other revenue sources have been affected as our patrons make spending cuts. Facing a severe shortfall in funds available for our operations—$1.4 million over the next 18 months—the History Center has moved this week to consolidate some operations and activities at both our Buckhead and Midtown sites. In a museum, the biggest costs are staffing, utilities and maintenance. Fifteen positions have been eliminated, and the remaining 59 staff members will see temporary cuts to their benefits. New energy conservation practices are being researched and implemented. We have cancelled the Lee-Grant exhibition planned for next November, suspended our retirement contributions to staff for 18 months, renegotiated our service contracts, suspended staff leave benefits, and negotiated a lower medical insurance policy on remaining staff. Contrary to news reports, the Margaret Mitchell House remains operational with tours

still being conducted and programs being produced with a combination of part time staff, contract staff, volunteers and members of our staff here at the Buckhead Campus. We have every intention of fulfilling our obligations to our donors and our programming promises to our public.

Though these decisions are never easy, they have been made based on thorough research, followed by consultation with and approval by committees of our Board of Trustees. These changes are necessary for the long-term strength of the Atlanta History Center.

As a donor/member, you are entitled to know that in these difficult economic times, we take very seriously our responsibility to act as dependable stewards of the History Center's archives, museum collections, historic houses, historic gardens, and other resources placed in the institution's care. We want you to know that your investment in the Atlanta History Center will continue to provide important support as we move through the year.

We remain fully committed to our mission and to our service to the community, and we will continue to present the excellent programs, exhibitions and services that you have come to expect from us.

On behalf of our board of trustees and staff, it is my pleasure to thank you for your ongoing support. We all hope you will continue to take advantage of the many lectures, public events, and exhibitions presented by the Atlanta History Center at both our Buckhead and Margaret Mitchell House sites. If you have any questions, I hope you will contact _____, our vice president for development at xxx.yyy.zzzz.

Sincerely,

One writer, David Johnston, suggested that in tough times, donors should consider three techniques if they have the capacity to give. They are conversion, deferral, and triage. He suggests that if a donor is making payments to an endowment the donor might suggest that some of that money go to operations instead. Conversely, a savvy fundraiser in the museum ought to suggest that much earlier to a donor. Johnston restates the obvious: "Endowments are intended to build long-term stability, but without money now an organization . . . could be forced to curtail operations sharply or to close."

Johnston further explains deferral as keeping the gift or pledge intact but extending a three-year pledge to five years. Triage, the most severe option, requires "separating out charities that will not survive without your

support, and trying to assess whether they are worth saving. Letting some nonprofits go out of business troubles many donors, yet it clears out duplication and inefficiency, as well as organizations whose time has passed."[11]

Author and fundraiser Joanne Fritz, writing on website About.com, reiterates eight important rules of thumb you need to consider in tough fundraising environments. Her suggestions are good common sense, and I paraphrase them here. They are: (1) Don't lessen your fundraising efforts; (2) tell your donors that you need them more than ever; (3) if you don't already do this, use heartwarming human stories that will emotionally engage your donors; (4) remain in touch with former donors; (5) do prospect research in industries that are thriving; (6) and (7) cut your fundraising costs strategically; and finally (8) look at projects that you had pushed to the back burner.

Taking a look at each one individually, the first line items many museums cut in bad times—no matter what their size—is their meager marketing budget and their fundraising allotment. Both of these actions seem reasonable to most board members and administrators because they are reacting against any suggestions that cuts in programs would be devastating. They fail to recognize that no one will come to those fully funded programs if they don't know about them. The same holds true of fundraising. Just as important is the need for your fundraising effort to tell the donors the truth. You need them now more than ever—which is Fritz's second point.

Donors will claim that they have been hurt by the downturn, but you as a nonprofit museum continue to rely on their help. Show them that you have taken responsible steps to ensure the viability of the museum but that they still hold a critical role in keeping your brand in front of the community.

Fritz's third point should be one you use in good times and bad. Always look for the heartwarming story of the child who found your museum a treasure house of opportunities and wonder. "Find the stories that will touch the hearts of your donors," Fritz argues. Make the connection between people—those served and those who support your institution.

Staying in touch with former donors, Fritz's fourth point, should be practiced—again, in good and bad times. "It is much better to keep in touch with lapsed donors. Keeping up communications will help those donors to resume giving when they can, once again, afford it. They will

feel close to those nonprofits with which they have an unbroken relation-
ship," she writes.

Perhaps the most intriguing advice Fritz provides is that there are
diamonds in the rough in a bad economy. She maintains that you can still
dig out those companies that are not only viable but thriving. Her advice
is to keep up with the business press to ferret out those companies doing
well. Here in Atlanta we thoroughly read the *Atlanta Business Chronicle.*

Cutting costs strategically and sensibly will go a long way in any econ-
omy. Is your mailing house open to discounts? Are other vendors willing
to consider price reductions in their services? Are some willing to donate
certain costs? If your big fundraiser is looming and you are concerned
about the bottom line, will the caterer donate a portion of his costs, will
the liquor distributor give you a price break, will the parking valet donate
his services—all to have access to your major donors? As Fritz states: "In
tough times, it can be just as important to cut costs as to raise revenue.
But don't cut costs in a way that will impair your organization's long-term
health or ability to achieve its core mission. Take a look at what is working
well and what isn't; what is essential to the mission and what isn't. Cut the
extraneous, the unfocused, and the inefficient."

And finally, reexamine those projects that were put aside in good
economic times in favor of more popular fundraising objects. When
the economy went sour at the end of 2008, the Atlanta History Center
delayed its capital campaign slated for twenty million dollars and concen-
trated on smaller grants and projects. During that time we were able to
secure a local foundation grant for nearly nine hundred thousand dollars
to support a project that had been on hold for years. As a result, we are
now able to reinterpret our thirty-three-acre site and our historic houses
and tie them all together with the exhibits and historical objects in the
museum. As Fritz counsels: "Don't worry about changing course. Let your
donors know, and explain why. If your reasoning is good and heartfelt,
your donors will come along with you. You will not only do more good,
but keep donors engaged until better times come along."[12]

In Summary

The awful reality of the recent "Great Recession" is that many nonprofits
are reacting too slowly to the new reality. Many are continuing to go about

their "old" and comfortable ways. "According to the Foundation Center, 67 percent of 568 foundations said the nonprofit groups that survive the recession will be stronger than before—a sentiment echoed by charities." Newer creative thinking along newer business models need to be pursued. At one time in the late 1960s and early 1970s, it was unheard of that a museum would buy paid advertisements for its programs. Marketing was a new idea. The gap between profits and nonprofits has shrunk considerably and will continue to do so. In recent months, news reports have resurfaced that cash-strapped municipal and state governments, in their search for more income, are once again looking at old ways—property and sales taxes—to increase revenue.[13]

In the end, remember that you will never be successful in your fundraising if you don't have a plan, if you don't have a goal, and if you never ask for the order. You must also make the major gift requests in person—never on the phone, by fax, by e-mail, or by snail mail. Ensure that you and your donor understand the conditions of the gift. Also, as a small museum, in these tough times concentrate on your membership and annual appeal campaigns. Ensure that these bases remain stable. They are your bread and butter for keeping the lights on, the AC running, and the payroll going to your staff every pay period.

MEMBERSHIP, ANNUAL
APPEAL, AND SPECIAL EVENTS

Americans of all ages, all stations of life, and all types of disposition are forever forming associations. . . . In democratic countries knowledge of how to combine is the mother of all other forms of knowledge; on its progress depends that of all the others.

—Alexis de Tocqueville

I n the beginning, memberships in museums were a way of obtaining unrestricted money for the museum's operation. Membership meant coming to annual meetings and voting on the new members of the board and retaining the older ones who never seemed to retire. Membership meant Jeffersonian democracy at its finest. Members could and often did present alternate slates of officers or board members if they did not like the slate presented by the board's nominating committee. Board members did not have term limits and could serve forever. On the other hand, if members did not like the way the museum was being run, they could and indeed did "throw the bums out." Membership no longer carries the weight it once did with the board of trustees. Trustees now have term limits and remain self-perpetuating. They are still required under most state laws to have an annual meeting of their body, have an annual report, prepare an annual accounting of the organization's financial affairs, elect officers, and appoint committee chairs. Members no longer have a voice in the board's makeup or its yearly activities.

Today, membership is in a confused state. For the past three decades, the IRS could not decide whether it was tax deductible or not and then gave in with the rationalization that it was "de minimus"—not really important. Then Congress decided that for all "memberships" over $250, charities were obligated to provide written documentation that indicates whether the donor received a benefit. Charities are required by law to provide documentation for gifts over $75 if the gift provided a meal or a token gift to the donor. The Atlanta Historical Society uses the following disclaimers.

A. Disclaimer for the receipt of a contribution whereby goods and services of fair market value were not provided to the donor:
 The Atlanta Historical Society, Inc. did not provide any goods or services of fair market value to you in consideration of this gift. Therefore, in accordance with IRS guidelines, your contribution is fully tax deductible. Please make this notification a part of your tax records.

B. Disclaimer for the receipt of a contribution whereby goods and services of fair market value were provided to the donor:
 As required by IRS guidelines, the estimated value of goods and services provided to you in exchange for your gift is $$$. Please make this notification a part of your tax records.
 OR
 As required by IRS guidelines, the tax deductible portion of your gift is $$$. Please make this notification a part of your tax records.

Museums as a whole really do not have a uniform method of defining what a membership is and how it differs from an out-and-out donation. Some museums that I have surveyed have seventeen levels or categories of "membership." Some cut it off at around one hundred dollars but then give "complimentary" memberships to donors who give over a certain amount. Also, who decides what a complimentary membership is and who is eligible to receive it? In that case, look to the museum's constitution and bylaws. If either calls for the organization to be a membership institution, then it is the board's decision to decide whether or not the trustees wish to give away memberships. Some may decide that membership is a "cash cow" and tighten the rules on whom and how many, if any, are issued. Others may insist that every donor, at any level, should get a membership.

To further muddy the picture, what is a "complimentary" membership anyway? What does it mean? If I give you a ten-thousand-dollar gift for sponsorship of a particular program, am I entitled to the same benefits of the fifty-dollar member? Do I get a membership card, or do you communicate with me in a "different way" that I have the same benefits of a lower-level member? Take this scenario further into reality. Suppose my extremely generous gift of ten thousand dollars to you is acknowledged in your very kind letter of thanks, which also includes a sentence that says I have free admission for the next year. I decide to bring my visiting relatives to the museum, expecting free admission. I am challenged at the front door because I have not been issued a membership card and have misplaced your kind letter. I am now a ten-thousand-dollar donor with egg on my face in your front lobby. It is a Sunday, and your membership person is home with his family. The person at the front door will not let me pass. As the front-door personnel are sorting out my situation, a fifty-dollar-paying, card-carrying member shows up behind me and is waved on into the museum. Here we have the ludicrous situation of a major donor being denied admission and a fifty-dollar member being admitted with her card. The situation boils down to a matter of communication with donors to your annual fund and to members. It is your responsibility to ensure that the benefits attendant to each level of membership/annual fund is clearly delineated. If it requires that a major donor also receive a membership card, then do it. It really doesn't matter whether you call it a "complimentary" membership or not. In fact, handing a major donor a "complimentary" membership card after such a generous donation is demeaning.

In larger institutions, membership is increasingly viewed as an economic proposition—particularly those that charge admission. In smaller institutions it can be seen as a donation and the "charitable" thing to do. It is also "time or age specific." By that I mean it represents different things to different people at different stages in their life. Young families, for example, often choose between the zoo, the aquarium, the children's museum, the science museum, or the history museum. The art museum appeals to an older, childless crowd—childless meaning empty nesters, singles, or couples without children. History museums appeal to older, upper-income demographics first and

then to families with young children, provided that there is much for them to do. Older members view their membership as "an investment" in a history museum that is carrying on a tradition of preservation and conservation of objects, archives, and valuable early ephemera. Newer members, especially families, are looking for an "economic and economical" exchange for an "experience."

Membership programs in American museums are a sticky morass that defies easy characterization.

Atlanta Historical Society family memberships skyrocketed with the Ben Franklin exhibition. We welcomed more than a thousand new members. They were drawn to the exhibition's "gee whiz" interactive technology. And not all of it was electronic wizardry—some of the hands-on interactive exhibits were definitely "low tech." Remarkably, these same families did not renew when we hosted the Jim Henson "Muppets" exhibit. Determining the reason for this seemingly disconnected behavior is a challenge for our development and membership and marketing and communications staff. In a small museum setting, ascertaining why a certain audience does not return for a similar experience requires either an outside consultant or a valuable staff member to interview those people. It is critical to understand your membership effort if your member numbers fluctuate wildly every year when you are relying on your budget-making process to ensure a stable cash flow.

Maslow's Hierarchy of Needs

Membership can be divided into three interconnected elements: sales, service, and fulfillment. They are all bound together in your "plan." You must approach your membership program as you do every other aspect of the museum, whether you are a four-person shop or smaller. Before you embark on a brand-new membership program, start a revised membership program, or are planning that year's membership campaign, you must have a plan of action that includes these three elements. They cannot be thought of separately or in a silo. They have to be planned in regard to each element. For example, before you begin "sales" you must determine how you will "service" the "product" you call membership and how you will "fulfill" the promises embedded in that sales proposition. Although we must speak of them separately, they cannot be planned separately.

Maslow's Hierarchy of Needs was promulgated in the mid-twentieth century. Critics are not convinced that there is indeed a hierarchy at all. My point in using this chart is to show that in times of stress and uncertainty, people will always concentrate on the lowest level of this pyramid and let the upper levels languish. People concentrated on their survival will not be inclined to join or donate money to a cause, no matter how important. They may consider and then reject your offer of membership if they must meet that month's mortgage payment or a medical bill.

Sales

Sales may be defined as getting people to join your organization. You begin by gathering names. The first names you should consider are as close to your organization as you can imagine. For example, are all of your trustees members? Are all of your docents members? Have the people who visit and use your services been asked to become members? These three groups of people should be your first line of inquiry as you build a membership base.

If you are just starting a membership program, you must think through several important issues that will affect the program's effectiveness. In no particular order, you must determine *who* you are going to ask, *how* you are going to ask, and *when* you are going to ask. Each of these elements requires board and staff input. Whatever you choose, know that your biggest challenge is to get through all of the static provided by today's overload of information via television, the Internet, and all of the social media. Using them to your advantage means if you cannot beat them, join them.

Once you have decided who to ask, you must make the determination *when* to ask for money. Should you ask once a year, twice a year, four times a year? Asking often during the year has been known to produce wonderful results; in other cases it has caused outrage among those being solicited. Only you can determine what your community and your constituency will tolerate.

A wave of donor fatigue is sweeping over the land at this writing. And partly related to this, from 2000 to 2004, the number of nonprofits increased 23 percent, and giving by individuals decreased slightly. According to a study done in 2006 by the direct-mail firm Craver, Matthews, Smith and Company in Alexandria, Virginia, "the critical bonding window for the first-time donor is within one to three months of the initial gift." All of these factors have placed a continuous and added burden on the fundraiser looking for annual appeal or membership dollars.[1]

You must also determine *how* you are going to ask. Will you use direct mail, phone solicitation, face-to-face, or a combination of all? Again, that depends on your particular position and situation in your community. One woman reported that she was tired of giving small amounts of money to a large organization because she felt that her money was being used to send her more pamphlets and brochures asking her for more money.

The dichotomy comes over how donors and nonprofit organizations see themselves. Your job as a fundraiser is to establish a relationship with a prospect, turn him or her into a donor or member, and keep him or her as close to your corporate bosom as possible. The donor, especially the smaller donor/member, sees the relationship as a "one-night stand." Once again, a community standard is your best guide in these circumstances.[2]

Direct Mail

Mail still works to a degree. The post office is no longer the fundraiser's friend since they began raising every conceivable cost. You have undoubtedly seen it in your own home. Today we receive fewer and fewer "cold" mass mailings. But lists are still available for every imaginable demographic. You can buy (rent) lists of any group imaginable. They represent segmented demographics down to zip codes and neighborhoods. You can buy/rent the names of subscribers to *Antiques Magazine* and similar publications. You should buy/rent from a reputable broker. The old para-

digm is to purchase a small sample, usually five thousand names for a test mailing. A 1 percent (fifty) positive return is still considered a good result. If you attain that level of success, then you have the option of buying a larger quantity of names, say 250,000 with the same demographic profile. Again, a 1 percent return of 2,500 new members is remarkable. The challenge for the small museum is having the "venture capital" on hand to rent/buy these lists. A simple and more labor intensive and less expensive way to gather names in your community is to organize a half-day meeting of dedicated volunteers to pore over names familiar to them in your community and send them invitations to join the museum. These names can be assembled from lists of former members, lists of service clubs in the area, and lists of members of other cultural and membership organizations. Do you have local book clubs, collector clubs, and cultural clubs with membership names? All are fair game for your membership rolls.

Premiums

Premiums have outlived their usefulness and smack of an earlier time in fundraising, although public broadcasting stations still use them to a certain degree of effectiveness. Eric Johnson of ParadyszMatera, a direct-mail company in New York, says that tests and studies have shown that people respond positively to premiums and that solicitations with them bring in more donations than without them. Personally, I have never been moved to donate to an organization with the lure of a "trinket" or "tchotchke." As a result, I would not recommend them. Put yourself in the place of a sophisticated donor. How many tote bags (mugs) can you own? Beside that, donors are more savvy today than ever before, and they resent that their donations are being used on trinkets. Additionally, there is little or no science behind offering them. For most, it is nothing but trial and error.[3]

From the fundraiser's point of view, you have to be prepared to repeat the offer every year if you want to keep your constituency in tow. As a result, you must then be prepared to escalate the value or the perception of value each and every year. And remember that premiums cost money, which results in a lower income from the annual fund/membership program. If you insist on using them, be sure to factor their cost into your budget for solicitation of members.

And last, think through the ideas thoroughly. An art museum in New York once decided to offer a premium (an exhibition catalog) to all its new members in membership categories *above* thirty-five dollars. They forgot that they also offered to anyone a spousal membership for an additional five dollars. So savvy new members bought below the threshold—thirty-five dollars—and added the extra five dollars in order to have the catalog. The museum honored its word and in a successful attempt to make lemonade out of a lemon, they got many members to upgrade, probably out of guilt.[4]

Membership Drives

Should you or should you not do membership drives? The answer is that it depends on your size and the community in which you operate. Drives are a good idea if you are a small history museum in a small, tight-knit community. It means a solid staff and volunteer push once a year. It means getting out and meeting your constituency, and it has an impact on your cash flow. A large sum of money into your coffers in December is wonderful if you have the discipline to apportion it appropriately through-out the year. It is far better to have a rolling enrollment during your fiscal year because it evens out cash flow, smoothing your operational needs every month. Of course, a rolling enrollment is labor intensive, requiring greater "service" of the membership than a yearly drive.

Memorial Programs

A memorial program is neither membership- nor annual appeal–based. But it does share one aspect in common with those two—small gifts/donations. Every museum, no matter what size, should have a memorial program in place with attendant policies to handle such gifts. For example, will the gifts, usually in the twenty-five- through one-hundred dollar-range, go into the operating fund? Will they be used for a special memorial plaque or other designation within the museum? Will the money instead go into endowment? And how much input should the family have? When one of the leading founders of the Atlanta Historical Society died recently, the family chose a special project in her area of in-terest on our grounds and in our gardens to remember her, and the money that we received in her name was spent on that purpose. Advertising a memorial program to your membership may strike some as unseemly, but

a small notice in every newsletter or tasteful communication alerts every-one of the opportunities to remember loved ones and help the museum. Memorial programs share a stronger kinship with history museums and their missions than with any other type of museum.

Donor Clubs

I briefly touched on special interest groups in an earlier chapter. The establishment of a donor club is a related but slightly different proposition. It is still probably a good idea that has not lost its appeal. I am referring to high-end gift/membership categories that are excellent vehicles not only for recognition (saying thank you) but also good for cultivation purposes. At the Smithsonian there is the James Smithson Society—a club that honors donors of $2,500 per year; Colonial Williamsburg recognizes an-nual donors who give five thousand dollars through the Raleigh Tavern Society. But you do not need to be one of these big outdoor museums with millions of dollars. At the Columbia Museum of Art (South Caro-lina) we began the Taylor Society, named after the family who built the house the museum occupied. It was a name well recognized in the com-munity. We began modestly, with entrance at five-hundred-dollar annual gifts for unrestricted support. Later, it caught on so well that members wanted to raise the recognition to a thousand dollars. The major perk was an annual dinner with a featured speaker. During the year, members were treated to Taylor Society previews to exhibitions and other programs.

When setting up such a program, remember to start with the highest donors, and don't give away the store. If you use year-end mementos or gifts, keep them tasteful, and don't spend more on them than each donor gives. When naming the new donor club, allow for new levels above or be-low the original starting point, make it annual, and do not allow lifetime memberships. Make your club or clubs exclusive and distinctive, but don't set up obstacles to membership. Encourage members to bring guests, but don't open the floodgates.[5]

Lifetime Members

If you have a lifetime membership program, discontinue it at once. It is an old concept and a very bad idea that started in the 1970s—in some areas of the country even earlier. It usually gave the keys to the kingdom

to anyone who became a life member for the princely sum of one hundred dollars. It also flourished in the period when membership conveyed voting privileges at the annual meeting—a condition that no longer exists.

I continue to be surprised by the resilience of such a bad idea as I occasionally run across it in small museums in smaller communities. The notion is that for one payment, no more, no less, an individual could partake of the museum or the historical society for so little until they passed into history themselves. Inflation of the 1970s disabused the more savvy institutions who had established lifetime memberships. From the members' perspective it was a deal too good to pass up. Those who were told and believed that they had a "contract" with the museum reveled in the notion that they would never be asked for additional gifts ever again! Museums loved the initial flush of cash and then were seriously hampered and poorer when the market of potential new members played out.

Levels of Membership

What membership levels are best and will work for you? If you do not now have a membership program and you must have one, the best advice for the small museum on the levels of membership is the acronym KISS—Keep It Simple and Specific. For the small historical museum, I would advocate no more than three categories: (1) student-senior; (2) individual; (3) family/couple.

Too often, membership levels are prepared by well-intentioned people inside the museum with no relation to what the market will bear and how much to charge. In a 1991 article entitled "Misconceptions Held by Museum Professionals" in *Visitor Behavior*, evaluator Marilyn G. Hood pointed out that one major misconception is, "In a museum that doesn't charge admission, devoted visitors will be so loyal they will want to become members." Most small museums don't charge admission, so her response was refreshing. "If they're getting all they want from their present participation," she continues, "and they don't value what is in the membership package, they have no reason to join. Since membership packages are assembled on the basis of what the museum wants to offer, rather than from what the member wants to purchase, there often is little incentive to join."[6]

Three points about the levels of memberships: They must bear some relation to cost. In an example of losing sight of the cost of a membership program, there is a case of a group of individuals who had been members

of a special membership category, let's call it "Young Historians." The group was formed in the early 1970s as a young professionals' membership category. It had been largely ignored by succeeding administrations until the education department began complaining of inordinate demands for greater services by the group. An internal analysis revealed that the membership had shrunk to less than one hundred members. For every one of the recent programs, more than thirty members of the group attending were rare. In addition, their membership dues had not increased from twenty-five dollars per year, per person. Further research indicated that each member was costing the museum, on average, $110 per year. The group was disbanded when the cold facts were presented in a cogent, coherent, and judicious manner. There could be no justification for continuing such a program. As Peter Drucker has written, because "results in service organizations aren't easily measured there is need for organized abandonment." He hits the target on the bull's-eye: "The manager of a service institution must constantly ask the unpopular question: knowing what we now know, would we get into this activity, this service, this effort if we were not already in it?" He calls for immediate disbanding if the answer is no. "He shouldn't ask for another study or try to find a way to repackage the old chestnut to make it look fresh to the donors. He should find a way to get out of that service as quickly as possible."[7]

The moral of this story is that administrators, directors, and managers need to constantly reevaluate the programs that have been in existence since the beginning of time to determine whether that program's future will provide growth for the institution or a playground for a few swells who really don't want others playing in their sandbox.

Try to keep the price of membership as low as possible to attract as many people as possible. As shown in the example above, you must cover costs at the very least. If you discover that it costs only eighteen dollars per year to service your membership, then a yearly membership charge of twenty-five dollars is not unreasonable. The same reasoning should be applied to family/partner and senior/military/student memberships.

And last, setting the price of membership dues goes to the concept of "value perceived"—and as you are setting these prices you must keep in mind: are the members getting their dollars' worth? Too many membership prices and programs in this country are set with the museum need in mind, not the potential purchaser of the membership.

Service

The membership must be serviced. It means accurate record keeping, prompt billing, and pristine maintenance of all records. In a large organization, the accounting department usually handles the billings and all record keeping. In a small organization, a bookkeeper or board treasurer might handle this responsibility. This function records membership, sends out the bills and notices of renewal, and maintains the membership list. Your records must be maintained in a pristine manner. You will never receive praise for the excellent job you do in maintaining your billing and record keeping. You will hear about it the minute you screw up. And remember, purge names every three years.

Fulfillment

Fulfillment is the backbone of your program. These are the services or perceived value of your institution, and they relate to your public face or image. These are the mechanisms to fulfill your commitment to the member for joining. These are the lectures, educational programs, films, travel groups, school tours, dinners, and opening receptions, among others. Perhaps the largest disconnect in museums is the one between the producers of the programs (educators and curators) and the salespersons (the director and the development person). It is imperative that the salespersons accurately and honestly portray the programs being developed and presented by the producers. The producers, on the other hand, must deliver the program as promised in the membership brochure or the marketing pieces. This principle works in your favor in the small museum. The large institutions, with layers of staff and bureaucracy, lose contact with each other and are usually burdened by outmoded policies and procedures—or worse yet, old-fashioned interdepartmental skirmishing. Just the mere size of some museums screams out "dysfunction" when it comes to delivering the product promised by another department or division. In a two- to four-person operation, if there is no coordination between the salespeople and the production people, there exists a much larger problem than bureaucratic dysfunction.

One often hears the term *perceived value*. The member will decide whether she has spent her money wisely, and if not, will not return for another season. Members will decide on the value of your offerings. A large annual turnover in membership might indicate that you are offering a poor slate of programs in fulfillment of your membership obligations.

Membership or Annual Fund?

The small museum often asks the basic question: Should we have a membership program, or an annual fund, or both? The answer depends on each organization's situation. If your museum is brand new and you are just starting out, you should carefully weigh your options before jumping into one program or the other—or worse yet, both. As one speaker years ago reminded an audience at a CASE (Council for the Advancement and Support of Education) conference, membership and annual giving programs are the "bread and butter" of any institution's fundraising program. Membership has benefits that draw people to your programs, but these benefits cost money. The net result is that memberships are subject to less net profitability than annual fund giving. In larger institutions with amenities such as food service or book and gift shops, membership can generate earned income—although with an expected discount. Membership provides an identifiable constituency, increases community awareness of your organization, provides for a ready pool of volunteers (although that is changing with households where both spouses work), and most importantly cultivates committed prospects for additional and increased giving.[8]

Membership requires those three elements listed above—sales, service, and fulfillment—embodied in a series of programs for those joining the museum. As it grows, it will require increasingly closer attention to an expanding group of people who will require tender loving care. On the positive side, in joining you, your members have given you a solid vote of confidence in your programs, collections, and leadership. They will become shoppers in your gift shop to use that discount. They may even rent the museum to take advantage of their discount if that is one of the perquisites you offer. They will eventually demonstrate a loyalty if they can be cultivated for donations.

On the other hand, the annual fund is not an entirely different animal. It closely resembles a full-blown membership program and, as shown above, is unclear to the general public, including some board members. Annual giving produces sustaining support and, like membership, involves many small gifts from many people. It uncovers special prospects who can be approached later for larger gifts and as such forms the basis for other fundraising, that is, project support. It also provides the museum with an opportunity to make an annual presentation of its case to the

donor base. Annual giving produces income for current operations, which can be either restricted or unrestricted. In 99 percent of cases, it usually funds unrestricted needs. It does not elicit the same degree of loyalty that a membership conveys. Like membership, the annual fund requires a set of pristine records and bookkeeping. The programming is not as intense. Annual donors usually receive fewer benefits since their payments to you are classified as donations and benefits reduce the gift's deductibility in the eyes of the IRS. Annual donors may require less hand-holding and maintenance. Some institutions combine the two concepts: membership and annual appeal. Some classify payments to their museum up to $100 or $250 as memberships and higher payments as annual gifts.

If you have established one or the other, should you entertain the notion of having both a membership program and an annual fund program? Could you or should you have both? Remember the pyramid. What is it you are trying to do with either or both of these programs? Your goal is to reach as many people as possible initially. Once a prospect is enrolled in your program, your next goal is to move that committed donor up the pyramid to a higher donor level. In connection with a successful membership program, annual giving may be defined as the "process of obtaining an additional gift from a donor who has faith in your institution. Annual giving may be in the form of a yearly solicitation to an institution's members and other previous donors, or it may be a series of solicitations from an institution for a variety of causes throughout the year."[9]

In an article in *Advancing Philanthropy*, authors Marcelo Iniarra Iraegui and Alfredo Botti creatively suggest that there is a different doorway into the pyramid. Calling it the "hidden gate" into the pyramid, the two posit that the pyramid might have yet another layer between the nonmember and the member called the "trysumer." The new layer "admits nonfinancial, digital supporters who arrive via new media—websites, email and the increasingly popular" text messaging. They define the "trysumer": "freed from the shackles of convention and scarcity, immune to most advertising, and enjoying full access to information, reviews and navigation, experienced consumers are trying out new appliances, new services, new flavors, new authors, new destinations, new artists, new outfits, new relationships, new anything with post market gusto." Stated another way, these new and experienced consumers are transient and are "becoming more daring in how and what they consume, thanks to a wide range of societal and technological

changes." Traditionally, entry to the pyramid came with a membership or a small donation. The authors maintain that the new entrance to the pyramid is through a "nonfinancial electronic door" before the users become donors. Friends on Facebook, devotees of Twitter, and other electronic entry points are all fertile ground in turning nonusers into members or donors. These "trysumers" are the people who want to be involved in an organization but have not donated or become members. With a world of more than 1.3 billion people using the Internet and more than 3.3 billion with mobile phones, the market is enormous. Finding your market in your community with all of these tools becomes your opportunity.[10]

The Williamsburg Model

Consider the Williamsburg model. Williamsburg has continually and consciously decided not to establish a membership program. They have survived without it. How have they done it without imperiling the mission and the future of the institution? Instead of a membership program, Williamsburg has a series of "donor clubs."

They are the Duke of Gloucester Society, which you can join with an annual gift of $100–$249; the Capitol Society, at $250–$499; the Colonial Williamsburg Assembly, at $500–$999; the Colonial Williamsburg Burgesses, at $1,000–$2,499; the Colonial Williamsburg Associates at $2,500–$4,999; and the Raleigh Tavern Society at $5,000 and above. Beyond those six donor categories for annual support, Colonial Williamsburg has the Goodwin Society for Planned Giving; the Business Forum, which handles corporate and foundation gifts; and finally a Friends of Collections Donations, which is "used solely to acquire objects for Colonial Williamsburg's collections." Parenthetically, the latter is an excellent strategy to build an acquisition fund.

Donors receive very little for their donation. Donors at the thirty-five-dollars-per-year level receive the quarterly history magazine *Colonial Williamsburg* and a 24-karat-gold-finished collectible ornament. Donors of one hundred dollars or more receive special benefits, including access to the St. George Tucker House Donor Reception Center. The institution does offer some out-of-the-ordinary programs. Special donor society members are invited to travel with Colonial Williamsburg, and friends of the foundation get singular access to private collections, exclusive properties,

and once-in-a-lifetime experiences. In effect, Williamsburg is "harvesting names." The name of every visitor who signs up for anything other than these special donor categories is captured for direct-mail purposes. If you register at one of its hotels, your name and address goes to a central database. If you make a reservation to eat at one of the inns, you are "in." The "Annual Pass" offered at the same price as a three-day and more pass provides the purchaser with one full year of access to all general admission pass sites and programs with daily come-and-go convenience, a 25 percent discount on most Colonial Evening programs, and free access to special-topic, guided walking tours with reservations.

If you don't have a membership program now, you might consider the Williamsburg model.

> *Helpful Hint: If you charge admission at your institution, then members will join as an economic proposition rather than a loyalty issue. In other words—they will quickly determine whether it is cheaper to join as a family of four rather than pay full price for admission. What does this mean? You can't determine the price of admission and the price of a family membership in a vacuum—you must reference either one.*

Mapping the Mini-Campaign/The Annual Fund

How do you administer an actual annual fund campaign? Relying on our three golden rules discussed earlier, we must first set our fundraising goal. And that goal is based on the institutional need, the frequency of past support, and level of past support. Last year, our annual fund provided $70,000 of unrestricted annual support. The need this year is for a 7 percent increase, or $75,000 over last year. We intend to approach our membership base of four thousand members. We know that within that group, five hundred have given to the annual fund repeatedly. Based on the annual fund's need and our donor's frequency and level of past support we are confident that we can raise the needed $75,000. In effect, we are basing our campaign on more than just need.

Our strategy will be to divide the annual fund campaign into three discrete phases. We will select prospects for each phase based on past support and level of same. But we will approach each phase with different tactics.

When mapping any campaign—large or small—you must attempt to understand all the opportunities as well as the risks, as in any military campaign. And, like any military campaign, the battlefield will ultimately make any well-conceived plan obsolete within days. This implies that you must always have a contingency plan or plans B and C if necessary.

Our expectation is to approach the entire membership base of four thousand and expect five hundred gifts overall. How will we accomplish that?

Phase I Tactics

In phase I, you will approach ten selected prospects and ask each for five thousand dollars. You know from their past giving record that one or two are capable of more, and they will be asked to repeat their gift of last year. Your goal is to secure one gift for every two prospects you have approached for an annual gift. Each of these ten donor/prospects will receive a warm personal letter from the chair of the board. E-mail is forbidden! A slow response will be followed up with a friendly call from either the chair of the board, the chair of that year's annual fund campaign, or the director of the museum. Based on a two-to-one positive response rate you can expect five gifts of five thousand dollars. The other five will not be lost, however. They will either come in lower, or in the case of those who gave more in previous campaigns, you will receive more than the first-phase

goal—always a nice situation. The total conservatively anticipated from phase I is $25,000, which is one-third of your goal.

Phase II Tactics

Now you still have 3,990 prospects from the entire membership pool or 490 from the donors from last year's campaign—and you are already one-third of the way toward your goal. From the latter list you will approach sixty highly qualified and vetted prospects and ask them for one thousand dollars each. Each will receive a letter from the chair of the annual appeal campaign and a follow-up phone call from the director or a member of the campaign committee. Again, do not use e-mail! Based on a conservative 50 percent response rate, you can reasonably expect thirty gifts at one thousand dollars each, or thirty thousand dollars. Once again, some of those who do not respond at the thousand-dollar level will give something, perhaps five hundred dollars, so those who do not come in at one thousand dollars are not "lost" to the process. The total conservative estimate of cash expected in phase II is thirty thousand dollars, giving the annual campaign a cumulative total of $55,000.

Phase III Tactics

You are now at 73 percent of your final goal of $75,000. And the remaining number of prospects from your membership pool is 3,965 and 465 in your donor pool since you already have thirty-five gifts counted. The last phase, which you can call the "retail" phase, will consist of a canned letter from the director, a special annual appeal brochure asking for one hundred, seventy-five, fifty, or twenty-five dollars to the entire membership pool. It will be followed up with phone calls and additional mailings. You will expect a response from at least 465 members with an average gift of forty-three dollars based on level and frequency of past support, or a conservative minimum of twenty thousand dollars, bringing the goal to $75,000. Follow-up here may be by e-mail, only after a reminder letter has been sent out within ten days.

Estimated Costs of This Campaign

When planning any campaign, whether it is an annual fund drive or a capital campaign, the benefits must always be weighed against the costs.

Not surprisingly, phase I, which raises the most money, is the least expensive. Phase I, including stationery, postage, minimal clerical help (volunteer time), and some telephoning should cost no more than one hundred dollars. Phase II, with some additional stationery, postage, and clerical help and some telephoning, may cost no more than $250. As you might expect, phase III is the most expensive. The brochure alone will represent a major part of the overall bill, which should not run higher than five thousand dollars. The total cost for all three phases might run as high as $5,350. Weighed against a successful campaign of $75,000, the cost-benefit ratio is well worth the entire enterprise. This will have a direct impact on your annual budget and your cash flow and will fund the necessary aspects of your strategic plan.

The most important lessons from such a campaign, aside from the obvious use of institutional need and the frequency and levels of past support, is that such campaigns call for personal attention at the highest level of donors, that you can't raise money effectively and efficiently by mailing to the entire community, that appeals must be targeted, and last, that you cannot raise money by the multiplication tables.

James Gregory Lord, a well-established author on philanthropy, has identified five principles to consider when drafting marketing tools for fundraising. These principles should be kept in mind for any campaign—annual or capital—or for any benefit you are planning.

1. *Design for people.* Campaigns are not won solely on the strength of your marketing materials. They are won by your people—the campaign leaders, volunteers, and donors.
2. *Focus on volunteers.* The purpose of your materials is not so much to convince the prospect, but to support the efforts of the volunteer solicitors, to build their enthusiasm and confidence so that their attitudes and behavior convince the prospect.
3. *Plan for responses.* Present stimulation that will evoke a positive response from the volunteer and potential donor. Supply facts and figures, but because the philanthropic act is as much emotional as rational, pay more attention to evoking action.
4. *Keep it simple.* People are most effectively moved when they are able to understand one simple, coherent idea.
5. *Aim outside.* It matters little what business the institution thinks it is in. The perceptions of the donor are what count. To develop a useful marketing perspective, it is necessary to base your process in that constituency.[11]

> *Helpful Hint: You cannot raise money with/by the multiplication tables—for example, we need $25,000. Let's ask twenty-five people for one thousand dollars each. That should do it. That won't do it. Never has, never will.*

Special Events:
The Benefit—Friend Raising or Fundraising?

Just say no to "but seriously folks." I have never been a fan of the benefit fundraiser, and I have developed a philosophy for small, mid-sized, and large museums—don't even think about it if you don't think that you can net (clear) a profit of at least $25,000. Marilyn Brentlinger and Judith Weiss, in a very sympathetic article entitled "To Benefit or Not to Benefit, That Is the Big Question" from *The Ultimate Benefit Book* agree that one should not attempt any benefit that will not net at least $25,000 or $50,000. They ask the very cogent questions, "What does success look like?" "What does failure look like?" and "Are you ready to begin?" Above all, they encourage would-be "benefiters" (my word) to "think long and hard about it."

Special events or "benefits" should never be run unless you have planned them down to the minutest detail. Always seek sponsorship to underwrite your largest expenses. Without a major sponsorship, you will inevitably fail.

They list several answers that are helpful to all nonprofits contemplating the big dance or benefit. They list what they call "criteria for success," which begins with the admonition to make at the least the minimum $25,000. They say, "Have market ticket price." That means, what are the symphony, the zoo, the art museum, children's health care, and the children's museum charging for their benefits? If the ticket price seems to be generally accepted at, say, one hundred dollars, don't think that you will be able to charge $150 and up for your shindig.

Presell all your tickets. Allow no walk-ups. This means that you will know well ahead of the night of the big "do" that you have enough cash on hand to pull off a successful event. I have been involved in many yearly annual benefits that have known months in advance that even before the general invitations were posted we had a success on our hands. If you allow last-minute walk-ups, they will be gravy on the beef and mashed potatoes.

Target a well-defined upper-income market. Once again, as the bank robber Willie Sutton reputedly said, he robbed banks because that's where the money is, so you must target your most affluent donors. Running an ad in the local newspaper to invite the general public to a one-hundred-dollar-per-person benefit has never been effective and never will. Resist the urging of well-intentioned volunteers who believe that some "really good publicity" will bring in hordes of donors. It does help to do publicity nearer the event to tell the community what you are doing and why. The publicity should show that the event promotes community involvement and continuing support. It should detail that you have identified a strong cause and have dedicated volunteers working diligently on it.

As for the event itself, it goes without saying that it must be carefully planned and executed down to the last detail. And the details can be endless. The key to gaining control of the details is the recruitment of effective leadership. In some communities there are "professional" volunteers who do these events all the time, and they have the routine down pat. They know the best caterers, the best valet parking facilities, the best public relations firms willing to donate time and talent, and the people in town who are their friends who will buy tickets to the event. Above all, the authors advocate lining up corporate sponsors from the beginning. The more you can get underwritten by corporate sponsors, the more money you will net in the end. I cannot emphasize this point enough. Having as much donated in either cash or in-kind will ensure success.

As importantly, the authors ask: "What does failure look like?" Unfortunately, failure has more immediate and recognizable aspects and is easy to identify. Failure looks like this: your benefit doesn't meet expenses, or worse, loses money. No matter how hard you may try to spin the results of your bake sale, if in the end you lost money or barely met your expenses, you have failed. A more abstract idea but a still critical indicator of failure is the inability to make new friends. Did your event attract the same old crowd? Or were there a lot of faces who were new to you and your board members?

If volunteers and staff fail to communicate effectively, you could have a huge problem. Probably the least understood and most devastating area of your operation is when staff and volunteers clash. Who is in charge on the staff level is exceedingly important to your success. Can that individual look past the often petty incidents that tend to flare up during the planning stages? Crises occur, and a level-headed staff person who can deal coolly and rationally with the benefit volunteers is critical.

A sure path to disaster is no corporate sponsorships. Getting nothing donated will ensure that you will have to pay for it all. From the beginning, let your mantra be "Get as much donated as possible." This can be as large as the entire food service donated (unlikely) or paid for by a sponsor, or the liquor donated, or the valet service given as a gift, or all the items in a silent auction. Leave no area untouched as a potential donation or sponsorship. The more you have donated or sponsored, the more money you will net.

Are you ready to begin? Is your organization well known in the community? Readiness means that you have recruited a qualified worker chair as opposed to one who is merely a figurehead and one who will be recognized by the community you hope will support this endeavor. A figurehead chair is perfectly acceptable, *after* you have recruited a working chair. Working co-chairs are also a feasible and more appealing solution because they bring different talents and different constituents to the party than one might. The chairs' primary duty is to enlist active and committed volunteers who will be organized and hard working. All should be allowed adequate planning time for the event. If this is a recurring event, work should begin on the next year's fundraiser immediately after the end of the last one. If you are beginning a new benefit fundraiser, the earlier you begin planning, the better. The earlier you recruit your chairs and volunteers, the better.

If you hold the benefit year after year, the first meeting after the benefit should be a postmortem. Here all the hard questions should be asked.

What worked, what didn't, and why? Did the board actively participate, and are they committed to continuing the event? Did you have adequate support staff involvement? Was the mailing list current, and if not, should it be updated for the next event?

One last detail that should be a part of your initial and then ongoing planning is that this benefit will be for a specific project or purpose. It should be placed in the context of all your other fundraising asks and should be targeted toward a specific purpose. Conservation of your painting collection or the museum's education programs are two examples. A popular cause in many museums is new acquisitions. Patrons can see the tangible effects of their efforts when that new object goes on exhibit with a label indicating that it was paid for from the proceeds of the museum's annual benefit.

Not to put too fine a point on their advice, the authors reemphasize the following points: "Be sure you have underwriting for the event before you undertake it; recruit double the number of volunteers you thought you would need to produce the event; be prepared to keep repeating the event for several years until the net surplus becomes predictable and meaningful to your budget." Above all, consider all the volunteer and staff time invested to raise a few dollars.[12]

In 1983, during another trying time in fundraising, a magazine entitled *Fund Raising Management* published an article entitled, "Thirty Ways to Fail at Fund Raising in Hard Times" by author Joan Flanagan. It remains as current nearly thirty years later. It also applies to fundraising in good times. Some of the ways to fail are poor attempts at humor, and some are inappropriate. For example, you would never ask someone for money who had fallen on hard times or who have no discretionary income to spare for philanthropy. Other tidbits of wisdom are dead-on.

1. Be negative.
2. Avoid anything new or different. "We never did it that way before."
3. Tell your local press that the hard times are hurting you.
4. Write proposals for government money. Spend your time lobbying Washington for money if you don't get it. Spend your time entertaining auditors if you do get it.
5. Write proposals to the same handful of foundations that everyone writes. If possible, use out of date information.
6. Berate the foundations who turn you down. Say they are insensitive.

7. Be too busy to write thank you notes.

8. Be too busy to make a long range plan for fund raising.

9. Be too busy to meet with each person on your board of trustees to find out what he or she wants to do.

10. Be too busy to evaluate last year's fund raising.

11. Decide you can't afford an audit.

12. Decide you can't afford any training.

13. Decide that you can't afford to take any chances

14. Never ask your current donors for money more than once a year because you think it is impolite.

15. Never ask your board for money because they already give you their time.

16. Never ask your volunteers for money because they already give you their time.

17. Never ask your family or friends for money because it is too personal.

18. Never ask your clients to raise money because they are a) unemployed, b) in trouble, c) under stress, or d) all of the above.

19. Never ask senior citizens to raise money because they are too old.

20. Never ask the youth to raise money because they are too young.

21. Never ask a low income person for money because you don't know them well enough.

22. Never ask a rich person for money because you don't know them well enough.

23. Never ask anyone new for money because they don't know the (museum) well enough.

24. Never ask old-timers for money because they never gave before.

25. Never trade your donors list with another group because you are afraid you may lose some donors.

26. Never include terms of office (for your trustees) in your bylaws. Keep all your dead wood on the board forever and let the new energetic people participate somewhere else.

27. Never tell a candidate for the board that the most important part of the job is asking for money. Wait until after they are on the board, and then surprise them with fund raising. Preferably, throw a tantrum in front of the entire board after the first financial report showing a deficit.

28. Never ask for advice.

29. Never ask for help.

30. Never ask for money.[13]

In Summary

Membership, annual giving, and special events (benefits) have an intimate relationship, and the sooner you recognize the connections, the more successful your fundraising will be. Special events, when well run, will spill out into the community's wellspring of "good feeling." Image building will enhance membership and your annual giving needs. In turn, members and donors will support your special event fundraising gala every year. The next time you sit down with your board of trustees or your development committee to plan the upcoming year's strategies, make sure that you have a serious conversation to include all three elements and their relationship to one another. Above all, do not forget that the marketing aspect of your membership campaign must rival all of those voices out in the marketplace vying for attention. This is tough on a limited budget, but sometimes lean budgets are marvelous stimuli for creativity. If you are small and lean, you are also creative. When institutions get fat and lax, they lose their creative edge. If you are a small institution, stay lean, stay creative.

MANAGING A CAPITAL CAMPAIGN

He who cannot give anything away cannot feel anything either.

—Nietzsche

What is a capital campaign? A capital campaign is defined by Goettler Associates as "an effort to raise a specific amount of money, for a specific purpose, over a specific period of time." The capital campaign, on paper, is an organized attempt to find sufficient capital to build an endowment or build a building. In reality, it is organized chaos. Goettler Associates' main point here is that you must be specific and you must plan a rational campaign. Remember the acronym "KISS"—Keep It Simple and Specific. They insist that you need both "hard data" (which you can get from a feasibility study) and the "experience and judgment it takes to *interpret* the data." Through rigorous planning you can fairly estimate what you can raise; what "portion comes from . . . the top 30 or . . . 100 gifts;" how many volunteers you will need; and "how long this will take." A deadline creates a sense of urgency and tends to focus the mind. Campaigns that go on forever lose momentum, interest, and enthusiasm. Donors and volunteers suffer fatigue, and usually the campaign fails. As Goettler says: "Without a goal, a schedule, and a strategy, there can be no campaign at all."[1]

In large institutions, a capital campaign every five to seven years has become the standard. This is particularly true of colleges and universities. Museums, as a rule, use the capital campaign to expand or build a new

building with an endowment component. Most fundraisers agree that an occasional capital campaign or your first will have untold benefits, many not readily evident. The campaign will develop a greater awareness of your organization and its services to the community. As one writer has said, "It will better establish the real value of the organization to its constituency or community." A campaign will raise the sights of your audience, which will raise their giving patterns. It will broaden your base of support from all sectors from those who may never have supported you in the past. Once the campaign is over, and those new donors are treated respectfully, they will continue to support your programs. It has a direct relationship to deferred giving in that a component for endowment can almost completely be funded through planned gifts.[2]

Establish the Need

The first step in any campaign is your assessment of the organization's need. What is most important for the institution? It is usually the need to establish or increase an endowment or a new or renovated building project. This is a process done in a consensus atmosphere where many different views can be aired and either accepted or rejected. Inevitably, departmental needs clash and necessitate resolution by strong and courageous leadership. The various institutional—not departmental—priorities and needs will be addressed in the campaign. The planning process usually begins with a series of wish lists. They should all be tied to the strategic plan, and above all they must carry a price tag. Once a consensus is reached on the most pressing needs, they can be "packaged" into no more than four or five categories such as "Endowment," "The New Auditorium," "Complete Renovation of Pioneer Gallery," and "Technology." Within each of these categories, further specifications may be in order. Colleges and universities—and now museums—often wrap their annual operating needs for the period of the campaign into the campaign as long as those needs are separately identified as a goal before the campaign is launched.

Prepare Internally

The first question you must answer satisfactorily is: "Is the desire to have a campaign board or staff driven?" If the board has not bought into the

idea, then you are wasting your time. The strategic plan should have identified all of the needs a campaign would address! The board should have accepted the strategic plan well before the notion of a capital campaign is raised. The lack of a coherent and compelling strategic plan is one of the surest paths to failure. According to Goettler Associates, "Without a vision and a plan, the organization will find it difficult to build a case that (a) captures the imagination of the donors and volunteers, and (b) convinces them that the vision can . . . become a reality. An unfocused collection of 'good ideas,' or a program designed to ensure mere survival, is unlikely to inspire donors and volunteers to make the extraordinary effort to bring about success."[3]

As Patricia Jacoby, the deputy director for marketing and development at the Museum of Fine Arts in Boston, wrote in an article entitled "Seven Golden Rules for a Museum Campaign," your museum should think pan-institutionally when planning a campaign. I would add that it should think that way all the time, not just when planning a campaign. She says that the best campaigns are about the whole, not a specific set of programs or silos in departments. The Boston museum changed "the relationship between curators and donors to shift from program to institutional planning." In the past, each department and curator had cultivated its own set of donors (this is typical in a traditional art museum and in some larger history museums). The donors were jealously guarded and hidden in each department with little or no sharing. "The results were destructive," she writes. "Sometimes . . . the same donor was solicited by more than one person for different major gifts at the same time—infuriating and confusing the donor, humiliating the solicitor, and seriously damaging the museum."[4]

The second question tests your staff and your capacity to mount, sustain, and conclude a successful campaign: "Do you have enough and the right kind of staff to run a campaign?" Although a feasibility study will ferret out the answer to this question, management must determine whether it has all the right people on the bus and in the right seats. If not, you will have to beef up staff temporarily. These new people can be charged to the capital campaign. The problem is that they must be hired and trained well before you raise your first dollar. This is a venture capital advance that the board must be willing to put forward as risk money with the intention that it will be recouped once the campaign has been launched and is successful.

The Feasibility Study

Why do you want to conduct a feasibility study? There are many reasons, but the most important is that the feasibility study will give you an immediate sense of direction for your campaign. It will tell you whether you have the capacity in your constituency to raise the money you think you need. From it you will learn about your institution from the community. You will learn who your friends are and whether you ready to launch a campaign. It will signal to your major donors that you are thinking of a campaign and the magnitude of that campaign. An honest feasibility study done by an ethical consulting firm will give you a candid appraisal of your chances of success. "Not every situation, however, calls for a study," say Goettler Associates. "If you're confident that you have an outstanding campaign chair lined up, and you know who your top donors are likely to be, then you may not need to conduct a study. At the other extreme, if you're in a weak position to undertake a capital campaign, even an expertly conducted study will not change that."[5]

A feasibility study will also help you set your goal. Your study will take the temperature of your constituents for their frequency of past support and levels of past support. In a recent study done for the Atlanta Historical Society, campaign consultants Coxe-Curry wrote eloquently about the objectives of a good study.

"A feasibility study is the first step in campaign preparation and is vital to the ultimate success of an organization's fund raising effort. It is to fund raising what a market analysis is to business. Conducting a feasibility study is a great deal more sensitive, however, because fund raising depends not only upon an accurate assessment of the market, but also upon a clear evaluation of the leaders, volunteers and donors who will participate in the forthcoming campaign. During the study, confidential interviews are conducted to test the feasibility of the proposed campaign and the readiness of key donors and leaders to support the effort" (*Atlanta History Center Feasibility Study Final Report*, December 10, 2009).

Specifically, a feasibility study will determine your potential for raising the amount of money you need to address your organization's critical issues. It will also help you develop or improve your case statement. It will identify key leadership gifts that are essential to getting your campaign off on the right foot. It will help you position the campaign with your com-

munity and give you a glaring and unbiased assessment of your standing in the community by identifying your strengths and weaknesses. It will identify major obstacles in your path to a successful campaign. An added bonus is that the leaders who are identified and interviewed will increase their ownership in your campaign because the process allows them to sound off *before* you begin the campaign and serious solicitation. Most important, the feasibility study, in the hands of an honest and competent consultant, will make recommendations and draw conclusions on strategy, tactics, leadership, timing, and other components of the campaign.

A good feasibility study will cost between twenty thousand and thirty thousand dollars. This is upfront or "venture capital" that must be on hand, approved by the board of trustees as an acceptable, early campaign expenditure, and repaid from the first gift or gifts in the campaign. It is not uncommon to find a board member or a donor to make the first gift to the campaign earmarked for the study's expense.

Ideally, the feasibility study will:

- Determine the potential for raising a certain amount of dollars to address an organization's most critical needs.

- Test and develop the case for support.

- Identify key leadership gifts for the museum.

- Help board and management to determine the best way to position the campaign within the community.

- Provide an unbiased assessment of the museum's strengths and weaknesses.

- Explore any obstacles to a successful campaign.

- Increase ownership among the potential campaign leaders and major donors by giving them voice in the campaign planning process.

- Draws conclusions and makes recommendations as to campaign strategy, different elements in the campaign, issues to be addressed, and, most important, campaign leadership and timing.

How is the study conducted? You could conduct the feasibility study yourself or have a fundraising consultant do it for you. I would never recommend doing one yourself for the very simple reason of objectivity. An outside consultant can and will ask the hard questions that will provide you with the answers you need to proceed. Once a capital campaign appears to be a consensus need by the board of trustees and key staff, an ad hoc board "feasibility committee" should be assembled—usually out of the development committee. The purpose of this committee is twofold. One is to approve the direction and goals of the campaign, including a review of a draft case statement and agreement on the names of those to be interviewed. The second responsibility is to accept the final feasibility study in order to recommend it to the full board. It should meet no more than twice, and the members thanked for their service.

Once the names have been determined, the consultant will ask for those top twenty-five to thirty donors. They will interview each one to determine their interest in your museum; their interest in your board and its effectiveness; your staff; and, if you are the director—you! The consultant will ask whether the potential donor thinks the museum should run a campaign, whether they will be interested in supporting that campaign, and to what extent. They ask whether the donor is comfortable with the amount of money needing to be raised. They also ask whether the prospective donor will be interested in serving in the campaign in some capacity. Essentially, the consultants will take the temperature of the community and determine the community's perception and awareness of your institution. They will test the case for support. Is it strong enough? Does it resonate with your major stakeholders? Does it sell the institution?

The most important part of the feasibility study is testing the campaign goals and key gifts. What does this mean? The consultants will determine whether the community is behind your goals and your plans to achieve those goals. And last, they will determine from the interviews whether your leadership—staff and board—are well suited for the campaign. Here again, a strong representative board is essential to a successful feasibility study and the succeeding campaign.

With the information gathered and examined, the consultant will bring in one of a number of results. The most hoped-for result is that the majority of the donors think you are on the right track and that they will support your need for the dollars you proposed. A negative report should

contain suggestions for improvement. I have seen reports that forthrightly indicate that you do not have a strong development office to mount a serious campaign for the amount of money you need. Or you may be a brand-new director that those in the philanthropy world in your community do not know. Or you need to increase the awareness of your museum in the community. A backhanded comment like "the Abacus Historical Society is the best-kept secret in town" is not promising.

Sometimes the consultant will report that you have wide support in your community for a lesser campaign goal. Or you may have too narrow support in the community. Or if you do have a large list of prospects, they might not be that actively engaged in your mission to entice them to support a major initiative like a capital campaign. Other times, the report will tell you to put your plans on hold until you address some serious internal or external issues. Another option is that you might learn that phasing in your campaign might be a better strategy. One historical society tested for $4.8 million. Based on the feasibility study, the museum decided to break their needs into smaller chunks over several years. In any case, the wise board of trustees and wise director will regroup and address the issues raised by the study before they attempt a campaign.

Testing your image through the feasibility study is critical. Negative perceptions held by those who support you are deadly. As Goettler Associates point out, these negative images could include a "lack of stature, visibility and/or creditability; past problems with the quality or accessibility of services; chronic operating deficits or excessive long term debt; or a history of unsuccessful capital campaigns." Your street "cred" is different from the "donor community" views of you. You can ameliorate the latter with substance, not sizzle. It also signifies that you are out of touch with your community. Goettler calls it "functioning largely from an internal perspective." In such an organization, "reality is defined by its own limited sphere of interest and activity; it may become difficult or impossible to understand how major donors and community leaders see the world and make decisions."[6]

In some areas, feasibility studies are considered by savvy donors and board members and less-educated directors to be a waste of time. This is especially true for small museums that have limited dollars to spend, limited dollars to raise, and a legitimate desire to have the most amount of money raised in the campaign directed toward the museum's needs. My

recommendation is that the entire idea should be deliberated by a feasibility study committee, with all views being vetted. Consider your goals and your individual circumstances. Are you such a small community that you think you can raise that $1.5 million dollars for a new storage area without a study? Has a sugar daddy stepped forward with a challenge pledge of half of it, making your goal now only $750,000? Then you might not need a study.

Picking/Using Consultants

How do you pick the right consultant? Start with your colleagues and friends. If your colleagues have run a recent campaign, they will have fresh memories of the good, the bad, and the ugly of their endeavors. Do not limit yourself to the museum field. Ask other nonprofits in your community, including private schools and social agencies. Call, write, or e-mail the Association of Fundraising Professionals. Members of this group espouse the highest ethical standards in the fundraising field. The association's website boasts that it represents thirty thousand members in 207 worldwide chapters.

Once you have narrowed the field down to five or six viable candidates, ask your chosen firms to submit proposals. The proposals should help you narrow your search down to two or three firms. Use the development committee to interview the two or three candidates that seem to fit your museum's culture and needs. Ask each firm to provide a client list, and then call the client list and ask how effective the firm was in their campaign. Probably the most important question you should ask a potential consultant is whether they have ever provided a negative feasibility study. An ethical firm should answer this question honestly, and without giving up confidential information, the firm can explain in general terms why an institution could not proceed based on their negative findings.

The Case Statement

What is it, how do you develop it, and what makes it work?

The case statement is an articulation of your vision for your institution designed to attract, inspire, and energize potential donors and volunteers. Its goals are to help you enlist your campaign leadership; inform and

support all of your volunteers making the solicitations; and, much like an investment prospectus, inform your donors of your intentions and their role in your future. It will also form the official basis for all other campaign materials like videos, brochures, letters, and so on. It will be your primary sales tool as you solicit support.

The process of developing a case statement is as important as the product. It all begins much like your last term paper in college—with homework. It begins with the most obvious—what are your capital needs? What has your research shown? How much money will suffice to meet your strategic goals? As importantly, where will the money be used? Do you have site plans, blueprints, or drawings?

Major stakeholders should be asked for input and reactions to subsequent drafts. Be sure to ask board, staff, and potential donors for their input, which, like the feasibility study, will provide them with ownership in the process and the final product. If you have hired a campaign consultant, one of their services (for which you will have to pay) is writing the case statement. They will heavily involve your staff with the process so that you need not be concerned about "outsourcing" this important document.

The staff or board volunteers tasked with running the campaign must manage the process once all the data is in. Limit the review of the document to the top managers who will be involved in the campaign. This should not be a problem in a small museum with few staff. In fact, fewer hands in the cooking will focus the case statement.

With all the data gathered and the differing views acknowledged, write and rewrite—and then rewrite some more. The case should be honed to three or four major needs of the museum. I have heard both sides of the argument that call for a detailed, long case statement that leaves no stone unturned. The other side has always argued vigorously for fewer words, fewer pages.

In the end, the case statement is credible because it was written from the reader's point of view. Do not present a drab list of institutional needs but a visionary statement apropos to your mission and how this campaign will increase your ability to fulfill your mission, make your museum relevant, and, as Stephen Weil said, "deliver an experience." Present the facts in an interesting and engaging way. Avoid jargon, inflated or academic language that is incomprehensible to your audience. Most of your donors are sophisticated individuals who serve on many other nonprofit boards

but who are not clued into "academics." Appeal to the civic spirit and responsibility of potential donors rather than the high-pressure tactics of heavy packaging of promotional materials, glitz and sizzle. "Give 'em steak" and not the sizzle alone.

Get endorsements of known and respected people. People give to people, and endorsements add credibility to your cause. Stay away from celebrities who are well known for nothing other than being well known. Today's society has fewer secrets than just ten years ago, and more is known about the deeds and misdeeds of celebrities than ever before. Sports figures with clay feet have increasingly burned major corporate sponsors with their bad behavior and tawdry personal boorishness.

Consider this story from Atlanta. The Georgia Campaign for Adolescent Pregnancy Prevention accepted a large gift from a man calling himself Christian Michael De Medici. His real name was Michael Manos, and the *Atlanta Journal-Constitution* reported that he had been arrested in California in February 2010 for "a parole violation warrant out of New York." Manos had "an extensive rap sheet stretching back to 1979 for convictions ranging from kidnapping to robbery" and was released from prison in 2004. He had contacted the Atlanta organization saying he was looking for a charity to donate money to. The *Dallas Daily News* reported, "He kept his past at bay for years. He strolled red carpets in New York saying he was a rich promoter seeking to do a reality TV show" and spent a good deal of time in Dallas before heading to San Francisco. In city after city, the article said, he raised money for charity and then allegedly left "a wake of unpaid bills behind him." At last reports he was facing fraud and theft charges in several states.[7]

A museum in a smaller community has the advantage where people are more likely to know each other and therefore avoid the entanglement of a wealthy and fictitious donor.

The Gift Chart

One of the most critical pieces of the case statement is a gift chart. This chart is merely a road map; a guideline to the gifts you will need in order to mount a successful campaign. Table 6.1 is a table for a modest campaign of $2.5 million. It shows everyone involved in the campaign, that you will need seventy-six gifts over five thousand dollars, and in which denominations to be successful. Notice that the seventy-six gifts

Table 6.1. $2.5 Million Range of Gifts Table for a Capital Campaign

Number of Gifts	Size	Cumulative	Total	Percentage
1	$500,000	$500,000	$500,000	20
2	$250,000	$500,000	$1,000,000	40
4	$100,000	$400,000	$1,400,000	56
6	$50,000	$300,000	$1,700,000	68
8	$25,000	$200,000	$1,900,000	76
20	$10,000	$200,000	$2,100,000	84
35	$5,000	$175,000	$2,275,000	91
Many	under $5,000	$225,000	$2,500,000	

will produce more than 90 percent of the campaign goal. As one reviewer of an early draft of this book wrote: "Development is not rocket science. We sometimes make it more complicated than it needs to be for the sake of building up a profession." That notion "is detrimental to smaller museums that can be intimidated by the process. Let's face it; a gift chart never sent anyone to the moon, but like any good space mission plan it does use math to plot the course needed to get you there" (Anonymous).

After the committee and everyone have their say, the case should be written by one person; do not let a committee write it. One voice is your goal.

Organizing the Team

Courageous Leadership Is Essential

A capital campaign is a team effort with everyone pulling in the same direction, and it requires courageous leadership. Team leadership should come from the board chair, or if necessary, very close friends from the community. Community leaders who are not board members are critical to your success because of their experience in other campaigns. By the time you have conducted the feasibility study, hired a consultant, and employed an inclusive process in writing the case statement, leadership and board involvement should be a foregone conclusion. Some campaigns involve two chairs—one is an honorary chair to give greater gravitas to the drive, and he or she is supported by a leader who will sign all the letters, attend the meetings, and help make the calls. On some occasions, I have experienced "name recognized" couples who have agreed to lend their names to the campaign as honorary chairs with the expectation that they will show up and smile for photo ops and lend their blessings to your

Team leadership in a campaign—no matter the size—is absolutely essential. If you do not have it, the campaign will flounder. Do these leaders have to have a natural talent of leading troops into battle? Not at all. If you have a good development team and a strong director, a leadership team made up of a prominent community couple who many in their peer class recognize will literally open countless doors to you.

endeavor. It is not unusual for campaigns to enlist more than a chair and a co-chair. Four co-chairs are becoming more common. The burden of a campaign is effectively spread among more capable hands.

Picking campaign leadership is more critical than any other aspect of a capital campaign. You can receive a sterling report card from your feasibility study, write a glowing and compelling case statement, and have overwhelming needs but completely fail if you have weak campaign leadership and unmotivated volunteers. "If the individuals who lead the organization don't have the trust and confidence of the 'donor community,' they may need to be replaced. . . ." Also, organizations that have never planned and executed a capital campaign believe that the "sooner they announce their 'need' for money, the faster it will come in." In turn, this pushes them to hurry the enlistment of leadership—particularly chairs. It is better to solicit the close family first to encourage someone on the outside to take on the role of campaign chair. Approaching a potential campaign chair prematurely, before all the plans are in place, will ensure an easy "no."[8]

Training the Team

Once the campaign leadership has been selected, the first duty the leaders have is to choose the teams of solicitors who will call on the prospects. Regular sessions with all solicitors should take place to instruct them on the goals, how to present the case statement, how to wait for the correct response, who should ask whom (assignments are so critical!), and above all how to make the call. The use of a job description for all solicitors is imperative. Here is a sample job description for the chair or chairpersons that your board chair should use when approaching a candidate for the campaign chairmanship, courtesy of Coxe-Curry, Atlanta.

> Campaign Co-Chairs will use his/her leadership skills to direct efforts of the campaign and participate in making key decisions which impact the campaign. Specifically, the Campaign Co-Chairs should:
>
> 1. Play an active role in determining the campaign strategy and organization; review, revise, and approve the campaign plan.
> 2. Help identify and recruit additional co-chairs and campaign committee members.
> 3. Working with staff, make three to five visits with lead and major donors.
> 4. Assist in the prospect identification, cultivation, evaluation, and assignment process.
> 5. Attend periodic campaign meetings (planning, kickoff, and report) as necessary.
> 6. Host/participate in cultivation event(s) during the campaign as necessary.
> 7. Sign letters, proposals, and other documents as appropriate.
> 8. Make a personal pledge to the campaign.
> 9. Serve as a spokesperson for the campaign, articulating the case at cultivation and other events.

Some will be hesitant to make face-to-face calls; others will be old hands at the wheel. Your job and the campaign counsel's are to set up everyone on the solicitation team for success. They should be familiarized with catchphrases to use, catchwords, ways of asking that are polite, indirect, and yet meaningful. In many fundraising classes I have taught over the years, it still comes as a surprise to me that many people admit that they would ask others for money if only they knew the right words. In other words, for lack of the magical words, fundraising did not occur.

A successful campaign demands both cooperation and enthusiasm. According to Ms. Jacoby, "Advocates must represent the institution, not just particular projects, departments or programs." Trustees "play a major role by forging team spirit and showing how the campaign will ultimately benefit everyone involved in the museum."[9]

Sequential Solicitation/Phasing the Campaign

Solicit the closest family members first. The board of trustees should lead the way. Trustees above all, as fiduciaries of the museum, are responsible for the campaign's success or failure. The size of your museum is immaterial. Solicit all large donors next. Move down the donor chain methodically. If you have identified 15 or 20 major prospects, they should be asked first for a lot of reasons. It will give the solicitors a great feeling of confidence. It will provide momentum for all involved in the campaign, even those who are not and are sitting on the side lines cheering you on. It will show the outside world that you can be successful and that possibly you will raise more than the original goal. Remember that 10% of your donors will provide 90% of your money, and 90% of your donors will provide the remaining 10% of the goal.

Phase I should be all gifts over twenty-five thousand dollars or fifty thousand dollars or a proportional dollar amount related to the size of your campaign. The Columbia museum campaign was sixteen million dollars, and major gifts were considered at $250,000 and above. Phase II should be addressed to those donors below a certain level—say, below one hundred thousand dollars. Phase III might be all remaining potential. Silent phase means a solicitation of all "family members" first before going public. Conventional wisdom suggests that you reach at least 50 percent (some say 80 percent) of your goal before "going public" for the remainder. Going public does not mean that you will have money pouring in the door by having a press conference or press release stating your success. All it means is that you are partially there and have a distance to go.

Two economists, John List, mentioned earlier, and David Reiley, tested the theory of seed money in fundraising. As David Leonhardt points out in his excellent article "What Makes People Give," "fund raisers generally like to have raised a large portion of their ultimate goal, sometimes as much as 50%, before officially announcing a new cam-

paign." According to Leonhardt, the announcement makes the cause "seem legitimate." List and Reiley sent out two letters on a campaign for computers. One claimed that they had raised two thousand dollars toward a three-thousand-dollar goal, the other that only three hundred dollars had been achieved toward the three thousand dollars needed. According to the two men, the results were astounding. The more money they said they had raised and on hand, the "more additional money" was raised. In the end, "the study suggests that seed money is a better investment for charities than generous matches."[10]

Public Relations

Too often uninformed trustees and volunteers (and sometimes, management) believe that you need public relations to fundraise. If you have read this far, I hope that you now know otherwise. That is not to say that public relations play no part in fundraising. It is an important adjunct, but it never replaces the face-to-face contact still required for successful fundraising.

Announce the campaign at the halfway or 80 percent mark. Experts disagree on this one. They are most in agreement that you should work hard to place stories of the campaign and its goals as you go along. This is much easier to do in a smaller community than in a larger one. Larger newspapers and their Internet counterparts are preoccupied with larger stories of immediate interest. This, in their parlance, is not "hard news." As much as you wish it were otherwise, they will usually throw your press release in the trash unless you have established a close rapport with one of the reporters.

Use the case statement as the campaign's gospel for all press releases and planted stories. Ensure that you speak with one voice. Designate a spokesperson. This is a particularly important step for the small museum. Larger museums have written policies and rigid procedures in dealing with the press. Smaller institutions, with well-meaning volunteers who have "friends at the paper" will attempt to insert themselves in the cause. If it's in the budget, produce press kits with photos, drawings, sketches—good visuals that will tell a story much better than words. Again, be wary of looking too slick and risking looking as though you do not need the money and you can "squander" it on fancy communications pieces. Conversely,

looking too "poor" will not work either. You must work hard at striking a balance somewhere in the middle.

Inevitably, some well-meaning person will suggest that you ask school-children throughout your community to donate their pennies to your capital campaign. Or someone will advocate the selling of bricks for your new front entrance. Both of these feel-good ideas sound appropriate on the surface; they are poor fundraising strategies. They are better public relations strategies. If you have to run either strategy, do it at the end of the campaign, after all of the serious money is in and has been counted.

In the end, solid leadership, a qualified and committed corps of volunteers (strong board), pacesetting leadership gifts (strong board), a worthwhile project, a compelling case statement, and a realistic/well-executed campaign plan will spell success. Each gift is cause for a minor celebration. The final goal achieved is cause for a major celebration.

Another public relations issue you may have to deal with is nonpayment of pledges. For a variety of reasons, many well-intentioned prospects will be unwilling or unable to honor their commitments. At the beginning of the campaign, you should budget an additional 10 percent on nonpayment of pledges. As the campaign proceeds and you ascertain that all or a large portion of the major gifts are paid and accounted for, you can drop your nonpayment contingency to 5 percent. If a large component of your funds is coming from municipal governments who have made public commitment, you should apply the contingency to only the private fundraising.

In Summary

The words of fundraiser Charles Webb of New York are particularly appropriate. He addressed a class at Williams College on January 15, 1993. Although that was nearly twenty years ago, his *Twenty Common Misconceptions about Capital Fund Campaigns* still rings true. Many of the comments below apply to fundraising in general and could also be applied to membership campaigns. The wisdom applies to all sizes of museums.

1. The logical fallacy: if we need $1,000,000, we'll get 1,000 donors to give $1,000 each. FACT: most successful campaigns almost always get most of the money from a smaller percentage of sources.

2. Mr. X and Mrs. Y have made a lot of money and must be looking for a way to give it away. FACT: people with money usually have their own priorities; they have to be convinced (to give their money away).

3. All we need to do is find an angel to give us most of the money. FACT: angels are rare.

4. We don't need to cultivate Board members; they already know the story and will give accordingly.

5. We need to turn this project over to (an executive director), (a development officer), (a fund raising consultant) who will get the job done for us. FACT: without the efforts of the board and other volunteers, campaigns will not achieve optimum results.

6. We need to get Mr. and Mrs. Big involved; let's ask them to come on the Board and tell them they really don't have to do anything . . . just lend their names.

7. Regardless of differences between our institution and others, we need to run this campaign by pre-conceived percentages: 30% from the board, 15% from corporate, etc., etc.

8. We don't have time or money to do a feasibility or planning study; besides, we know what to do. Let's just go ahead with one. FACT: studies not only confirm the wisdom of the proposed approach, they also involve the key players and make them more likely to give.

9. Our donors recognize the need. No reason to cultivate them (they're too sophisticated to come to such events anyway). Let's just go out and ask them right now and wrap this thing up in a few weeks.

10. If we really need to cultivate our donors, the most important thing is to get them here on the premises. Let's just invite all of them to a big party here in the (museum) (concert hall) (theater) (historic house) (library) and they will quickly see our needs.

11. There's no point in asking Mr. and Mrs. X, I know them and they only give to (Harvard)(Choate)(Ducks Unlimited)(the church) (UNICEF)(Save the Whales), etc.

12. We can get most of this money from foundations.

13. We can get most of this money from corporations.

14. These "hard-nosed" business persons don't really understand what we're trying to do here in our (museum) (theater) (library) (arts center), so we'll have to appeal to their selfish interests. FACT: many business people are quite knowledgeable about the arts . . . and a lot of other things.

15. We can get most of the money from the (Japanese) (Chinese) (Saudis).

16. We can get most of the money from the federal government.
17. This is not a good time to raise money; (too many campaigns going on) (economic slump) (everybody's on vacation in the South of France), etc., etc.
18. People are tired of our going to the well so often. Let's just write a letter to our central core of donors and not bother with a personal call. FACT: without personal calls, no campaign will ever reach its optimum goal.
19. They'll all give. Hell, it's just a tax write-off anyway.
20. These fund-raising experiences aren't relevant to our situation because things are different here in (Fresno) (Waukegan) (Valdosta) (Elmira) (Bangor), etc., etc.[11]

GRANTSMANSHIP

Philanthropy is almost the only virtue which is sufficiently appreciated by mankind.

—Henry David Thoreau

Once you understand your mission, once you have a strategic plan in place, once you understand your goals, and once you understand your museum's image in the community, you are ready to write a grant.

Prospects for Project Support

Corporations

In the early 1990s, corporations began to become more assertive in their approach to sponsorships of museum projects. One critic told a crowd at an American Association of Museums meeting in Boston in 1993 that the corporate sponsor could be "described as having the modesty of P. T. Barnum, the ethical probity of Boss Tweed, the attention span of a tsetse fly, the broad humane knowledge of a billiard ball, and a sense of the aesthetic style honed by how many and what color ducks to put on golf pants." The audience nervously laughed.[1]

That is only one side of the story. It is true that corporations usually support projects with wide audience appeal, are more conservative than individual donors or foundations when it comes to programs and causes,

Not all prospects are suitable for all projects. Although there are notable exceptions, corporations will normally support noncontroversial exhibits or high-profile projects; foundations will fund research and public programs; and individuals may contribute to all of them. Your job as a prospector is to find out which is which.

and look for noncontroversial projects that will not injure the corporate image. Please keep in mind that corporations are not in existence to give away their money. Quite the opposite, they are charged with the responsibility to return a profit for their investors, the more the better. As one critic put it, "Corporations are not Medicis; they never have been and they're not supposed to be. They're not in the business to be philanthropic."[2] Yet they remain great prospects to sponsor exhibits. They

are always looking for positive exposure. They want maximum bang for their buck, and their support is market driven. Corporations will always want to understand what is in it for them. As that same critic remarked, "Philanthropy is a gift. It is a good deed. Corporate sponsorship is not philanthropy. Sponsorship is an expenditure of marketing dollars, and if they don't do their job, they are not going to allocate them next year. Sponsorship purchases something. It is sales, it is marketing."[3]

By the late 1990s corporations were well embedded in the museum community and were pushing the limits of their sponsorships as far as possible. In order to deal with the fallout at the Brooklyn Museum in the late 1990s, when lenders of the exhibition "Sensations" were also the financial sponsors of the show, the American Association of Museums decided that it was an opportune time to provide some direction for American museums when it came to corporate relations and sponsorships. As a result of much prolonged study, the AAM produced an elaborate set of guidelines for American museums. Although the "moral hazard" of cozy sponsorships is more art museum oriented, other museums can find themselves in situations where the overbearing sponsor literally wants to "run the show." Those guidelines are long and demand professional attention. An abbreviated "executive summary" follows.

AAM Guidelines for Corporate Relations: Five Points of a Good Corporate Policy

A. *Loyalty to Mission.* Board-approved policies to protect assets and reputation and be consistent with the mission. Methods of developing and managing business support should be consistent with a museum's mission and with the policies and procedures that flow from that mission.

B. *Compliance with Applicable Law and Code of Ethics.* The AAM's Code of Ethics states that compliance with applicable local, state, and federal laws and international conventions is a minimum requirement. Ethical standards should exceed these minimums.

C. *Content Control and Integrity.* It is your responsibility to control the integrity of the content of your programming for the general public. The museum community recognizes and encourages collaborations with a variety of stakeholders, including national, regional, and local funders. AAM advocates careful examination and control of the content and integrity of programs, exhibitions, and activities essential to its public trust responsibility.

D. *Avoidance of Conflict of Interest.* AAM's Code of Ethics notes that where conflicts of interest arise—actual, potential, or perceived—the duty of loyalty to the museum and its mission must always be honored. The board of trustees and staff must ensure that no individual or business benefits at the expense of the museum's mission, reputation, or the community.

E. *Transparency.* AAM asks that museums take steps to ensure that the museum's actions are transparent and understandable to the public—especially in areas where lack of transparency may reasonably lead to an appearance of a conflict of interest.

These suggestions by the American Association of Museums, if adopted, will keep you and your corporate sponsor at arm's length in a professional and businesslike contractual relationship that will be beneficial to both parties. Policies adopted by your board of trustees well ahead of any corporate sponsorship arrangement will keep the institution and you out of trouble. Both sides of the contractual arrangement will have a clear idea of goals and expectations *before* the first object is placed in the sponsor's exhibition.

Corporations should be targeted for special projects with an entirely different set of vetting criteria than foundations. You might think about corporate support along the following lines.

Geographically, or geographical ties: If you are doing an exhibition on Native Americans in Alaska, you might involve a corporation with drilling or oil interests in that state.

Product or subject ties: An exhibition on early medicine would likely attract a medical or pharmaceutical manufacturer. An exhibit on sports or sports equipment might attract a sports equipment manufacturer looking for a marketing vehicle or promotional send-off for one of its products.

The market tie is perhaps the most sophisticated level of approach. This allows the corporation to open a new market area using your exhibit as a vehicle. It is even more valuable to a potential sponsor if you can travel your exhibit. Most small museums will not be in a financial position to mount and travel their own exhibit, but if you are taking an exhibit from another institution, you might be able to convince the local branch of a major corporation to sponsor the exhibit in your venue.

Be advised that corporations will never fund the full amount of the money you need to mount an exhibition or successfully execute a program. They might wish to be a lead donor or sponsor, but never the entire underwriter.

Foundations

All but operating foundations are fair game for project support. As stated earlier, foundations support societal needs, disease research, hunger relief, humanitarian causes, and scholarly research, and they are more outcome oriented than corporations. Most foundations will never fund general operating support and do not tend to fund endowments. They prefer specific projects and capital campaigns that build buildings. A curator recently asked me: "Do you mean to tell me that XYZ will help us build a new wing and not help us with the operational needs it will ultimately generate?" Yes, and the answer implies that once you build it with the foundation's money, it is your responsibility to operate it and find the funds to do so. But with more than seventy-five thousand foundations in the United States, it is the professional's responsibility to find which will actually fund your special needs. It is an enormous universe, but someone has to narrow down which ones to approach. For the small museum in a tight-knit community, most funding sources are known and probably oversubscribed.

Foundation fundraising can be very frustrating because of all the rules and regulations, state and federal, and their own internal policies. One fundraiser, Nancy Lublin, posted online an open letter to her foundation "friends" that captured the frustrations some feel in dealing with foundations. Ms. Lublin noted at the onset that although we are "friends," we seldom talk seriously to each other and that we need to have some healthy conversations about our relationship. She acknowledges the fact that the nonprofit world depends on the "goodness of strangers," but we don't speak honestly to each other. By that she means the nonprofit world speaking to the foundation world. She maintains that our "world" doesn't speak truth to power. As she says, "We don't say when we think you've made a bad decision, because in the hoity-toity world of big money (yours) and little not-for-profits (us), that would be impolite—and, on my part, stupid. We fear losing your money."

In her tirade she calls out four areas where she thinks the foundations are not listening to us. The first admonition she fires across the foundation world's bow is: Stop thinking you know everything. Lublin voices what many in our field have thought a long time. In so many words, she asks the foundation officials to walk in our shoes when they consider grant proposals and to stop acting like they know it all.

Her second sore point is "stop mistaking marketing for overhead—and stop hating on overhead." Lublin hit a hot point with me here. I recently ran across stiff foundation opposition in asking for money to "rebrand" the museum. The response from the foundation was that we should rebrand before we raised more money. It made no sense at all. Another foundation executive, completely out of touch with modern advertising, wanted to see us on more "billboards around town." It reminded me of a similar story of the CEO of a modern for-profit company who was chided by his boss— the chairman of the board—that he didn't see enough of his company on the city's billboards. The CEO, taking his cue, bought billboard space in his chairman's neighborhood on his morning and evening route to and from work. With that the chair was satisfied and the CEO kept his job. As Lublin points out, we all have business expenses like for-profits have and that we must "spend money on expenses that you (foundations) label with the most unfairly pejorative word in our business: overhead."

Lublin's third rant to the foundation world is a plea to pick the recipients of its largesse much as does Warren Buffet, who, she writes, "picks targets that make long-term sense and pulls in smart investors with him." She feels that there is too much redundancy in our field that is encouraged by sloppy funding and a "Santa Claus" mentality. "Does it make sense to bankroll three different organizations claiming to be the umbrella coalition for New York not-for-profits—or could we just get behind one?" she asks. As a counterpoint, I would be remiss not to rebut this particular argument. I have worked in a few situations where this is definitely not the case. I have witnessed situations where foundations have forced organizations to work more closely together or merge in order to avoid duplication; a duplication producing more mouths for the foundation world to feed.

But I must agree strongly with Lublin's fourth rant: "Stop thinking that newer is better." I believe she is correct in complaining that foundations are always looking for new ideas and new projects. Sometimes we need the money just to keep the doors open. "We just wish you'd get behind programs with proven track records so that we could focus on making them better, rather than coming up with a new gimmick to catch your eye. We know that much of what we do isn't sexy, but it is important; think about funding the not-for-profit Ugly Bettys too." During the recent economic downturn, several New York foundations recognized the need to discard their rules and requirements in order to save many nonprofits from closing

forever. In a parting shot, author Lublin wrote, "On my end, I promise to stop calling 'for advice' or 'just to check in' when that's never the point of the conversation. We both know what I really want: your check."[4]

Reactions to her "rant" were mixed. Some responses agreed with her frustrations and candid talk but wondered whether she was being too "snitty and judgmental." One respondent was appalled at her abrasiveness, comparing it to the welfare office line, where all they want is "your check." Clearly foundations and donee organizations need to keep the lines of communication open in both directions. Sadly, though, there is a kernel of truth in her comments that some major foundations are out of touch with the needs of the nonprofit community.

During the "Great Recession" of 2008–2010, some foundations responded positively and promptly to the shifting financial sands. The Doris Duke Foundation realized that its policy of funding capital projects needed to be modified to serve other needs. "Some foundations decided to increase the amount they dispense each year, even though that may trigger a higher excise tax. Others allocated "their grants to support nonprofit groups' operating costs, when they traditionally" had supported programs or capital. Several foundations renegotiated their outstanding grants with nonprofits, a process unheard of in ordinary times. A few extended payments or reduced the matching requirements. One was prepared to make grants allowing arts groups to use the money just to get through the rough patch.[5]

Smaller museums should routinely check with their local foundations and see whether they have changed their focus in tough times as these large foundations have. The opportunity is too important to let it slip away. The director of a small museum should have a list of those family foundations or funds in the community foundation that are susceptible to change and nimble to respond to the economic environment. Your need is for unrestricted funds, not capital or special projects support. If they haven't changed to suit the new reality, a visit with your chair to inform him or her of your need to keep the doors open, the AC on, and the staff paid instead of sponsoring an esoteric exhibit on exotic textiles.

Major Individual Donors—Carefully Chosen

A few wealthy individuals will provide project support, but they will usually do it through a private foundation or family trust they have

established for this very purpose. As stated earlier, many wealthy families are no longer establishing costly foundations to manage and give away their money but are turning to donor-advised funds with financial institutions. Knowledge of your donor constituency is imperative before asking an individual for support of an exhibition. It is rare that the individual will fund the entire amount.

Service Clubs

Don't overlook service clubs such as Rotary, Lions, Sertoma, and others. They are community based, small, and capable of giving small grants such as five thousand dollars for a cataloging project or school outreach. These organizations are best approached by someone within the organization who has an interest in your museum and its educational (usually) programs. Again, here is another reason to have people on your board with wide interests such as these all-important community organizations so that they can open doors and introduce you to the decision makers.

Government Agencies

Of course, government agencies—state, local, and federal—are usually always prime candidates for grants of all types and sizes. In the latest economic downturn, however, only the federal government has the authority and continues to print money—a power that state and local governments do not have. State granting agencies such as the state humanities or arts councils have been devastated by falling state revenues and have suffered drastic cuts that may never be restored.

Elements of a Successful Grant

Do Your Research

As one fundraiser wrote years ago: "The great mystery that surrounds proposal preparation usually stems from lack of information and/or experience. (Successful) proposals in most cases are submitted in reply to a foundation's response to initial inquiry; a random proposal submission is a waste of time, money and mutual good will."[6]

Failing to research and evaluate prospects thoroughly is the surest way to lose the gift and a potential long-term supporter. Conversely, good research will produce a fruitful relationship that cultivated over the years will produce gifts many times over.

Sources

Today, the main source of information has become the Internet. Powerful search engines like Google will take you to any granting source within seconds. As mentioned above, most foundations—corporate and independent—have posted their guidelines on the Web. You can literally spend hours navigating the Web for specific funders.

Another older resource available in real and virtual space is the Foundation Center. The center has real locations in New York City, San Francisco, Atlanta, Washington, D.C., and Cleveland. Before the Web, a grant seeker would have to travel to one of these cities or write via snail mail and then wait for an answer. Now each of these centers has its own website.[7]

In addition, the center has what it calls "cooperating collections" throughout the United States. As of this writing, the center had "collections" in all fifty states and Australia, Brazil, Mexico, Nigeria, South Korea, and Thailand. According to the center, "participants in the

Foundation Center's Cooperating Collections network are libraries or nonprofit information centers that provide fundraising information and other funding-related technical assistance in their communities. Cooperating Collections agree to provide free public access to the Center's online databases and a basic collection of Foundation Center publications during a regular schedule of hours, offering free funding research guidance to all visitors. Many also provide a variety of other services for local nonprofit organizations, using staff or volunteers to prepare special materials, organize workshops, or conduct orientations." These are an important resource for all grant seekers and should be first on your list in doing your preliminary research. Additionally, the Foundation Center can break down funders by type and most importantly by region. The latter designation will cut your research time down considerably, allowing you to concentrate on your immediate area.

Perhaps its most useful tool, "FDO" or "Foundation Directory Online" provides instant information on donors and more particularly all the research tools needed for successful grant writing. On its website, the foundation promises access to "nearly 100,000 U.S. Foundations and corporate donors, 1.9 million recent grants, and over 500,000 key decision makers." The Foundation Center offers five different subscription levels with fourteen different databases—grant makers, companies, grants, and IRS 990 access. The latter contains a wealth of information in your research. The infamous 990 forms were revised in the 2007–2008 time frame. The 990 form is to all nonprofits what the 1040 is for individuals. It is the Internal Revenue Service's tax return for all charities. For the grant seeker it is a gold mine of information concerning all properly registered foundations. According to the IRS, "Form 990 is used by the IRS as the primary tax compliance tool for tax-exempt organizations. In addition, most states rely on the form to perform charitable and other regulatory oversight and to satisfy state income tax filing requirements for organizations claiming exemption from state income tax. The Form 990 is a public document that is made available by filing organizations, the IRS, and others. It is the key transparency tool relied on by the public, state regulators, the media, researchers, and policy makers to obtain information about the tax exempt sector and individual organizations. Each year, over five hundred thousand organizations file a Form 990 or Form 990-EZ with the IRS."[8]

Today's forms provide a veritable cornucopia of information previously unknown to funders that make their viewing even more rewarding. The foundations are required to reveal practically every transaction, salaries of highest-paid employees, grants made, grants paid, grants deferred, three-year payouts, and much, much more.

Since 1899, Marquis's *Who's Who* has published biographies of famous and infamous Americans and world leaders. The book, issued at random times and now in several different versions, such as *Who's Who in American Politics, Medicine and Healthcare, in American Art*, and *in the World*, to name a few of the total of twenty-four. The online version claims to provide access to more than 1.4 million biographies.[9]

Individuals spotted in *Who's Who* will not tell you what money they will give you, but you will get a feel for their status within a particular geographic area, the boards they sit on, and the charities they support (either stated or implied). For more information, turn to the waning usage of periodicals such as *Forbes* and *Town and Country* magazines. Every month these prestigious magazines offer a view into the privileged classes the world over. While the information they provide can be peripheral or vapid, their favorite charities documented with charity balls and events can provide insights. Couple those sources with occasional newspaper or weekly business chronicles that list the top fifty to one hundred businessmen, entrepreneurs, Realtors, developers, bankers, and so on in your area, you are beginning to build an intelligent portfolio of movers and shakers in your community or region.

Contact

Whatever you do with a foundation, do not drop in on its offices because you "just happened to be in town." Call ahead and set up an appointment to see them—not to make a pitch, but either to introduce yourself if you are unknown to them or, if you are well known, to have a regular, planned meeting with them annually or semiannually to bring them up to date on your institution. This is not a solicitation call, but a cultivation call. Do not e-mail them. Call them and ask whether they will see you. Make personal contact. Find out who the decision maker is, and try to get in to see that individual. Ask whether the information you have is current. With today's instant information via technology, the latest is always available.

The Nissan Foundation is an interesting example. When they came to see us at the Atlanta History Center, their representative spent about

an hour with us to determine our suitability as a prospective investment. They were checking us out to see whether their giving program matched our needs and to verify whether we were worthy of a grant.

If you are finally there "on the call," a few words of advice are in order. If you are not the principal investigator (project director), take that person with you. They know far more than you about the details of their project than the director, the chair, or the development director. If you are the project director, take the chair of your board and the director—or at least one influential member of the board. Dress appropriately; a dignified appearance is essential. Do not wear thrift shop, army surplus, or punk fashions when calling on conservative corporations or foundations.

Be on time; better yet, be early. Leave when your host signals the end of the conversation, and don't drag it on with one more point. Have your facts straight about your host/prospect. You don't want to tell Microsoft how much you are enjoying your iPhone or confuse Pepsi with Coca-Cola (especially in Atlanta). You need to avoid controversy in the conversation—this is not the time to proselytize for your favorite cause. Your favorite cause is your museum at this point. Besides, most of these conversations are so brief—fifteen to twenty minutes—that you will never get into hot-button issues anyway. Above all, be direct, open, friendly, genuine, and sincere, and exhibit all the aspects of a Boy or Girl Scout.

During the interview, listen, ask questions, and take notes. One of the reasons to bring along a colleague is that one of your can take up the slack during an awkward pause in the conversation or remember a fact that the other has forgotten. By all means, rehearse the call with your colleague before you visit the prospect, and determine who will cover what. Contradictions and conflict on the visiting team's part should be avoided at all costs. Airing your organization's dirty laundry is déclassé; and trashing the competition is bush league. The other museums in your community have strengths and weaknesses just as your institution does and it will do you no good at all if you denigrate your colleagues—and it will probably hurt you in the long run. In the short run, it may even doom your chances for an immediate grant.

Be enthusiastic, but don't be a cheerleader. Above all, have your facts. Understand just what it is you are selling and what you expect of the prospect. Know your institution, your mission, your goals, long-range plans, and the various images, real or perceived, so that you can intelligently respond to questions.

Immediately after the interview, send a thank you note. Keep it brief, be upbeat, and refer to a hoped-for "successful conclusion" of your negotiations. If this was a preliminary conversation and you are now to submit a full proposal, promise that it will be forthcoming quickly and state that you know it will receive a judicious review. If the purpose of the interview was to clarify/defend points in a previously submitted proposal, you can express the conviction that you have addressed the concerns of the interviewer. Reinforce the notion that you remain available to answer further questions, and list your direct telephone number.

Helpful Hint: A new common practice is for a foundation/corporation to ask for a letter of inquiry. In Atlanta, the Atlanta Community Foundation recently received more than 176 inquiries, requested that only thirty-six of those provide a proposal, and awarded only sixteen grants to area nonprofits.

Writing the Proposal

Once you have established your top four or five foundations or corporations, determined your need, and have a crystal-clear idea of what you want to seek grant funding for, you must begin to put your word processor to work. The most important advice I can give is to use crisp thinking and writing. If the process is collaborative, be sure that only one person writes the grant application and not a committee. One writer, one voice.

The proposal is the most effective way to present your case to a prospect who might be interested in investing in your enterprise. Entrepreneurs of startup companies face the same challenges when they approach venture capitalists. They may be asking for millions more than you are, but the principle is the same. Above all, use proper language and try to avoid jargon. Clarity and brevity should be your watchwords. For years, I have been an IMLS and NEH grant reader and reviewer. I read one of the most extraordinary grant applications several years ago. It suffered the most remarkably atrocious case of poor English and fulsome jargon that I copied it for future use. In this astonishing narrative, the writer was trying to explain how the museum would approach research. The museum wrote:

"The basic model for developing a framework for evaluating special project grants is contained in the General Objectives . . . provided for the study. These four objectives provide both a logical sequence for concep-

As a museum person, you are well qualified to write a grant proposal. The best ones come from the heart and are nothing more than a very good narrative.

tual development and a taxonomy of relevant constructs whose definition and operationalization are the key elements in providing valid substantive information." What a delicious example of what to avoid in writing a grant. How could a reviewer possibly understand what the writer had in mind? My spell check rejected "operationalization" with "No Spelling Suggestions" and offered to add it to my dictionary.

Whether you are writing to a corporation or foundation, be sure to follow the prospect's guidelines. They wrote them for a reason, and they usually take points off if you do not follow the rules, even though you think you are being cute and creative.

Use and attach auxiliary materials sparingly. If they ask for specific materials, by all means include them; if not or if in doubt, leave them out.

As always, ask for the order. Tell the grantor what it is you expect of them. The lesson here is no different than explained earlier, that the prospect in a capital campaign and a prospect for a project have to know what their stake in the project is. Again, always place the order in context. If you are attempting to raise $75,000 to start a new interpretive program and you are seeking a third of that from this particular prospect, say so. Tell them the entire length and breadth of the project and their "piece" of the action. Some large foundations like the Lilly Endowment will invariably require a match. Others will indeed wish to fund the entire project. Others will want to know who else you also intend to approach so that you are not relying on them for the full cost.

Be sure to lay out your cause or challenge in the clearest language possible. Here is what we want to do and what must we do to succeed. What is it you wish to accomplish—what need will be met? Will it just be a museum need, or do you have a more compelling story to tell that has community-wide implications? Tell a story that a layman can understand without the jargon and inside baseball terminology. Always give a brief history of the organization, its mission, the strategic plan, the goals and objectives, and above all your vision for the future of your organization and how this particular project fits and moves along that vision.

If they don't ask you, you do not hurt your case by revealing other corporations or foundations you are approaching. Multiple simultaneous proposals do not hurt if you are open and transparent about your strategy. If you are approaching a corporation for a sponsorship, the negotiations must be sensitive to the real world and competitors. Major sponsors want to ensure that you do not offer equal sponsorships to their competitors. In fact, if they do sign on, they may require a clause in the sponsorship agreement that you do not approach another bank/Realtor/railroad/energy company/airline.

They will sometimes ask and then require knowing whether your museum committed resources to the project. Are you supplying cash or personnel? Usually foundations and sometimes corporations will accept staff salaries and administrative overhead as a match to their hard dollars. More important, you will be required to prove that you are a sound institution. In the Atlanta fundraising scene, foundations are particularly concerned with your bottom line. Are you continually running a deficit? How strong

are your board contributions? Do you have 100 percent participation by your board in the annual appeal? Are they all members?

Be sure to address the length of the project. Will the project be one, two, or three years? Will the project be sustained after the grant expires? If so, how? Will you increase your operating budget to cover the increased costs? Or will you be seeking more grant money to continue your program? Are the skill sets and qualifications of the principals involved in this project suitable to bring it to a successful conclusion? Have others tried this program, or is this a model than can be duplicated elsewhere? If others elsewhere have tried this program, has it been successful, and why? If not, why not? Above all, what makes your museum qualified to take on this project?

Increasingly, foundations and corporations are asking for evaluations. Quantify your goals with numbers served, households reached, and homeschoolers attending. In the old days, when a museum applied for money from either, there was usually no accountability. Today, metrics and outcomes are all the rage, and rightly so—these granting agencies want to ensure that their money is being spent wisely, with measurable outcomes. Here you need to refer back to your mission and your strategic plan. You should already have procedures and mechanisms in place to determine the effectiveness of your plans.

Supporting documents are usually required. The foundation may ask for additional information such as your 501c(3) status letter, your 990 form, a list of board members, your articles of incorporation, your latest budget, and/or your latest financial report. Letters of support may help; they may also hurt—ask your grantor whether it wants to see them before you seek them. It's as simple as that.

As one writer eloquently said, "Simple proposals with minimum of gloss or frills are better received than elaborate proposals because window dressing often reflects bad taste or preoccupation with trivialities." That same writer wisely advises, "Don't oversell" your institution. "Most foundation staff members have heard the virtues of education, health care, religion and social service many times."[10]

Helpful Hint: Listen carefully to the feedback from corporate or foundation grant officers and build your proposal according to their suggestions.

Writing the Budget

Where to start? Tackle the biggest numbers first. In most grant applications, unless you are trying to buy an expensive piece of equipment, personnel will probably be your largest expense. It is best to start with personnel at any rate because if you are proposing a multiyear project, don't overlook annual increases. Don't forget security and maintenance. A common error is to overlook benefits such as health care, vacation, sick time—all common costs to your regular employees. If you hire someone as a consultant, all those costs are the consultant's responsibility, including all taxes. In fact, it sometimes makes more sense to hire a specialist for the project on a contract basis rather than as a temporary employee of your museum during the grant period.

Going to hire consultants? Be sure to budget travel and all of their out-of-pocket costs and expenses. Office supplies, equipment, and materials must be honestly and thoughtfully planned out. Above all, don't forget indirect costs as a percentage, such as heat, AC, and lighting, all of which can be legitimately prorated for the project. One of the most elusive costs is administrative. Remember that it costs money to monitor a grant. Bookkeepers must keep a pristine paper trail, checks against the proceeds of the grant must be cut, receipts monitored, reports prepared, and bills delivered. All this costs money. Some large universities charge enormous administrative fees, ranging as high as 150 percent of the grant. Some of these are negotiated with the federal government and govern federal grants.

Last-Minute Details

A host of details must be attended to before you send off the package. Ensure you have the correct number of copies specified by the funder. Make sure all the usual items are correct—the funder's address, correct spelling, title, and required number of enclosures. Your final proposal should look professional. It needs to be in that middle ground between looking too glitzy and too poor. Above all, remember to keep a copy for yourself.

Follow Up

Do call after a few weeks to see whether they have received the proposal. Above all, don't harass them. Genuinely inquire to see whether they have any questions about your request. If the funder has no timetable, check back often only on a comfortable basis. E-mail is also another

means of checking, but it is also easier to get a premature no. If you are on the funder's timetable and it is January and they have told you they will have a decision for you in July, call immediately after you have submitted the proposal to ensure they received it and all is in order, and then do not call again until July if necessary. Usually it is unnecessary to call the major foundations; they will give you an answer when they promised.

Acceptance and Rejection

There are four possible responses that you will hear from the funder: let's talk about your application; we would like to have additional information; no; and yes. I particularly like the first response. Here is a chance to go for the gold. Here is an opportunity to fill in the details, to make another passionate plea, and perhaps sway the prospect toward the project, particularly if they were leaning away or undecided. The second response is a corollary of the first. It is an opportunity to extrapolate further with another appointment with the funder to make your case.

Rejection

If rejected, don't go away mad; thank them and move on. If rejected, ask them how to improve the proposal for the next time. Don't argue over a rejection, but ask for advice—how can you strengthen the proposal? If you do get funded by some other foundation or source, send them news clippings and show them, in a nice way, that you are doing a good job. Never badger them or argue about a rejection. Your job is not to win the hearts and minds of a single foundation or corporation, but to ensure the financial integrity of the museum. Grant applications get rejected every day—only some are turned down because they were terrible applications. There is a host of other reasons funders turn down applicants that have nothing at all to do with the quality of the application or the institution you represent. Rejection may be a result of overcommitment by a foundation, by the fact that they had funded a similar program elsewhere, or that the funder has abruptly changed direction. In hard times, many funders have narrowed their fields of giving to social services. The UPS Foundation changed its focus to environmental issues and improving global communities. For a local museum or other nonprofit not focused on the global stage, this hurdle is large and insurmountable, no matter how creative you are.

Above all, take rejection in the most positive way possible. Look at it as a learning opportunity and a way to strengthen your proposal for a subsequent resubmission. Do not become angry, petulant, vindictive, or resentful. Instead find ways to improve the product for a second attempt.

If rejection is indeed the applicant's failure, the proposal could have been rejected for a host of reasons. You may have failed to ask for a specific amount or to demonstrate that the grant fits into a larger picture (put it in context). You may have failed to show that others have committed to the project (remember, they usually do not want to be the only funder), or you might have described the problem but not the solution. Perhaps the museum does not meet the funder's priorities or you are not in the correct geographic area, the budget is not within funding range, it doesn't follow funder's format (big research failures). Perhaps the proposal was just poorly written and difficult to read and filled with jargon (have others critique the proposal before sending it out). Or, as one foundation executive concisely

put it, "In some requests for general support, the proposal describes the organization as a 'sinking ship' and then invites the foundation to fund the organization. Why would a foundation want to board a 'sinking ship?'"[11]

You may have been rejected if you did not set up preproposal meetings with the funder and they really don't know you. This cardinal sin should have been avoided by setting up meetings for show-and-tell sessions where you could adequately cultivate the funding prospect. The use of a preproposal would have been helpful here. Did you use your board for entrée?

It is also possible that the proposal didn't appear urgent and its impact was indeterminate. The proposal should have sounded urgent and not in a panic or crisis mode. Or you promised to deliver an obviously undeliverable program in an unrealistic time frame. Perhaps you failed to provide evidence that your program would have become self-sufficient and sustainable after the grant period. Did you get a grant from them before and fail to say thank you or, worse yet, fail to report on your expenditure of the funds? The latter could very well eliminate you from future consideration by that particular funder.

Above all, do not threaten them with a visit or a call from one of your high-powered board members. That is dumber than a post. You mission in life is not to intimidate support, but to nurture it.

Acceptance

Have a celebration, and always remember to say thank you—recognition is paramount here. Get out a press release with the funder's blessing—some wish to remain anonymous. But also realize that the work is just beginning. You cannot take the money and run. The funder who showed enough interest in you to provide you with a grant did so because they have an interest in how well you do with their money. You now have an obligation to keep them informed of your progress or lack of it.

Helpful Hint: The Federal Institute of Museum and Library Services, in its Museums for America Program, has reduced the application for funds into four general categories that could serve as a model for all grant applications to any funding body. They are: a statement of the need, the project design, the project resources (budget, personnel, and timeline), and the impact of the grant. Every good grant application should contain elements of these four categories.

The twenty grant-writing tips that follow come from the Arcus Foundation, which like many foundations has certain niche programs and projects that they support. They do not support arts and culture. According to their descriptive copy, the "Arcus Foundation is a leading global foundation advancing pressing social justice and conservation issues. Specifically, Arcus works to advance LGBT equality as well as to conserve and protect great apes." This is a highly unusual and divergent focus for any granting agency, but it illustrates quite well the need for every nonprofit to do its homework well and in depth before charging out the door asking for money. The twenty tips, however, apply to every grant application you consider, regardless of your size and focus. Written by Arcus Foundation's senior director of grantmaking and evaluation, the twenty suggestions and admonitions are worth their weight in gold. Ignore them at your own peril.

20 Grant-Writing Tips

1. Program Planning-Good Proposals: programs and organizations designed with clear goals and measurable objectives, time lines, budgets, and work plans easily translate to good proposals.
2. Make Sure You Can Accomplish What You Propose: don't chase funds that are not compatible with your mission and strategic direction; make sure you are not promising something you cannot deliver or in a timeframe that is impossible; don't ask for an amount that is unreasonably high for that specific funder, but don't lowball your cost estimates either.
3. Guidelines, Guidelines, Guidelines: a foundation's guidelines should act as your road map to proposal preparation, guiding both your proposal's content and its format. Remember: if you've seen one foundation, you've seen one foundation!
4. The Four C's—Clear, Concise, Connected, Creative:
 a. make sure the proposal is **clearly** written and not full of the "jargon" of your field; define your terms;
 b. be **concise** and try not to repeat the same thing over and over; you can include longer pieces of information (e.g., detailed descriptions of other programs in your organization that are not the subject of the proposal) as attachments to the proposal rather than as part of the main narrative;

 c. **connect** with your audience (i.e., the funder); use language that will appeal to that specific funder (e.g., you might talk about "investment in the community" to a corporate or business funder and you might talk about "empowering marginalized communities" with a social change funder);

 d. be **creative**: tell a story and let your writing flow; get inspired by the visionaries in your organization; remember, this is NOT government grant writing.

5. Use Statistics and Hyperbole When Appropriate, but Don't Overdo Them: data and statistics, whether about your organization or the population/community you serve, can be helpful in setting forth your statement of need; hyperbole—stating that your organization is the "biggest" the "first" the "most accomplished"—has its place as well. Use both strategically, but don't overwhelm the funder with either.

6. Anything That Raises a Flag Should Be Explained: if your organization is having problems, if something unexpected has occurred (e.g., your executive director is resigning), be proactive about telling the funder outright. This way, you are in control of communicating the information and stating how your organization will be responding. Don't let a funder find something out from the community, another funder or, especially, from the daily newspaper.

7. The Organization Description Section Should Convey a Sense of Stability (or Innovation!), Leadership, Expertise and Excitement: explain why your organization is well positioned to take on the work for which you are seeking funding; explain why you are the best organization to do this work; explain where you fit with respect to other organizations in your field; let the funder know with whom you collaborate and that you work and play well with others.

8. The Statement of Need Should Be an Opportunity to Educate the Funder: place your work within a context; focus on the specific geographic need that you will be addressing (e.g., for a teen suicide prevention program in your city, provide information and data about teen suicide rates in your area as opposed to the national rates); explain the extent to which more funding can help you meet increasing demand.

9. The Program Description Should Flow from the Statement of Need: make sure that the program you are proposing connects back to the need you have defined; include measurable (i.e., quantifiable) objectives.

10. Know the Difference between Outputs and Outcomes: organizing three educational workshops serving 90 people is not an outcome of your project, it is an output; the outcome is increased skill and knowledge.

11. In the Evaluation Section, You Are Stating How You Will Know If the Project Is Successful: don't be afraid of evaluation; it doesn't require a PhD. Just tell the funder what you will be measuring and how you will be measuring it. Remember, process evaluation measures how well you carried out your work plan ("we held 3 workshops that served 90 people") while outcome evaluation measures whether your activity made a difference ("90 percent of our participants were still practicing safer sex after six months").

12. Don't Forget to Connect Your Request with the Funder's Priorities: you can do this in an introductory or concluding section or in the cover letter.

13. Include Both Revenue and Expense Items in Your Budgets and Financial Reports.

14. A Budget Reflects a Plan for Future Revenues and Expenses; A Financial Report Reflects Actual Revenues Received and Expenses Incurred: a budget narrative is an excellent way to explain the details of your budget (e.g., the line item for staff at $100,000 reflects two full-time positions and benefits at $60,000 and $40,000).

15. A Funding Plan Explains How You Will Be Raising the Remainder of Funds Needed: show each anticipated source category (e.g., individuals, special events, grants) and detail where proposals have been or will be submitted.

16. Put Your Attachments in a Logical Order or in the Order Specified in the Funder's Guidelines.

17. Use Simple Stapling or Binding Clips Instead of Expensive Packaging.

18. Re-Read the Funder's Guidelines to Make Sure You Have Included Everything and Have Complied with Production Requirements: including the number of copies required.

19. Remember . . . Someone Has to Read This: make sure the document has readable font sizes, decent margins, numbered pages, no misspellings, and the name of the Foundation to which you are applying (NOT the name of the Foundation you sent something off to last week!).

20. Have Someone Outside Your Field Read Your Proposal: give it to your best friend, your sister or significant other. See if they understand

it, if it is free of typos and jargon. Remember the funder may not
be immersed in your area of work and may be learning about your
field for the first time.[12]

For Internet guides and resources on good grant writing, I suggest the
following websites:

http://www.learnerassociates.net/proposal; this is from Michigan
State University and reliable. For guidance in all areas, such as science,
geology, federal, writing aids, and bibliography, see http://www.pitt
.edu/~offres/proposal/propwriting/websites.html from the University of
Pittsburgh. Emory University offers an evening program for a Certificate
in Grant Writing at http://cll.emory.edu/eate/certificates/grantwriting/
index.htm?gclid=CN77hOGklKICFRabnAodMCyZGA. The Minne-
sota Council on Foundations at http://www.mcf.org/mcf/grant/writing.
htm should be consulted for guidance in preparing your proposal. And
then there is always Indiana University Purdue University at Indianapolis
Center on Philanthropy, which has a wealth of information on all sorts of
fundraising. See also the bibliography in this book for resources in writing
that successful grant application.

In Summary

All knotted up just thinking about writing a grant application? Relax
and remember why you are in the museum business—you are a story-
teller! Writing the successful proposal entails communicating with the
funder, following directions, being creative, clear, concise, and accurate;
emphasizing what the museum will do; telling the funder how you will
conduct an honest appraisal of the project with rigorous evaluation, and
proofreading carefully before you package it and drop it in the mail or
transmit it electronically. Think about that grant application as a narra-
tive and write a good narrative. Of all people, museum people are great
storytellers, and the best grant writers know how to weave a compelling
narrative. You write narratives for your exhibits, your newsletter, your
annual report, your programs, and your daily correspondence, whether
e-mail or snail mail—why not for your grant applications? Write a very
rough draft of all you want to cover, and then edit the heck out of it.

If you are not the person, find that person on your staff, in your volunteer group, or in your community. If you are really desperate, there are unemployed English majors who will hire out to write your grant for you. This is great, but one must wonder whether they can convey the passion and excitement of your vision as well as you or someone on your staff can.

MAJOR GIFTS, TRANSFORMATIONAL GIFTS, AND PLANNED GIVING
Concepts for the Advanced Institution

Do your givin' while you are livin'. . . then you'll be knowin' where it's goin'.

—Ann Landers

Whether you are in a four-person museum or a forty-person organization, sooner or later you will be dealing with major gifts, transformational gifts, and deferred giving. Some advanced larger institutions have major gifts and planned giving officers within their rather large development offices. These particular gifts of a transformational nature are not considered something in which smaller institutions are involved. At one time or another, you will most certainly be involved in the disposition of a will. As stated earlier, you must understand the various details of any gift, but more specifically the major transformative lifetime or deferred gift. Crystal-clear gift agreements as outlined in chapter 5 are critical.

But be aware that human beings can make agreements and human beings can change or ignore those contracts no matter how tightly drawn they are. Frederic Fransen, executive director of the Center for Higher Education, has pointed out that the human time horizon does not necessarily extend to an indefinite point. He reminds us that when nonprofits "repurpose" a gift, they encounter problems when they don't follow "appropriate legal procedures." In an article entitled "Don't Let Universities Stiff Donors," Fransen makes the case that both sides of a gift agreement eventually are taken over by time. "Donor intent doesn't just abruptly end," he writes.

"More often, it fades away." And you have certainly seen this in nonprofits. "A key faculty member retires; there is turnover in the president's office; a budget crisis arises; or the donor dies; and people plain forget." Fransen cites one university that includes a provision in its gift agreement that allows it to reallocate restricted funds after twenty-five years.

On the donor side, Fransen makes the cogent observation that "the half-life of donor intent may be no more than about 10 years. For the first few years, the institution probably will adhere to the terms of the gift. By the tenth year, the program will still exist, but with a different shape. By

Once you understand that fundraising has become more complex and you have mastered all of the intricacies involved in the donor process, you must keep the end goal in mind. No matter how chaotic the process is, keep your eye on the prize—a major donation eventually from that special donor you have been cultivating all along.

year 20, the program might exist in name only. By the 30th year it will be merged into something else. And by the 40th year the program will disappear." He paints a pretty bleak picture of the major gift. "The money," he continues, "won't disappear." The corpus will remain and grow within the general endowment. He argues that donors must understand that "forever doesn't mean forever. Money donors give today could be financing things they wouldn't imagine 10 or 20 years from now." And that, he concludes, is why it is "important to get gifts right." And the donor, he argues, must keep nonprofits accountable.[1]

Princeton University is also involved in a controversy over the largest gift ever given up to that time to higher education. The Robertson Foundation gave the university thirty-five million dollars in A&P stocks for the establishment of the Woodrow Wilson School of Public and International Affairs. The family now contends that Princeton routinely ignored their wishes over the years and has brought a lawsuit to retrieve the money. The university claims that the descendants were upset that they were not the recipients of their parents' largesse, and the family has shot back that the university is "really no better than your typical con artist." The parties settled in December 2008 after six bitter years of dispute. Princeton will maintain its control over the Robertson gift and will continue to use the legacy as agreed fifty years ago—to train individuals in government service. The implications of the lawsuit and settlement put in play the age-old question—do descendants have any rights or control over gifts made by their ancestors (or for that matter, by others not related) years later for any reason whatsoever?[2]

Recognizing this reality, lawyers William Schwartz and Francis Serbaroli suggest that donors understand that their gift's terms—whether cash or collections—might be altered by a charity or by descendants at a later time. They suggest that donors explore "whether they want to include an alternative charitable disposition of their assets instead of risking the possibility of a court ordered deviation." Or a donor "could be less specific and confer a power on a designated person or committee to reform or modify the gift in a manner most closely approximating the donor's charitable" intent. A lawyer should be involved in the event that estate and IRS complications could cloud the original objective. Schwartz and Serbaroli conclude that both the donor and nonprofit "work cooperatively and carefully . . . in planning . . . gifts and drafting legal documents that govern their administration. Donors and charities should bear in mind the

admonition that, without careful planning and execution, their laudable goals and hopes may provide a good breakfast but a poor supper."[3]

Major Gifts

Why segregate major gifts from the general discussion of fundraising? First and foremost, they require much more care than the annual fund donor at one hundred dollars. Both are important, but the major donor requires extra care. You will want to eventually move that hundred-dollar donor up the chain to major gift stature, but that will involve much time and effort—by some efforts, more than five years. Experienced fundraisers will tell you that prospects fall into five groups. They are (1) those who see the need and respond without being asked; (2) those who are responsive when simply told of the need; (3) those who need to be persuaded but will eventually respond; (4) those who may or may not respond, even when heavily persuaded; and (5) the inert five—nothing could ever get them to give under any circumstances.[4]

In 2006, the Bank of America produced the results of a study they commissioned on high-net-worth philanthropy. The study surveyed nearly one thousand respondents with household income greater than two hundred thousand dollars and a net worth of at least a million dollars. The results were indicative of trends in philanthropy before the big chill, but may hold clues to the future course of charity when the economy rebounds. There were six major findings.

1. Giving back was more important than leaving a legacy. The latter motivation was cited by only 26 percent of the respondents. Most of the respondents wanted to "meet critical needs."

2. The bank found a surprising correlation between donations of time and dollars. This may have been surprising to the Bank of America, but the Independent Sector (IS), an independent nonprofit umbrella organization of hundreds of national nonprofits, discovered this phenomenon years ago in their biannual survey of nonprofits. They discovered that volunteers were excellent prospects, prime donors, and loyal supporters across the spectrum.

3. Even major tax policy changes would not impact their giving. IS also discovered years ago that major donors are not motivated by tax incentives to give. They are motivated to give *more* because of tax policies.

4. Entrepreneurs are especially generous donors. This is new and important information. The bank discovered that entrepreneurs stood out from those whose wealth was inherited. Entrepreneurs averaged contributions of $232,206 per year compared with old money donors, who gave an average of $109,745 per year. That was still higher than those whose net worth came from savings ($84,882), return on investment ($69,978), or real estate ($11,015).

5. Charitable giving increased over the previous five years (2001–2006). Nearly two-thirds of all respondents dramatically increased their giving. These people are the ones recipient nonprofits should have handled with extreme care in the recent downturn, for they would have continued to be their best hope for continued philanthropy.

6. Wealthy donors support a broader array of causes. High-networth donors differ from the general populace in that they support a broader array of charities. This is a nice thought, but for the struggling museum it is far from comforting. Your donor is spreading his charity around to others and not concentrating solely on you and your needs.[5]

Major gifts are defined as those of the largest in your institution and therefore stand out as a special category. In a smaller institution, they may be only ten thousand dollars; in a larger institution, they could be in the millions. All donations are relative. Fundraising consultant Cliff Underwood defined major gift cultivation and solicitation as "giving at a level which the donor considers to be an important share of his or her assets and which the institution or program recognizes as a major donor contribution towards its objectives." Underwood described a process called the "moves" concept, which is a method to identify those who have evinced a desire to give at a much higher level than others and, of course, have the inclination and capacity to give at a high level. He speaks of two

pitfalls: one, to overlook potential, that is, "not recognizing" those with the potential and, two, those whom you incorrectly identify and then on whom you waste valuable time and resources. Spending time courting the misidentified causes you to neglect the legitimate prospects.[6]

The concept of "moves" comes when a major prospect has been identified. The "moves concept" gets at the notion of measuring effectiveness of your fundraising in a micro sense. What does that mean? Performance by any fundraiser must be measured. How else do we know whether that individual—museum director or development officer—is doing his or her job in cultivating and soliciting prospects? In some cases, as we have pointed out earlier, it may take years to move a prospect from a one-hundred-dollar-per-year donor to a major gifts donor. The "moves" concept provides interim "moves" that help meet the need to measure success or progress. As Underwood described it, a move is "oriented toward advancing the prospect's awareness, interest, involvement, or commitment to your cause." Dealing with more than fifty major prospects that require your identifying them, providing them information, creating awareness of your programs, developing their interest in your programs, developing their involvement in your programs, and then asking them for a commitment are all "moves" to a successful "ask." Underwood suggests using your calendar to schedule and record each and every move you make with a prospect.

The upshot of the major gifts "moves" concept is that the director or the development principal strategically plans each step of contact with a major prospect, leaving nothing to serendipity. It measures the workload, concentrates the effort, and in the end should result in a gift. It is labor intensive and not at all haphazard.[7]

Transformational Gifts

Transformational giving and gifts further refine the need and search for major gifts. Author Kay Sprinkel Grace, recognized the shift in modern philanthropy from passive major donors who simply wrote the check and were either never heard from again or the organization did nothing to stay connected with them (checkbook philanthropy) to the invested donor. Grace writes that "to be effective partners with donor-investors and communities, nonprofits will need to shift from transactional giving to transformational giving."[8]

In the end, all fundraising is the "art of the deal." Fundraising is a negotiation with both sides receiving satisfaction through the transaction.

The author goes on to describe eight characteristics of a major transformational gift:

1. The gift impacts not only your organization but also your community, your constituency, and the donor.

2. Designating a gift as transformational is dependent on how it is cultivated, solicited, and stewarded.

3. These are more than gifts; they are investments.

4. They are motivated by shared values between the organization and the donor.

5. The gifts are rooted in the belief in the importance of the organization's mission and may be issue driven.

6. Donors expect solid returns from their gift—a return on values and the management of their investment.

7. "Just as a gift is designated major by its size relative to the budget or the campaign goal, some donor-investors should be treated like major donors because of the relationship of the size of their gift to their capacity to give."

8. You don't have to be huge or old to attract a major gift as long as "the mission or issue is big in the eyes (or heart) of the donor."

Grace goes on to give an egregious example of a woman who gave a small organization a seven-thousand-dollar donation in her community—an "impact-level gift"—and never heard from the organization again, and never gave another gift either. Grace's message should resonate with small institutions. She confirms the argument that major gifts are not solely the province of the big, well-oiled development machines in large institutions. She writes, "In nonprofits of all sizes, major gifts are both a goal and a program." They are the "fulcrum of successful development operations. They are a critical part of institutional stability—strengthening programs, building endowment, creating operating or capital reserves that guarantee the continuity of services, and signaling to the community that the organization is capable of attracting and managing significant philanthropic investment."

Her most important point is that the mission, not the size of the organization, really matters. She rejects the myth that small institutions must "wait" before they can solicit major gifts. In modern philanthropy, your success in major gifts depends on three factors unrelated to size. They are: "the importance of the need the organization is meeting; the way the issue is marketed to the community; and the success of the organization's planned or actual approach to the issue."[9]

Planned Giving

Deferred giving refers to gifts given, in life, which do not become the sole property of the nonprofit until the donor dies—unless there is a residual beneficiary. There are many types of deferred gift, including wills and their resultant bequests. A deferred or planned gift is the result of careful planning that takes into consideration a donor's overall financial, tax,

and estate planning objectives in order to maximize benefits for both the donor and the museum. Planned gifts usually, but not always, come from a donor's assets rather than income. They can be either outright, deferred, or a combination of the two. They are regulated by law and require legal expertise and knowledge in order to maximize the donor's tax treatment. But the advantages for the donor can be many and beneficial. The donor can enjoy a current income tax deduction; he or she can possibly avoid long-term capital gains, an increase in income, and possibly a reduction in estate and gift taxes. All deferred gifts can be considered as "gifts given twice"—once during the life of the donor and again upon his or her death.

Bequest in a Will or Living Trust

The simplest form of a deferred gift is the will or living trust. A bequest is a gift made through a will or living trust. The museum can be named beneficiary in the wills and living trusts of members and donors. Bequests may be stated as a percentage of the estate, as the residual of the estate, or as a specific dollar amount. Since a will can be changed, no income tax benefits are associated with a bequest; however, the donor's estate is reduced by the amount of the bequest for estate tax purposes. The museum should never be involved in the establishment of an individual's will. The museum should recommend strongly, in all cases, that the prospective donor consult with an attorney, particularly one who specializes in probate and estate planning. The museum can suggest language to guide a prospect if that prospect has a special interest—say, in one particular collecting area or another. But beware: a will can be changed at any time by the prospect. There are countless cases of donors falling out with the original institution of their dreams and cutting them out of their will.

A living trust is also revocable, but it provides for the donor and family during their lifetimes. It allows the donor to stay in control of his or her assets, but unlike wills, the terms of a living trust can be put into effect immediately. The benefits to the donor are that he or she receives income from the trust during the donor's lifetime; a professional trustee does the detail work, and the individual can name the museum as a beneficiary. The trust has the added benefit in that its assets bypass probate, so the terms are private. For the museum, a trust may also contain art and other prized collections that can come to the institution. Other assets can include cash and securities.

CHAPTER EIGHT

Life Income Gifts

Pooled Income Fund

The pooled income fund, after the will/bequest, is the simplest vehicle to convey a gift from one's estate or assets. In a pooled income fund, the museum establishes the fund—much like a mutual fund—with a reputable financial institution. The donor transfers money, securities, or both to a qualified separately maintained fund, where it is invested with others who have made similar life income gifts. The fund is invested in stocks, bonds, CDs, and other relatively conservative financial instruments. The donor or a designated beneficiary receives a share of the fund's earnings each year. That income to the donor is fully taxable. The original gift to the pooled income fund is fully deductible. Upon the death of the donor or the death of a residual beneficiary, payments stop and the assets equal to the value of the donor's units in the fund are paid to the museum to be used as it wishes. Unlike a will, the gift agreement governing the original corpus to the fund is irrevocable.

The Charitable Remainder Annuity Trust and the Charitable Remainder Unitrust

In 1969, Congress created a new type of trust that helped charities and not-for-profit organizations generate more revenue for their causes. There are two basic types of charitable remainder trusts—the charitable remainder annuity trust and the charitable remainder unitrust. Both can be funded through a gift of stock, cash, or other assets during a donor's lifetime or through a will. Both provide life income for the donor and/or designated beneficiaries. The donor may claim a tax deduction for the estimated portion of the assets that will ultimately go to the museum. The assets of the trust are available for future use by the museum for the designated purpose. Most important for the institution, the remainder trusts are irrevocable, whereas a will can be changed at any time. The trusts are legally binding agreements between the donor and the institution.

The *charitable remainder annuity trust* provides a predictable yearly income. It pays a fixed dollar amount annually to the beneficiaries based on the trust's initial value. This amount cannot change during the life of the trust. Unlike the unitrust, the annuity trust allows no additional con-

tributions, although you can establish additional annuity trusts with the museum. An income tax deduction is allowed for an amount equal to the present value of the museum's remainder interest in the trust.

The *charitable remainder unitrust* allows the donor to transfer cash, real estate, or securities to an irrevocable trust that provides yearly, fluctuating income to the donor or other beneficiaries for a specified term or for life. The income fluctuates because the donor agrees to receive a percentage rather than a fixed amount. Trust assets are revalued annually, allowing potential growth in income to the beneficiaries. Additional contributions can be made to the trust. Upon the death of the final beneficiary, the charity receives the principal and distributes it according to the donor's wishes. An income tax deduction is allowed for an amount equal to the present value of the museum's remainder interest in the trust. For example: Sam, age 65, has stocks valued at one hundred thousand dollars that yield a 4 percent dividend. She transfers them to a unitrust, incurring no capital gain. She agrees to receive 6 percent of the fair market value of the unitrusts each year, payable as she wishes. She receives an income tax deduction. The first year she receives six thousand dollars (6 percent of one hundred thousand dollars). The next year, if the trust makes money, she will receive more; if it drops, so will her income. For the donor, it assures lifetime income, an income tax deduction when the gift is made, avoidance of capital gains tax if the donor funds the unitrust with appreciated securities, and professional management of the fees. The museum benefits when the donor or the final beneficiary dies.

Charitable Lead Trusts

With a charitable lead trust, the museum receives the income from the donor's assets for a specified time, after which the asset is transferred back to the donor or to the donor's heirs. A lead trust can reduce gift and estate taxes or provide a charitable deduction for the donor. In other words, the donor "loans" the museum his or her assets for a legally specified time and allows the museum to "harvest" the income from the "loan." The museum, after the specified time, must relinquish the asset back to the donor. This particular form of trust is less used today in favor of the unitrust, the annuity trust, and the charitable gift annuity.

Charitable Gift Annuity

The charitable gift annuity is a contract between the museum and the donor whereby the museum promises to pay a fixed annuity to a maximum of two beneficiaries (beginning immediately or deferred to a later date) in exchange for the irrevocable transfer of assets by the donor to the museum. Annuity payments are based on the initial market value of the assets contributed and the ages of the income beneficiaries. A portion of the annuity payment may be considered a tax-free return of principal. An income tax deduction is allowed for the difference between the value of the gift and the present value of the annuity. These types of planned gifts are not recommended for the small museums because if the donor outlives the actuarial tables and the corpus of his original gift, the museum is liable for the difference. If, for example, the donor gives the museum fifty thousand dollars at age seventy-five and is paid, say, $4,500 per year in quarterly installments, he or she could outlive the fifty thousand dollars plus the interest it spun off for many years. And when he or she outlived the gift, the museum would end up losing money because it would be obligated to continue paying the donor until the donor's death.

These gift annuities were popular when the actuarial tables entertained a lowered life expectancy. Today, their economics need to be completely understood by both the donor and the museum. Here, museum counsel is imperative.

Deferred Gift Annuity

Like a standard gift annuity, a donor makes a gift now and receives an immediate income tax deduction; however, the donor begins receiving a "deferred" annuity payment at a future predetermined date. Because of compounding between the date of gift and the first annuity payment date, the amount of the annuity payment can be significant and at a much greater rate than of the standard charitable gift annuity. This is an excellent arrangement for the younger donor who is more concerned with an immediate tax deduction. In the meantime, the growth of the annuity is in his or her favor, and when the time comes to draw it down, the income will be greater than when he or she first made the gift.

Retained Life Estate

A donor may transfer a personal residence or a farm to the museum while retaining the right to live there for life. The donor is entitled to a charitable income tax deduction for a portion of the appraised fair market value of the property at the time of the transfer. In addition, the donor escapes capital gains tax on the property's appreciation, and his or her estate will be entitled to a charitable gift annuity.

Be careful here if you really are hungry for future dollars. I know of a personal instance where a donor offered a nonprofit organization a piece of property that was on such a severe slope of land in the nearby mountains that the property was unsalable. The owner had tried several tactics to sell the undesirable piece of land and the house on it—all unsuccessful. When the nonprofit did its due diligence, they rejected the gift outright. Had they accepted the property, they would have been burdened with the seller's/potential donor's dilemma and unable to sell it at any price. Remember also that the property will not become the property of the museum until the donor dies. This gift does not lend itself to immediate, short-term strategies.

Retirement Accounts

A donor can name the museum as primary beneficiary of a retirement account with the value being fully deductible for estate tax purposes. Furthermore, income generated by a retirement account is untaxed since the museum is a tax-exempt entity. More and more donors are considering transferring IRAs to nonprofit organizations as a new method of avoiding taxes and helping their favorite charity. Until Congress changes the rules, an IRA can be taxed twice. The first instance is when the donor dies and an estate tax is levied on his nest egg. The second taxable event happens to the beneficiary, who must declare it as income and thus pay income tax on it. For example, let's say that you as an individual have built up a large retirement fund over many years. When you first began participating in that retirement plan, you were required to name a beneficiary. In the event of your demise, that beneficiary will have to pay ordinary income tax on that wonderful gesture you made years ago to care for them after you have departed this world. As a museum person, you can point out the tax implications of this particular gift and that it could be the most cost-effective

gift the donor could consider. As always, donors should check with their financial advisers.

Life Insurance

A life insurance policy donated to a museum can become a valuable gift. The donor names the museum as the beneficiary. Three different giving opportunities are available with life insurance. First, a donor can contribute a "paid up" policy and receive an income tax deduction equal to the policy's cash/replacement value. Second, a donor can name the museum as primary beneficiary of the policy, resulting in estate tax savings but no income tax deduction. Third, a donor can name the museum as owner and beneficiary of a new policy and receive an income tax deduction for an annual gift in the amount of the premiums, which the museum pays. In this last scenario, the donor makes an annual contribution equal to the premium. The museum then pays the insurance premium to the insurance company. The donor receives a tax deduction for each premium payment (gift to the museum). When the donor dies, the museum is the beneficiary of the proceeds of the donor's insurance policy.

Selling a planned giving program is complex and must not be handled lightly, but with dignity and the highest degree of professionalism. Such a program should be pursued with the complete understanding and unqualified endorsement of the board of trustees. Small museums cannot afford to hire a planned giving officer and as a result, I would recommend that the board establish a committee of knowledgeable people such as an attorney qualified in wills and estate planning, an investment banker, a trust officer, an insurance person, an accountant, and the museum's director. The program can be marketed as a service in estate planning by the museum. The individuals mentioned above could serve as an advisory committee, establishing planned giving seminars with a consultant and expert in planned giving.

Trustees, selected donors, and local members interested in estate planning should be invited through e-mails, direct-mail pieces, advertisements, your newsletter, or any other media with which you are comfortable. The demographic for this will undoubtedly be the fifty-year-old and older age-group. After the seminar, the audience is offered the opportunity to talk with the museum director or development officer about an available deferred giving program. Seminars also increase the general level of so-

phistication about estate planning and about the charitable giving aspect of estate planning. It also helps improve your organization's image and public relations. It can increase annual gifts and eventually produce a planned gift.

The subtle message is, "If we show you how to save thousands of dollars through estate planning, perhaps you will find it advantageous to share some of those savings with our institution." The simplest form of planned gift—the will—should be mentioned in all your newsletters and annual reports. You can discreetly remind your members that the museum would benefit from a mention in their will. As one of my board members said recently, we should market planned gifts with the motto: "Before you are history, think of the museum in your will."

> *Helpful Hint:* As with all major financial decisions, donors should consult with their attorney and financial advisers if they decide to make a planned gift to your institution. As a good steward of your museum and its resources, it is your moral and ethical responsibility to encourage your potential donors to seek legal and financial advice before making any of these decisions.

If one were to choose just one last word on fundraising or development, I would repeat a word I used in the first chapter: trust. It is the basis of all charitable impulses. Yes, there are myriad motivations for people's giving, but in the end trust rules all. When he was the president of the Ford Foundation, McGeorge Bundy pointed out that three elements are necessary to successful fundraising: practice, concern, and trust. The first relates to a donor who wisely chooses to give and to give—not until it hurts, but until it feels good, as John Rosenwald has said. The latter "two factors relate directly to management." According to Bundy, "The institutions that reap the largest philanthropic benefits are those that can welcome a potential donor and listen to his concerns; they involve him in the institution and secure his commitment through an active process of gaining his understanding and showing that they can be responsive to his reasonable concerns." His closing line should resonate with every museum and museum professional interested in serious and successful fundraising: "The well-managed institution will instill trust in the donor, and will be able to respond to legitimate concerns because it has clearly defined and understood goals and objectives."[10]

"A man wrapped up in himself makes a very small bundle." —Benjamin Franklin

In Summary

Fundraising is easy in flush times. It is obviously much harder when times are lean. These are obvious statements. A not-so-obvious statement is that fundraising does not require a genius IQ. I am not a scientist, but I have heard enough about EQ—emotional quotient—to know that good fundraisers enjoy very high EQs. Good fundraisers are good "people persons." They can be sympathetic and empathetic with donors. They do not look at their supporters as a bottomless pit of money. They regard them as individuals who have staked some of their fortunes with the museum. And these fundraisers need not belong to major large museums to be successful. A director of a small community museum can be as successful as the director of a large museum. He or she will be much closer to the community than the CEO of a large museum. The commonality they share as thriving fundraisers is that they relate to others on a very human level. This attribute becomes paramount in hard times.

During good times it is wise to listen to your donors. In hard times, communication becomes even more important. What are the donors thinking? Are their businesses in trouble? Do they have concerns about your institution? Have they been steady supporters in good times? If so, you have a leg up on the competition. But you need to keep the lines of communication open in the hard times. Tell them the measures you are taking to cope with the hard times. How about that one donor who has supported you in far greater proportion to others but who has definite ideas about how you should run the museum? Your EQ should tell you that he probably is not being a pest after all, but he is an investor in your institution and is merely protecting his—or perhaps his family's—investment. Remember that major gifts and, to a lesser degree, smaller gifts are a matter of negotiation. There is a little art and a little science to the process, but basically it is a human endeavor that matches needs—the donor's and yours.

Look over your giving roster. This is something that you should do periodically in good times and bad. As Goettler Associates advise: "This is not the time to rely on one major grant. Get back to the donor pyramid and ensure that you have major donors at the top, numerous donors in the middle, and broad base of support." Other words of wisdom are: get back to the basics—identification, cultivation, solicitation, and steward-

ship. Above all, concentrate on stewardship. Bring your EQ into play and ensure that your donors genuinely believe that you have stayed on mission, that you have their interest at heart, but that in these difficult times you are counting on their support like never before. They will only know that if you communicate your needs in relation to your vision and your mission. Never lose sight of either as you slog through the difficult fundraising environment.

Major gifts, transformational gifts, and planned giving are not for the fainthearted. They are not for beginners, but if you are seriously interested in this form of giving—which is really an extension of membership, annual giving, and major gifts through a capital campaign—then either hire a professional or ask a local estate planner, an estate attorney, a bank trust officer, or an advanced tax attorney to help you with the many facets of this form of fundraising. Sometimes financial planners will offer "pro bono" services in this area—to a point. Board members who are versed in the byzantine ways of planned giving can help you also. On the other hand, asking someone to remember you in their will does not require a brain surgeon. Anyone who is legitimately impassioned by your programs or museum in general will see the benefit of a planned gift and will undoubtedly be happy to tell you about it.

NOTES

Preface

1. "How Charitable Giving Fared During Crises in U. S. History," *Chronicle of Philanthropy, Special Report* (October 4, 2001).

2. David Thelen and Roy Rosenzweig, *The Presence of the Past: Popular Uses of History in American Life* (New York: Columbia University Press, 1998).

3. Duncan F. Cameron, "The Museum: A Temple or the Forum," *Curator* XIV, no. 1 (1971): 11–24.

4. Stephen E. Weil, "Museums: Can and Do They Make a Difference," in *Making Museums Matter* (Washington, DC: Smithsonian Institution Press, 2002), 55–74.

5. Paulette V. Maehara, "Giving in America: Six New Trends in Fund Raising," *Museum News*, March/April 2003.

Chapter 1: Philanthropy and the Nonprofit World

1. Beverly R. Hoffman, "Some General Principles of Charitable Nonprofit Fundraising," ARCH Factsheet Number 6, National Resource Center for Respite and Crisis Care Services (May 1992), http://www.archrespite.org/archfs6.htm.

2. Charles A. Edwards, "Development in Context," *Museum News* (May/June 1978), 40.

3. Elizabeth E. Merritt, "Museums: A Snapshot," *Museum News* (January/February 2010), 58.

4. Joanne Fritz, "Six Steps to a Fundraising Plan for a New Nonprofit," About.com, Nonprofit Charitable Orgs, http://nonprofit.about.com/od/fundraisingbasics/tp/basicfundraisingtips.htm?p=1.

5. Andy Markowitz, "In the Arts: S. F. Museum Reaches Midpoint to Half-Billion Goal," *Chronicle of Philanthropy*, http://philanthropy.com/blogPost/In-the-Arts-SF-Museum/21085/.

6. Elizabeth Schwinn, "Trustees Don't Do Enough to Help Charities Raise Money, Study Finds," *Chronicle of Philanthropy*, November 8, 2007.

7. "The Nonprofit Board Report," from "The Power of Brands," by Adrian Sargeant and John B. Ford, in *Stanford Social Innovation Review*, www.ssireview.org, July 2007.

8. Association of Fundraising Professionals, "Barely Half of All Charities Require Board Member Contributions," http://www.afpnet.org/Audiences/ReportsResearchDetail.cfm?ItemNumber=2291, January 2008.

9. Robert L. Gale, "Using Your Board in Fund Raising," *Sightlines* 4(1) (1985).

10. Robin Pogrebin, "The Nonprofit's Guide to Surviving the Downturn," *New York Times*, November 9, 2008.

11. Jim Hackney, Alexander Haas Newsletter 143, November 2009. Reprinted with permission.

12. Nonprofit *Board Report*, June 2007.

13. Israel Unterman and Richard Hart Davis, "From the Boardroom: The Strategy Gap in Not-for-Profits," *Harvard Business Review*, May–June, 1982, 35.

14. Aaron Berger, "The Four Key People You Need on Your Board," http://www.culturalturningpoint.com/blog.html, February 9, 2011. Reprinted with permission.

15. Richard T. Ingram, *Ten Basic Responsibilities of Nonprofit Boards*, 2nd ed. (BoardSource, 2009). Reproduced with permission.

16. William J. Hoffman, "How to Fail at Fund Raising: Eight Easy Steps to Getting on the Unemployment Line," *NonProfit Times*, July 1995.

17. This article is reprinted with permission from the Board Café, now part of *Blue Avocado*, a free-enterprise online magazine for community nonprofits cosponsored by CompassPoint Nonprofit Services, Nonprofits' Insurance Alliance of California (NIAC), and Alliance of Nonprofits for Insurance, Risk Retention Group (ANI-RRG). For more information and to sign up, visit www.blueavocado.org.

18. "Happy New Year from All of Us at Alexander Haas," *Atlanta Results*, January 2010. Reprinted with permission.

Chapter 2: The Universe of Fundraising

1. John Durel, "Mission and Profit," *QM²*, 2002.

2. With acknowledgment to Thomas E. Broce, "The Process of Successful Fund Raising," June, 1980 in author's possession.

3. Elizabeth E. Merritt and Erik Ledbetter, "Taking the Long View," *Museum News*, January–February 2010, 29.

4. Elizabeth E. Merritt, "Museums: A Snapshot," *Museum News*, January–February 2010, 61.

5. Giving USA, "Giving during Recessions and Economic Slowdowns," *Giving USA Spotlight* 3 (2008); and Holly Hall, "Americans Didn't Pull Back on Their Giving Last Year, Report Finds," *Chronicle of Philanthropy*, June 9, 2010.

6. Mike Spector, "Family Charities Shift Assets to Donor Funds," *Wall Street Journal*, April 22, 2008.

7. Stephanie Strom, "Foundation Giving in '08 Defied Huge Asset Decline," *New York Times*, March 31, 2009.

8. Noelle Barton, "40% of Foundations Expect Giving to Drop in 2009, Chronicle Study Finds," *Chronicle of Philanthropy*, March 31, 2009.

9. The Foundation Center, Research Studies, National Trends. http://foundationcenter.org/gainknowledge/research/national trends.html.

10. http://www.nissanusa.com/pdf/about/corporate_info/2009_Foundation_Brochure.pdf.

11. R. Howard Dobbs, Jr. Foundation Grant Guidelines.

12. David Lansdowne, "The Relentlessly Practical Guide to Raising Serious Money, 2007," posted in the GuideStar.org *Newsletter*, October and November 2007. Emerson & Church, Publishers, http://www.emersonandchurch.com. Reprinted with permission.

Chapter 3: Stewardship

1. David Leonhardt, "What Makes People Give," *New York Times Magazine*, March 9, 2008.

2. Eric Gibson, "Giving without Giving a Darn Who Gets the Credit," *Wall Street Journal*, August 3, 2001.

3. "Fund Raising Matters," Goettler Associates, *Newsletter* 1(3) (Fall 1996). Reprinted with Permission.

4. The Independent Sector, "2001 Giving and Volunteering in the United States: Key Findings," November 2001, at www.independentsector.org/programs/research/nation.html.

5. Kay Sprinkel Grace, *Over Goal!: What You Must Know to Excel at Fundraising Today*, 2nd ed. (Medfield, Mass.: Emerson & Church, 2006) (www.emersonandchurch.com), as cited in Joanne Fritz, "Top Ten Tips on the Fine Art of

Cultivating Donors," About.com, at http://nonprofit.about.com/od/fundraising/tp/cultivating.htm. Reprinted with permission.

6. Kim Klein, "*Getting over the Fear of Asking*," in *Raise More Money: The Best of the Grassroots Fundraising Journal* (Hoboken: Jossey Bass, 2000). Reprinted with permission.

7. John D. Rockefeller, paraphrasing Aristotle. Courtesy H. Martin Moore, director of the Georgetown University Campaign, *Washingtonian Magazine*, December 1982.

8. With thanks to the website of Tony Poderis, "Rating and Evaluating Prospects: Whom Do You Ask for How Much," Fund-Raising Forum Library, http://www.raise-funds.com/library.html.

9. "When 'Rosie' Asks, New York's Elite Can't Say No," *New York Times*, November 20, 2000.

10. Bruce Hedrick, "Weekly Wisdom, Tips and Tidbits from Hedrick Communications," April 20, 2005.

11. "Accent on Recognition: Saying Thank You to Donors and Volunteers" (Washington, D.C.: Seventh-day Adventist World Headquarters, 1991).

12. "Accent on Recognition."

13. Susan Kinzie, "Embarrassing or Just Strange, Some Gifts Turn Out Not to Be," *Washington Post*, September 4, 2007.

14. Derek Bok, "Reflections on the Ethical Problems of Accepting Gifts: An Open Letter to the Harvard Community," Supplement to the Harvard University *Gazette*, May 4, 1979.

15. Erica Orden, "Koch Now, Not Forever," *Wall Street Journal*, May 12, 2010.

16. Kimberlee Roth, "Smaller Charities Need Creativity and Care When Recognizing Donors," *Chronicle of Philanthropy*, March 20, 2003.

17. Tracie McMillan, "Donor Drain: Mistrust Grows, Loyalty Goes," *Contribute Magazine*, MSNBC.com, December 17, 2007.

Chapter 4: Methods of Solicitation

1. Robert Gale, "Using Your Board in Fund Raising," *Sightlines* 4(1) (1985).

2. Goettler and Associates, *Fund Raising Matters* 13(3) (Summer 2008). Reprinted with permission.

3. FASB 116 was issued in June 1993 and has an effective date for fiscal years beginning after December 15, 1994. For those not-for-profit organizations that have less than five million dollars in total assets and less than one million dollars in annual expenses, the effective date is delayed until fiscal years beginning after December 15, 1995. Copyright © 1995–2003, 1800Net.com, 1800Net, LLC. All rights reserved.

4. I am indebted to the Fall 2001 newsletter of Katz, Sapper and Miller, Inc, Indianapolis, for the explanation of these terms.

5. John H. Wade, "Legal Issues: Return to Donor? Legal Rights of Unhappy Contributors," *Currents*, June 1999.

6. Harvey McKinnon, "Control Freak: What to Do When Donors Demand Control over Their Gift," *Contributions* 22(4) (2008). This article is adapted from Harvey McKinnon's new book, *The 11 Questions Every Donor Asks and the Answers All Donors Crave*, available from www.emersonandchurch.com. Reprinted with permission.

7. Jennifer Steinhauer, "Wielding Iron Checkbook to Shape Cultural Los Angeles," *New York Times*, February 8, 2010.

8. Randy Kennedy, "Los Angeles Museum Board Members Ordered to Undergo Financial Training," *New York Times*, April 19, 2010.

9. David Cay Johnston, "Smart Giving in a Troubled Climate," *New York Times*, May 21, 2009.

10. In an article entitled, "A CEO's Guide: Getting Your Money's Worth from your Fund Raising Manager," in *Nonprofit Times*, August 15, 2005, author Mal Warwick states flatly that he has "never met a fundraiser who was truly successful without being a dedicated and effective listener. In face-to-face solicitations, listening is essential to understand the way that a donor's personal values and interests might be linked to a particular project. But listening is just as effective in direct mail, telefundraising, or other forms of direct response: how else could he/she really come to understand what a project or issue is about, or what motivates donors." www.nptimes.com.

11. Warwick, "A CEO's Guide."

12. Joanne Fritz, "The Nonprofit Hard Times Survival Guide: Nonprofits Need to Ride Out Economic Storms," About.com, http://nonprofit.about.com/od/nonprofitfinances/tp/nonprofitrecession.htm.

13. Ian Wilhelm, "Nonprofit Organizations Urged to Radically Rethink How They Do Business to Thrive in the Rough Recovery," *Chronicle of Philanthropy*, November 11, 2009.

Chapter 5: Membership, Annual Appeal, and Special Events

1. Alina Tugend, "Feeling Charitable and a Bit Badgered," *New York Times*, April 29, 2006.

2. Tugend, "Feeling Charitable."

3. Tugend, "Feeling Charitable"; David Leonhardt, "What Makes People Give," *New York Times Magazine*, March 9, 2008.

4. John Limpert, "Marketing Challenges in Cultural Fund Raising: A Personal View," *Museum News*, May–June 1982.

5. "Annual Giving," Williamsburg Institute, Vice President, Resource Development, Rensselaer Polytechnic Institute, June 23–27, 1984.

6. Marilyn G. Hood, "Misconceptions Held by Museum Professionals," *Visitor Behavior* 6(1) (Spring 1991).

7. Peter F. Drucker, "Managing the 'Third Sector,'" *Wall Street Journal*, October 3, 1978.

8. "Membership and Annual Giving," *Private Support for Museum's in Today's Economy*, CASE Conference, Washington D.C., January 6–8, 1982.

9. "Membership and Annual Giving."

10. Marcelo Iniarra Iraegui and Alfredo Botti, "Social Trysumers and the Hidden Gate in the Pyramid," *Advancing Philanthropy*, November/December, 2008, 12–13.

11. James Gregory Lord, *Philanthropy and Marketing: New Strategies for Fund Raising* (Cleveland: Third Sector, 1981).

12. Marilyn Brentlinger and Judith Weiss, "To Benefit or Not to Benefit, That Is the Big Question," in *The Ultimate Benefit Book* (Cleveland: Octavia Press, 1987).

13. Joan Flanagan, "Thirty Ways to Fail at Fund Raising," *Fund Raising Management*, 1983. As cited on website http://www.thelennyzakimfund.org/LZFInstitute/FR_30%20ways.doc.

Chapter 6: Managing a Capital Campaign

1. Goettler Associates, "Running the Red Lights: Nine Reasons That Capital Campaigns Fail," *Fund Raising Matters Special Report*, no date. www.goettler.com. Reprinted with permission.

2. Robert C. Connor, "The Capital Campaign-Pre Launch," Remarks at the 25th Anniversary Fund Raising Conference, National Society of Fund Raising Executives, no date. (In author's possession.)

3. Goettler Associates, "Running the Red Lights." Reprinted with permission.

4. Patricia Jacoby, "Seven Golden Rules for a Museum Campaign," *Museum Trusteeship* 10(4) (Fall 1996).

5. Goettler Associates, "Running the Red Lights." Reprinted with permission.

6. Goettler Associates, "Running the Red Lights." Reprinted with permission.

7. Jennifer Brett, "Peach Buzz," *Atlanta Journal-Constitution*, February 9, 2010.

8. Goettler Associates, "Running the Red Lights." Reprinted with permission.

9. Goettler Associates, "Running the Red Lights." Reprinted with permission.

10. David Leonhardt, "What Makes People Give," *New York Times Magazine*, March 9, 2008.

11. Charles Webb Company, Inc., "Twenty Common Misconceptions about Capital Fund Campaigns," Excerpts from Charles Webb's lecture at Williams College, January 15, 1993. Copyright © 1993 The Charles Webb Company, Inc., 1133 Broadway, Suite 304, New York, NY 10010, 212-691-1055.

Chapter 7: Grantsmanship

1. Art Jahnke, "Losing the Win-Win Game?" *Museum News*, September–October, 1993.

2. Robin Pogrebin, "Arts Organizations Adjust to Decline in Funding," *New York Times*, February 21, 2007.

3. Jahnke, "Losing the Win-Win Game?"

4. Nancy Lublin, "Foundations' Four Biggest Faux Pas." FastCompany.com, February 1, 2010. http://www.fastcompany.com/magazine/142/do-something -we-really-need-to-talk.html.

5. Stephanie Strom, "Charities Loosening Strings on Arts Grants," *New York Times*, June 4, 2009.

6. Thomas Broce, "Foundation Fund Raising," paper in author's possession, June 1980, 10.

7. The Foundation Center's main office is in New York. Its field offices are in the other four locations. New York at 79 Fifth Avenue/16th Street, New York, NY 10003-3076, 212-620-4230, foundationcenter.org/newyork. Field Offices: Atlanta, 50 Hurt Plaza, Suite 150, Atlanta, GA 30303-2914, 404-880-0094 foundationcenter.org/atlanta; Cleveland, 1222 Euclid Avenue, Suite 1600, Cleveland, OH 44115-2001, 216-861-1933, foundationcenter.org/cleveland; San Francisco, 312 Sutter Street, Suite 606, San Francisco, CA 94108-4314, 415-397-0902, foundationcenter.org/sanfrancisco; Washington, DC, 1627 K Street NW, Third Floor, Washington, DC 20006-1708, 202-331-1400, foun-dationcenter.org/washington.

8. http://www.irs.gov/pub/irs-tege/summary_form_990_redesign_process .pdf.

9. http://www.marquiswhoswho.com/.

10. Thomas Broce, "Foundation Fund Raising," 11, 13.

11. Michael Radock, "Words to the Wise: Foundation Executives' Comments on the Most Frequent Errors Made in Grant Proposals," *Journal*, National Society of Fund Raising Executives, Winter 1990, 22.

12. Cindy T. Rizzo, Senior Director, Grant Making and Evaluation, The Arcus Foundation, http://www.arcusfoundation.org/pages_3/home.cfm. Reprinted with permission.

Chapter 8: Major Gifts, Transformational Gifts, and Planned Giving

1. Frederic J. Fransen, "Don't Let Universities Stiff Donors," *Atlanta Journal Constitution*, December 7, 2007.

2. Susan Kinzie, "Exacting Donors Reshape College Giving," *Washington Post*, September 4, 2007.

3. William Schwartz and Francis J. Serbaroli, "After the Barnes Ruling: What Donors Should Do to Protect Their Wishes," *Chronicle of Philanthropy*, March 31, 2005.

4. David R. Dunlop, "Major Gifts Fund Raising," CASE Summer Institute in Educational Fund Raising, August 7, 1979, Dartmouth College.

5. Bank of America, "High Net Worth Philanthropy Study," at http://newsroom.bankofamerica.com/index.php?s=press_kit&item=63.

6. Cliff Underwood, "The Moves Concept," paper delivered to the Western Museums Conference, September 17, 1987. Underwood uses the same language and the "moves" techniques described by Dunlop in his 1979 paper at Dartmouth, cited above.

7. Underwood, "The Moves Concept."

8. Kay Sprinkel Grace, *High Impact Philanthropy: How Donors, Boards, and Nonprofit Organizations Can Transform Communities* (New York: Wiley, 2001), 20.

9. Grace, *High Impact Philanthropy*, 20, 21, 26.

10. Charles A. Edwards, "Development in Context," *Museum News*, May–June 1978, 43.

BIBLIOGRAPHY

Countless books and articles are available to the beginning or the advanced fundraiser for all manner of nonprofits. A quick check on the Internet will only add to one's confusion. The list of sources below is a compilation of nearly forty years of fundraising with an eye toward the museum field specifically and the arts and cultural world in general. Many are recent articles relevant to the current economic downturn (2008–2010). Older articles and books were useful in that many tenets of successful fundraising never change, especially those that have to do with the ethics of fundraising, the need to plan, the need to make face-to-face calls, the need to understand the context in which all nonprofits exist, and the need to continue to raise money for a nonprofit sector that grows every year. What Be Haas wrote fifty years ago is still valid. No one yet knows what ultimate impact modern technology and the modern media will have on fundraising. I have tried to suggest—and use in this book—modern readings that will inform your fundraising prowess and progress. Technology is morally neutral. It can be used for good or for ill. It has potential for fundraisers but should never replace the human connection.

Alexander, G. Douglass, and Carlson, Kristina. *Essential Principles for Fund Raising Success: An Answer Manual for the Everyday Challenges of Raising Money.* San Francisco: Jossey-Bass, 2005.
Anderson, Gail, ed. *Reinventing the Museum: Historical and Contemporary Perspectives on the Paradigm Shift.* Walnut Creek, Calif.: AltaMira Press, 2004.

"Annual Giving." Williamsburg Institute. Vice President, Resource Development, Rensselaer Polytechnic Institute. June 23–27, 1984.

Bank, David, and Brannigan, Martha. "Battling 'Donor Dropsy'": Some Major Contributors Slash Gifts to Charities as Their Net Worth Tumbles." *Wall Street Journal*, July 12, 2002.

Bank of America. "High Net Worth Philanthropy Study." http://newsroom .bankofamerica.com/index.php?s=press_kit&item=63.

Barton, Noelle. "40% of Foundations Expect Giving to Drop in 2009, Chronicle Study Finds." *Chronicle of Philanthropy*, March 31, 2009.

Berger, Aaron, "The Four Key People You Need on Your Board," http://www .culturalturningpoint.com/blog.html, February 9, 2011.

Board Café. "Five Things One Board Member Can Do to Raise $100 to $5,000." Board Match Plus+/Compass Point, 706 Mission Street, San Francisco, CA 94103. 1999.

Bok, Derek. "Reflections on the Ethical Problems of Accepting Gifts: An Open Letter to the Harvard Community." Supplement to the Harvard University *Gazette*, May 4, 1979.

Bray, Ilona. *Effective Fund Raising for Nonprofits: Real World Strategies That Work*. Berkeley: NOLO Press, 2005.

Brett, Jennifer. "Philanthropist Arrested." *Atlanta Journal Constitution*, February 9, 2010.

Broce, Thomas. "Foundation Fund Raising." Paper in author's possession, June 1980.

———. "The Process of Successful Fund Raising." Paper in author's possession, June 1980.

Cameron, Duncan F. "The Museum, a Temple or the Forum, *Curator* 14(1) (1971): 11–24.

Ciconte, Barbara L. *Fund Raising Basics: A Complete Guide*. Sudbury, MA: Jones and Bartlett, 2005.

Cilella, Salvatore G. "The Administrator and Fund Raising: A Beginning." American Association of Museums, 1988.

———. "Fund Raising for the Small Museum." *History News*. Technical Leaflet, American Association for State and Local History, 2000.

Clifton, Robert L., and Dahms, Alan M. *Grassroots Administration: A Handbook for Staff and Directors of Small Community-Based Social Service Agencies*. Prospect Heights, Ill.: Waveland Press, 1971.

Connor, Robert C. "The Capital Campaign-Pre Launch." Remarks before the 25th Anniversary Fund Raising Conference, National Society of Fund Raising Executives, n.d. Remarks in author's possession.

Crouch, Ron. "The New Future of the World: The World's Population is Changing—But Not How One Might Think." *Converge Magazine*, Spring 2007.

Dayton, Kenneth N. "Governance Is Governance." Originally a speech by Kenneth N. Dayton to an Independent Sector Leadership/Management Forum in 1968. It was first published as a monograph in 1987, updated in 1998, and again in 2001. The Independent Sector, 2001.

Drucker, Peter. "Managing the 'Third Sector.'" *Wall Street Journal*, October 3, 1978.

Dunlop, David R. "Major Gifts Fund Raising." CASE Summer Institute in Educational Fund Raising, August 1979, Dartmouth College.

Durel, John. "Mission and Profit." QM²—Quality Management to a Higher Power, 2002.

Edies, Peter. *Fund Raising: Hands-on Tactics for Non-profit Groups.* New York: McGraw-Hill, 1992.

Edwards, Charles A. "Development in Context." *Museum News*, May/June 1978.

Feldstein, Martin. "Rich and Poor." *Museum News*, May/June 1991.

Flanagan, Joan. *The Grass Roots Fundraising Book: How to Raise Money in your Community.* Lincolnwood, Ill.: NTC Publishing Group, 1982.

———. *Successful Fundraising: A Complete Handbook for Volunteers and Professionals.* 2nd ed. New York: McGraw-Hill, 2002.

Fransen, Frederic J. "Don't Let Universities Stiff Donors." *The Atlanta Journal-Constitution*, December 7, 2007.

Fritz, Joanne. "The Nonprofit Hard Times Survival Guide: Nonprofits Need to Ride Out Economic Storms." About.com Nonprofit Charitable Orgs, http://nonprofit.about.com/od/fundraising/tp/cultivating.htm.

———. "Top Ten Tips on the Fine Art of Cultivating Donors." About.com Nonprofit Charitable Orgs, http://nonprofit.about.com/od/fundraising/tp/cultivating.htm.

———. "Six Steps to a Fund Raising Plan for a New Nonprofit: How to Develop a Fund Raising Plan that Works." About.com Nonprofit Charitable Orgs, http://nonprofit.about.com/od/fundraisingbasics/tp/basicfundraisingtips.htm?p=1.

Gale, Robert L. "Using Your Board in Fund Raising." *Sightlines* 4(1) (1985).

Gelatt, James P. *Managing Nonprofit Organizations in the 21st Century.* Phoenix: Oryx Press, 1991.

Gibson, Eric. "Giving without Giving a Darn Who Gets the Credit." *Wall Street Journal*, August 3, 2001.

"Giving It Away: The Money Issue." *New York Times Magazine*, March 9, 2008.

Giving USA Foundation. "Giving during Recessions and Economic Slowdowns." *Giving USA Spotlight*, issue 3 (2008).

Grace, Kay Sprinkel. *High Impact Philanthropy: How Donors, Boards, and Non-Profit Organizations Can Transform Communities*. New York: Wiley, 2001.

———. *The AAA Way to Fundraising Success: Maximum Involvement, Maximum Results*. Seattle: Whit Press, 2009.

Green, Marc. *Fund Raising in Cyberspace*. The Grantsmanship Center, http://www.tgci.com/magazine/Fundraising%20in%20Cyberspace.pdf 2005.

Hall, Holly. "Americans Didn't Pull Back on Their Giving Last Year, Report Finds," *Chronicle of Philanthropy*, June 9, 2010.

Hedrick, Bruce. *Weekly Wisdom: Tips and Tidbits from Hedrick Communications*. Hedrick Communications, 201 Capitol Avenue, Indianapolis, IN 46225, April 20, 2005.

Hoffman, Beverly R. "Some General Principles of Charitable Fundraising." ARCH National Resource Center for Respite and Crisis Care Services Factsheet Number 6, http://www.archrespite.org/archfs6.htm.

Hoffman, Marilyn. "Writing Realistic Grant Budgets." *Museum News*, January/February 1980.

Hoffman, William J. "How to Fail at Fund Raising: Eight Easy Steps to Getting on the Unemployment Line." *NonProfit Times*, July 1995.

Hood, Marilyn G. "Misconceptions Held by Museum Professionals," *Visitor Behavior*, Spring 1991, Volume VI, No. 1.

———. "Giving and Volunteering in the United States, Executive Summary, Findings from a National Survey," 1999 ed., http://www.independentsector.org/GandV/default.htm.

———. "Giving and Volunteering in the United States, Key Findings 2001." http://www.independentsector.org/programs/research/nation.html.

"How Charitable Giving Fared during Crises in U. S. History." *Chronicle of Philanthropy Special Report*, October 4, 2001, http://philanthropy.com/article/How-Charitable-Giving-Fared/53676/.

"How to Choose Counsel." Giving USA Foundation, http://www.aarfc.org/counsel/index.cfm

Ingram, Richard T. "Ten Basic Responsibilities of Nonprofit Boards." 2nd ed. BoardSource, 2009, http://boardsource.org/Bookstoreasp?item=112.

Iraegui, Marcelo Iniarra, and Alfredo Botti. "Technology: How to Make the Most of Technology in Fund Raising." *Advancing Philanthropy*, November/December 2008.

Jacoby, Patricia B. "Seven Golden Rules for a Museum Campaign." *Museum Trustee Newsletter* 10(4) (Fall 1996).

Jahnke, Art. "Losing the Win-Win Game?" *Museum News*, September/October 1993.

Johnston, David Cay. "Smart Giving in a Troubled Climate." *New York Times*, May 21, 2009.

Katz, Sapper and Miller, LLP, Certified Public Accountants and Consultants, 11711 North Meridian Street, Indianapolis, IN 46240. "Contribution Complications: Keeping Up with Nonprofit and Donor Donation Responsibilities." *Profitable Solutions for Nonprofits Newsletter*, Fall 2001.

Keegan, B. Burke. *Fundraising for Non-Profits: How to Build a Community Partnership.* New York: HarperCollins, 1994.

Kennedy, Randy. "Los Angeles Museum Board Members Ordered to Undergo Financial Training." *New York Times*, April 19, 2010.

Kennen, Estela. "Non-profit Board Responsibilities: Overview of Non-profit Board Governance." February 21, 2007. http://non-profit-governance .suite101.com/article.cfm.nonprofit_board_responsibilities.

Kinzie, Susan. "Embarrassing or Just Strange, Some Gifts Turn Out Not to Be." *Washington Post*, September 4, 2007.

———. "Exacting Donors Reshape College Giving." *Washington Post*, September 4, 2007.

Klein, Kim. "Getting Over the Fear of Asking." In *Raise More Money: The Best of the Grassroots Fundraising Journal.* Hoboken: Jossey Bass, 2000.

Lansdowne, David. "The Relentlessly Practical Guide to Raising Serious Money, 2007." *GuideStar.org Newsletter*, October–November 2007.

Lewis, Catherine M. *The Changing Face of Public History: The Chicago Historical Society and the Transformation of an American Museum.* DeKalb, Ill.: Northern Illinois University Press, 2005.

Limpert, John. "Marketing Challenges in Cultural Fund Raising: A Personal View." *Museum News*, May/June 1982.

Lord, James Gregory. *Philanthropy and Marketing: New Strategies for Fund Raising.* Cleveland: Third Sector, 1981.

———. *The Raising of Money: Thirty-Five Essentials Every Trustee Should Know.* Cleveland: Third Sector, 2000.

Lublin, Nancy. "Foundations' Four Biggest Faux Pas." *Fast Company*, February 1, 2010, http://www.fastcompany.com/magazine/142/do-something-we-really -need-to-talk.html.

Maehara, Paulette V., CFRE, CAE. "Giving in America: Six New Trends in Fund Raising." *Museum News*, March/April 2003.

Margolin, Judith B., ed. *Foundation Fundamentals: A Guide for Grantseekers.* 4th ed. The Foundation Center, 1991.

Markowitz, Andy. "In the Arts: S. F. Museum Reaches Midpoint to Half-Billion Goal." *Chronicle of Philanthropy*, February 5, 2010.

McKinnon, Harvey. "Control Freak: What to Do When Donors Demand Control over Their Gift." *Contributions* 22(4) (2008).

McMillan, Tracie. "Charities Lose Lots of Money Replacing Departing Benefactors." *Contribute* (2007).

"Membership and Annual Giving." *Private Support for Museums in Today's Economy.* CASE Conference, January 6–8, 1982, Washington, D.C.

Merritt, Elizabeth. "Museums: A Snapshot." *Museum News*, January/February 2010.

Merritt, Elizabeth, and Erik Ledbetter. "Taking the Long View." *Museum News*, January/February 2010; *New York Times*, November 20, 2000.

Orden, Erica. "Koch Now, Not Forever." *Wall Street Journal*, May 12, 2010.

Panas, Jerold, Linzy and Partners, Consultants to Philanthropy. 500 North Michigan Avenue, Chicago Illinois, 60611. "Raising Funds in Tough Times," no date.

Panel on the Nonprofit Sector. "Principles for Good Governance and Ethical Practice: A Guide for Charities and Foundations." Independent Sector, October 2007.

Persellin, Kerura. *The NonProfit Board Report.* June–July 2007.

Philanthropic Service for Institutions, Seventh-day Adventist Church World Headquarters. *Accent on Recognition: Saying Thank You to Donors and Volunteers.* Silver Spring, MD, 1991.

Pogrebin, Robin. "Arts Organizations Adjust to Decline in Funding." *New York Times*, February 21, 2007.

———. "The Nonprofit's Guide to Surviving a Downturn." *New York Times*, November 9, 2008.

———. "Cultural Giving by Companies: A Two-Way Street." *New York Times*, November 13, 2006.

Poleshuck, Walter S. "Corporate Fund Raising." *Museum News*, March/April 1982.

Public Management Institute. *Seven Ways to Contact Corporate Funding Executives.* Prepared by the Staff of Public Management Institute, San Francisco, 1980.

Radock, Michael. "Words to the Wise: Foundation Executives' Comments on the Most Frequent Errors Made in Grant Proposals." *Journal* (National Society of Fund Raising Executives), Winter 1980.

Rosso, Henry, and Associates. *Achieving Excellence in Fundraising: A Comprehensive Guide to Principles, Strategies and Methods.* San Francisco: Jossey-Bass, 1991.

Roth, Kimberlee. "Smaller Charities Need Creativity and Care When Recognizing Donors." *Chronicle of Philanthropy*, March 20, 2003.

Roug, Louise. "Charities Feel Wall Street Pain." *Los Angeles Times*, April 29, 2008.

Schwartz, William, and Serbaroli, Francis J. "After the Barnes Ruling: What Donors Should Do to Protect Their Wishes." *Chronicle of Philanthropy*, March 31, 2005.

Schwinn, Elizabeth. "Trustees Don't Do Enough to Help Charities Raise Money, Study Finds." *Chronicle of Philanthropy*, November 8, 2007.

Senge, Peter M. *The Fifth Discipline: The Art and Practice of the Learning Organization*. New York: Doubleday, 1990.

Setterberg, Fred, and Schulman, Kary. *Beyond Profit: The Complete Guide to Managing the Nonprofit Organization*. New York: Harper and Row, 1985.

Seymour, Harold J. *Designs for Fund-Raising*. 2nd ed. Rockville, Md.: Fund-Raising Institute, 1988.

Shapira, Ian. "Grappling with a Wealth of Guilt: Young Heirs Seek Moral Balance between Inherited Windfalls, Social Responsibilities." *Washington Post*, November 20, 2009.

Skramstad, Harold, and Susan Skramstad. *A Handbook for Museum Trustees*. Washington, D.C.: American Association of Museums, 2003.

Spector, Mike. "Family Charities Shift Assets to Donor Funds." *Wall Street Journal*, April 22, 2009.

Steinhauer, Jennifer. "Wielding Iron Checkbook to Shape Cultural Los Angeles." *New York Times*, February 5, 2010.

Strom, Stephanie. "Bracing for Lean Times Ahead." *New York Times*, November 11, 2008.

———. "Charities Loosening Strings on Arts Grants." *New York Times*, June 4, 2009.

———. "Foundation Giving in '08 Defied Huge Asset Decline." *New York Times*, March 31, 2009.

Thelen, David, and Roy Rosenzweig. *The Presence of the Past: Popular Uses of History in American Life*. New York: Columbia University Press, 1998.

Toscano, James V. "Development Comes of Age." *Museum News*, January/February 1982.

Tugend, Alina. "Feeling Charitable and a Bit Badgered." *New York Times*, April 29, 2006.

Unterman, Israel, and Richard Hart Davis. "From the Boardroom: The Strategy Gap in Not-for Profits." *Harvard Business Review*, May/June 1982.

Vogel, Carol. "Museums Fear Lean Days Ahead." *New York Times*, October 20, 2008.

Wade, John. "Return to Donor? Legal Rights of Unhappy Contributors." *Case Currents*, June 1999.

Warwick, Mal. "A CEO's Guide: Getting Your Money's Worth from your Fundraising Manager." *The Warwick File*, NonProfit Times, August 15, 2005, www.nptimes.com.

———. *Five Strategies for Fundraising Success: A Mission-Based Guide to Achieving Your Goals*. San Francisco: Jossey-Bass, 1999.

Wasley, Paula. "Charitable Donations Fell by Nearly 6% in 2008, the Sharpest Drop in 53 Years." *Chronicle of Philanthropy*, June 9, 2009.

Webb, Charles. "Twenty Common Misconceptions about Capital Fund Campaigns." Excerpts from Charles Webb's lecture at Williams College, January 15, 1993.

Weil, Stephen E. *Making Museums Matter*. Washington, D.C.: Smithsonian Institution Press, 2002.

Wilhelm, Ian. "Are Charities Ready for Tough Times Ahead?" *Chronicle of Philanthropy*, http://philanthropy.com/premium/articles/v22/i03/03000101.htm.

Website Resources

Association of Fund Raising Executives: http://www.afpnet.org

BoardSource: http://www.boardsource.org

The Chronicle of Philanthropy: http://philanthropy.com

The Foundation Center: http://www.foundationcenter.org

Free Management Library, Nonprofit Fundraising and Management: http://managementhelp.org/fndrsng/np_raise/np_raise.htm

GIFT: Grassroots Institute for Fundraising Training, Oakland, CA: http://www.grassrootsfundraising.org/article.php?story=contact

Goettler Associates Newsletters: http://www.goettler.com

The Grantsmanship Center: http://www.tgci.com/magazine/fundraising.shtml

The Independent Sector: http://www.independentsector.org

Indiana University School of Philanthropy: http://www.philanthropy.iupui.edu

Kathryn Miree and Associates: http://www.kathrynmireeandassociates.com

Michigan State University Libraries: http://staff.lib.msu.edu/harris23/grants/4fcelec.htm

The Philanthropy News Digest: http://foundationcenter.org/pnd

Philanthropy 2173: http://philanthropy.blogspot.com

Poderis, Tony. Fund Raising Forum Library: http://www.raise-funds.com/library.html

University of Wisconsin. Grants Information Collection. A Cooperating Collection of the Foundation Center Library Network: http://grants.library.wisc.edu

INDEX

AAM. *See* American Association of Museums

ABC. *See Atlanta Business Chronicle*

acceptance, of grant, 172–73

accounting terms: conditional promise to give, 93; contribution requirements, 94; donor suggestions, 94; intentions to give, 94–95; permanently restricted gift, 90, 93–94; reliance, 94; temporarily restricted gift, 90, 93–94; time and purpose restrictions, 93; unrestricted gift, 89–90

accreditation, AAM strategic plan for, 36

Advancing Philanthropy (Iraegui/ Botti), 122

AFP. *See* Association of Fundraising Professionals

AHP. *See* Association for Healthcare Philanthropy

American Association of Museums (AAM), xii, 13, 153; corporate relations guidelines of, 155–56; on recognition, 80; strategic plan for accreditation by, 36

American Museum of National History, 80

Americans, generosity of, *39*, 40–41

annual fund, 121–27; campaign, 30–31; for general operating support, 101; gift, as unrestricted gift, 90; IRS and, 122; mapping of, 124–27

annual meeting requirement, for board members, 109

art, contribution of, 92

articulated goal, 32

art museum, viii, 11

ask: of charitable donation by volunteer, 61–62; of closer board member type, 17; face-to-face approach, 14, 52, 67–71, 85–86, 147, 201n10; failure to, 48, 72–73; grant and, 167; knowing when to, 64; Rosenwald rules for, 74–75; unified, of Atlanta Historical Society, 16

Association for Healthcare Philanthropy (AHP), 83–84